Site-Seeing Aesthetics

Spatial Practices

AN INTERDISCIPLINARY SERIES IN CULTURAL HISTORY,
GEOGRAPHY AND LITERATURE

General Editors

Christoph Ehland (*Paderborn University*)

Editorial Board

Christine Berberich (*University of Portsmouth*)
Jonathan Bordo (*Trent University*)
Oliver von Knebel Doeberitz (*University of Leipzig*)
Catrin Gersdorf (*University of Würzburg*)
Peter Merriman (*Aberystwyth University*)
Christoph Singer (*Paderborn University*)
Merle Tonnies (*Paderborn University*)
Cornelia Wächter (*Ruhr University Bochum*)

Advisory Board

Blake Fitzpartrick (*Ryerson University*)
Flavio Gregori (*Ca' Foscari University of Venice*)
Margaret Olin (*Yale University*)
Ralph Prodzik (*University of Würzburg*)
Andrew Sanders (*University of Durham*)
Mihaela Irimia (*University of Bucharest*)

Founding Editors

Robert Burden
Stephan Kohl

Former Series Editor

Chris Thurgar-Dawson

VOLUME 34

The titles published in this series are listed at *brill.com/spat*

Site-Seeing Aesthetics

California Sojourns in Five Installations

By

Lene M. Johannessen

BRILL
RODOPI

LEIDEN | BOSTON

Cover illustration: photography by Lene M. Johannessen.

Library of Congress Cataloging-in-Publication Data

Names: Johannessen, Lene, author.
Title: Site-seeing aesthetics : California sojourns in five installations / by
 Lene M. Johannessen.
Description: Leiden, The Netherlands ; Boston : Brill, 2021. | Series: Spatial
 practices, 1871-689X ; volume 34 | Includes bibliographical references and
 index. | Summary: "This binary also speaks more generally to how we tend to
 conceive of the relation between place and space: As many scholars have
 pointed out, place often comes valued as "the sphere of the everyday, or real
 and valued practices," or "a locus of denial" trailing ideas of the "closed, coherent,
 integrated as authentic, as 'home', a secure retreat" (Massey 2005, 5-6). Doreen
 Massey's descriptions speak to our perceptions of a center, of a core toward
 which energy flows, and in so doing marking, in Michel de Certeau's words, "an
 instantaneous configuration of positions"– Provided by publisher.
Identifiers: LCCN 2020032638 | ISBN 9789004437999 (hardback) |
 ISBN 9789004438002 (ebook)
Subjects: LCSH: Place (Philosophy) | Place attachment–California. |
 California–Historical geography. | Space and time. | Aesthetics.
Classification: LCC B105.P53 J647 2021 | DDC 304.2/309794–dc23
LC record available at https://lccn.loc.gov/2020032638

Typeface for the Latin, Greek, and Cyrillic scripts: "Brill". See and download: brill.com/brill-typeface.

ISSN 1871-689X
ISBN 978-90-04-43799-9 (hardback)
ISBN 978-90-04-43800-2 (e-book)

Copyright 2021 by Koninklijke Brill NV, Leiden, The Netherlands.
Koninklijke Brill NV incorporates the imprints Brill, Brill Hes & De Graaf, Brill Nijhoff, Brill Rodopi,
Brill Sense, Hotei Publishing, mentis Verlag, Verlag Ferdinand Schöningh and Wilhelm Fink Verlag.
All rights reserved. No part of this publication may be reproduced, translated, stored in a retrieval system,
or transmitted in any form or by any means, electronic, mechanical, photocopying, recording or otherwise,
without prior written permission from the publisher. Requests for re-use and/or translations must be
addressed to Koninklijke Brill NV via brill.com or copyright.com.

This book is printed on acid-free paper and produced in a sustainable manner.

Contents

Acknowledgements VII

Introduction: Sojourn Aesthetics 1

1 The Time of Loss: Chavez Ravine 26

2 The Time of Ghosts: Chinese Camp 51

3 The Time of Hope: Letters from a 49er Everyman 74

4 The Time of Desire: The Winchester House 98

5 The Time of Romance: Fort Ross 122

Conclusion: Tangled Figurations 147

Works Cited 163
Index 173

Acknowledgements

Site-Seeing Aesthetics is the result of several years of work, and funding for the various stages of research from the University of Bergen has helped bring it to completion. I am very grateful to the Latin American and Caribbean Studies Institute (LACSI) at the University of Georgia for hosting my year-long research stay there. A warm thanks goes to Derek Bentley and Paul Duncan for daily companionship and conversations, and to John Lowe and Richard Gordon for making the stay at UGA possible. I would also like to thank Manuel Díaz for my first tour of Dodger Stadium. For their helpful comments and suggestions to different parts of this project, I thank Jena Habegger-Conti, Asbjørn Grønstad, Øyvind Vågnes, and Tim Saunders, and extend particular appreciation to Henrik Gustafsson and Jennifer Ladino for their very valuable commentaries to the final draft of this book.

This book is for my dearest sojourn companions: Vilde, Emma, Sofie, Paul, and Kevin, for so many journeys to so many places.

Introduction: Sojourn Aesthetics

Site: "2a. The situation or position of a place, town, building, etc., esp. with reference to the surrounding district or locality. Occasionally without article. [...]3a The ground or area upon which a building, town, etc., has been built, or which is set apart for some purpose [...] 3c. Archaeol. A place containing the remains of former human habitation; an excavation"

OED

∙ ∙ ∙

Sight: 1 a. A thing seen, esp. of a striking or remarkable nature; a spectacle. Sometimes with the addition of the infinitives to behold, to see, with an intensifying force. 1c. plural. Those features or objects in a particular place or town which are considered to be specially worth seeing.

OED

∙ ∙
∙

There was a time when my bus to work went through a neighborhood called Five Points, a very busy intersection where five roads come together in starlike formation. The traffic lights were slow, so there was usually ample time to contemplate the "star," and whatever was going on there early in the morning. One thing that continued to interest me was the name itself, and the locus of energy it described. One morning while waiting for the light to turn green, I looked it up on the *GeoNames* website, and a staggering 305 hits came back for different kinds of places around the US named Five Points. Just out of curiosity I then entered *Four* Points, which returned significantly fewer hits; *Three* Points came up with even less, and *Two* Points only one, listed on the website as a cape. Five Points overwhelmingly wins that contest. For someone interested in and thinking about what site, place, and space mean as we visit and pass through, the "star" of that intersection is helpful. It very nicely illustrates the first definition of site in the epigraph above as the "position of a place, town, building, etc., esp. with reference to the surrounding district or locality." The site of a Five Points owes its existence precisely to its relation to what lies

around; this is what creates it as a place of crossings, vigorously forming a nucleus for encounters, trade and business, and attracting to itself all the energy of traffic and exchange. However, the very same nucleus by the same token also offers five roads *away* from its center. The dynamism created in a Five Points is consequently not only inward directed, but as likely and sometimes perhaps to some, as desirably, outward directed. The convergence of five roads into a defined and definite place with the concomitant potential for a momentum of divergence consequently carries some likeness to how Mikhail Bakhtin thinks about the dynamism of language: "Every utterance," he says, "participates in the 'unitary language' (in its centripetal forces and tendencies) and at the same time partakes of social and historical heteroglossia (the centrifugal, stratifying forces)" (Bakhtin 1991, 272). All roads leading to – a "unitary language" of vectors agreeing in their trajectories – already also carry the possibility of leading from – the fact of stratification and unpredictability.

This binary also speaks more generally to how we tend to conceive of the relation between place and space: As many scholars have pointed out, place often comes valued as "the sphere of the everyday, or real and valued practices," or "a locus of denial" trailing ideas of the "closed, coherent, integrated as authentic, as 'home', a secure retreat" (Massey 2005, 5–6). Doreen Massey's descriptions speak to our perceptions of a center, of a core toward which energy flows, and in so doing marking, in Michel de Certeau's words, "an instantaneous configuration of positions. It implies an indication of stability" (1984, 117). As we come back to in the following pages, we might want to add to these readings of place: "so far." This is perhaps what underlies philosopher Edward Casey's point that, "[i]t is rare, if not impossible, to experience an entirely isolated place: a place without relation to any other place, without imbrication in a region" (Casey 2001, 690). For the instantaneous configuration is precisely that, a coterminous presently, and in no way promising lasting permanence. Hence, as an order for distribution, as de Certeau calls it, place is unpredictable, already in its sudden configuration spatially conditioned, a coordinate on a much bigger surface and always inter-connected. In contrast to understandings of place as fixed and settled, space, as Massey notes in an echo of de Certeau, "is the product of interrelations; as constituted through interactions" (Massey 2005, 10). Elsewhere she more concretely concludes that "the spatial is social relations stretched out" (Massey 1994, 2). But place and space cannot be completely and rigorously separated, and to the extent that they can, this may be a question of the relation between inward and outward orientation. From the point of view of the Five Points intersection, it commands the spatial multiplicity that forms and informs it; however, from the point of view of one of its inward bound roads, it is destination, a definite point and place onto itself.

We are in other words returned to the dictionary definition in the epigraph of site as the position of a place relative to its surroundings: The place posing as center, however insulated it may think itself, must contend with its absolute reliance on the coordinates beyond it that give it shape. This is an idea I will keep coming back to throughout the chapters that follow.

The five sites that figure in this book's sojourn are all located in California, but the approach to the performativity of site and the aesthetics of site seeing I propose applies more generally; indeed, the concluding chapter will take us across the continent to a site in the very differently originated and storied South Carolina. It must be said, though, that California poses as a veritable five points in and of itself, and as a region, perhaps more dramatically than many others, it comes into the world as a center of gravitation for waves of at times extreme impulses of hopes and dreams. It pulls into its center energies from all over, becoming a "star" in more senses than that of the actual configuration that the various routes create. Walt Whitman's celebration in his "Song of the Redwood Tree," known also as "a California song," is addressed not only to the region's accumulation of energies but pronounces its position precisely as a star in terms of unique newness. The poet's declaration abounds in descriptions rejoicing in the unique promise held out by the region, concluding:

> Fresh come, to a new world indeed, yet long prepared,
> I see the genius of the modern, child of the real and ideal,
> Clearing the ground for broad humanity, the true America, heir of
> the past so grand,
>> To build a grander future. (1900, 102–105)

Written in 1874, "Song of the Redwood Tree" articulates a vision of the past as it must yield to the future in familiar Whitmanesque style. The closing lines of the poem capture a sensibility to and a conviction of advancement and progress that suggest the California coast as more than just an emblem of national significance. In the poem, it comes to stand as a singular trope of modernity in the "new world," a harbinger of "a grander future," and "the promise of thousands of years," thus imagining and reflecting, as we perceive in so much of Whitman's work, a cultural imaginary devoted to newness.

He was not the first to frame California in triumphant and near fantastical terms, and neither was he the first to prophesize the role it would, or should, have; nor the last, for that matter. Centuries before Whitman saw "the genius of the modern" in California, the coast had been the host to what James Clifford describes as,

the mix of human times we call history: the long span of indigenous traditions and folk histories; the waxing and waning of tribes and nations, of empires; the struggles and ruses of conquest, adaptation, survival; the movements of natives, explorers, and immigrants, with their distinct relations to land, place, and memory; the changing rhythm of markets, commodities, communications, capital – organizing and disorganizing everything.

CLIFFORD 1997, 302

The twenty something Indian tribes that lived between what is today Oregon and the Mexican border when Spanish explorer Juan Cabrillo made landfall in San Diego in 1542 covered between them six different language families. All the tribes had different names for the places where they dwelled, and hence, "in the tribal mind and in the tribal world, [California] did not exist" (Hicks et al, 2). Indeed, the very name California is itself the result of fantastic fiction, conjured up in Garcí Rodriguez Ordoñez de Motalvo's romance *Las Sergas de Esplandián* (*The Adventures of Esplandián*), published in Madrid in 1510. Herein is described an island populated by Amazon women who are led by their Queen Calafia, and so, as Clifford comments, "long before the name appeared on maps, California had a place in the European mind" (Clifford 76–77). Many years after de Motalvo composed his narrative, Karl Marx and Friedrich Engels would assess the discovery of gold in California as follows, and I quote them at some length:

The Californian gold mines were only discovered eighteen months ago and the Yankees have already set about building a railway, a great overland road and a canal from the Gulf of Mexico, steamships are already sailing regularly from New York to Chagres, from Panama to San Francisco, Pacific trade is already concentrating in Panama and the journey around Cape Horn has become obsolete. A coastline which stretches across thirty degrees of latitude, one of the most beautiful and fertile in the world and hitherto more or less unpopulated, is now being visibly transformed into a rich, civilized land thickly populated by men of all races, from the Yankee to the Chinese, from the Negro to the Indian and Malay, from the Creole and Mestizo to the European.

MARX and ENGELS 1850, 8

The emphasis on the trade routes that open up, and on the prospect of confluence, prosperity, and movement of peoples and commodities that will follow already define the dynamic of a globalization of economies and cultures, and

at a rather early point. As in Whitman's "California Song," Marx and Engel's reflections do not significantly question the direction of this "transformation" of "the most beautiful and fertile" land into one that is "civilized" and "thickly populated." And, as in Whitman, the direction of the modern, what he calls the "chant of the future," is not significantly problematized. A glance at for instance these lines from the same poem tells of an outlook laden with future and future only: "Ships coming in from the whole round world, and going out to/the whole world,/To India and China and Australia, and the thousand is-land/paradises of the Pacific/" (Whitman 1900, 91–92). The sentiment in Marx and Engels as well as in Whitman consequently rather poignantly refracts a dynamic of convergence and divergence, and the centripetal and centrifugal we looked at in relation to Five Points above. Similarly, Casey's observation, that one cannot imagine "a place without relation to any other place, without imbrication in a region," works accurately as a translation of California into a prime example of spatial practices in oscillation between peripheries and centers. They come through in innumerable chronicles of real as well as fictional and mythical encounters, sojourns, interpellations that have furnished the state with its complex and rich history. Whether they are actual, historical events, or the stuff of imagination, they can all be deciphered according to temporal and spatial circumstances. Hence, all of the above presences and perspectives on California also exemplify the argument Arjun Appudurai makes in relation to area studies generally, that "we need to recognize that histories produce geographies and not vice versa. We must get away from the notion that there is some kind of spatial landscape against which time writes its story. Instead, it is historical agents, institutions, actors, powers that make the geography" (Appudurai 2010, 9). And, we should add, that make places.

California can perhaps be seen as a particularly densely crisscrossed space and one that continues to invite inquiries into the multiple, overgrown monuments once presiding over local as well as global movements and moments. They speak in different tenors, and they cannot always show for themselves continuity of storyline, but they invariably host complex histories of encounters and relations, however hasty they may be. For, it may be that places in the West came up and were torn down faster than you could make a friend, but that doesn't mean they left nothing behind. As any sojourner to the West generally and California specifically will protest, there is no shortage of places and stories of precisely dramatic swiftness and volatility that live on in the remotes of inhospitable foothills, dried out outskirts of deserts, the depths of impenetrable forests. This presents us with a similar promise to that held out by archeology, inviting, as Michael Shanks puts it, "a material practice set in the present which works on and with traces of the past. What archaeologists

do is work with evidence in order to create something – a meaning, a narrative, a story – which stands for the past in the present" (quoted in Turner 2004, 378). Such storying of place is furthermore never very far removed from the storying of self; think only about the question we routinely ask of each other: "Where are you from?" Even if you hail from a place everybody knows – San Francisco, Copenhagen, Berlin, nine times out of ten there will be a follow up question: "*Where* in …?" In our further elaborations our responses often tend toward the claim to a form of identity grounded in identifications attached to a more finely defined place: We come from so and so neighborhood, traditionally it was …, it changed into …, we feel … about that change; we go on to tell of what we miss, what we don't miss, etc. etc. These are all markers of who we are every bit as much as of where we are from. The narrative places us just as we place the narrative.

These preliminary remarks on the relation between site, place and space, and narrative, will serve as a tentative introduction to the sojourns and site-seeings that follow. I say tentative, because this is inherently unruly matter, and absolute restrictions and boundaries, whether in argument or empiricism, will only take us so far in these excursions. To begin with, let me therefore say that each of the five chapters depicts a specific place and its stories, memories, and "performances." The motivation for their "visits" is to allow these sites to speak, not only as a point of unity and gathering, but as the locus for centrifugal forces, for that which diverges and takes flight, for spatial turns and practices, expected as well as unexpected ones. The book thus makes momentary stops and brings to light the inherently temporary nature of the sites themselves, the fabric of vectors from the invariably multiple directions of which they are part. Movement and site in this state of spatial impermanence form certain shapes, figures that orchestrate the discourse a given site comes to have about itself and inviting in turn our responses to it. The figures may take various forms, and as in a literary text they may be a motif, a symbol, or they can be anchored in sentiments of nostalgia, or romance, challenging us as audience to make sense of what we see, what we "read." For invariably, the site thus conceived, namely as a fabric, as "text," often participates in storytelling across great distances, and across time. It must, however, also be emphasized that seeing site and reading, arranging it yields a narrative that is only one; as with texts, there will be other narratives, other emplaced and embodied seeings and arrangements. For my own reading and making sense of how the sites come to pose before us here is not that of the trained historian, nor the geographer. I am instead interested in the way place and site converse with the visitor, and how the relationality that dwells in the homonymity of sight/site brings the idea of spectacle to bear on the situatedness of the place.

While they signify in their own rights as locales, the names and the spaces the sites collected in this book designate moreover form knots in intricate webs of California – and in many cases and as the references to early conceptions of the region testify to, world history. As Neil Campbell notes in *The Rhizomatic West*, it has "always had a global dimension as a geographical, cultural, and economic crossroads defined by complex connectivity, multidimensionality, and imagination, even if these have often been elided in favor of a more inward-looking and emotive vision" (Campbell 2008, 3). The multiple and variously originated strands of human life that gather on and in a given site thus nearly always, and in their citations, lead us elsewhere, and "elsewhen." They are therefore not only the stories we tell; they are fundamentally also the places we tell. Borrowing from performance artist and scholar Mike Pearson's thinking, we could say that the sites are "locales that […] constitute moments of particular density or depth […] drawn to our attention through what happens there" (Pearson 2006, 11). That happening depends on memory and narrative for its continuing happening in the world, so to speak, for prompting our recognition, and be told again, reminded of. In a kind of aesthetic-cultural archeology the chapters thus *see* the sites they sojourn through in their layeredness. This means excavating from under various coatings entire registers of complex pasts and alternate forms, that we as audience may listen to and hear them tell their stories – again:

The Dodger Stadium in Los Angeles, host not just to ballgames, but also to Ry Cooder's sonic excavations of the buried neighborhood on his album carrying its name, *Chavez Ravine*. The story stretches out complexly to connect with historical vectors that show no sign of abdicating from their original momentum.

Chinese Camp in the Gold Country, overgrown and ghostly, is easy to miss en route to more impressive Yosemite, but was once home to a substantial Chinese community. The story of its fate in many ways allegorizes the history of Chinese in the West, still to be fully told.

The itinerary through that same country as described on the site of the yellowed, stored–away letters which a 49er looking for gold wrote back to his mother between 1849 and 1855. His was a dream still dreamed, whose visionary coordinates are hard to imagine outside the West.

The Winchester House in San Jose, home to Sarah Winchester, whose terror of the ghosts of the many who fell to her husband's notorious gun she could only still by never stopping adding to the house. Or so the legend goes. There may well be other interpretations of her story and the place that holds it.

Fort Foss, a few hours north of San Francisco, serenely overlooking the Pacific. Today a museum and historic state park, it once played a key role in

the argument two empires, Russia and Spain, had about their borders, and in a tragic romance between a Russian Count and the daughter of a Spanish Commander.

Finally, in the concluding chapter we see an orchestration of site on the court square of a small town in South Carolina, assuming its part in the larger play of reckonings with history. Here monuments and memorials speak in their own tenor, and with stories of a different kind.

In relation to all places and stories, the volatile and erratic ways of human desire for journeys and departures, for passages into spaces *other than*, are of as much interest to the representation of the sites as are the strivings for unity and completion in bounded place. They will thus receive due attention as we see them in their exact locations, but equally importantly in their instances as intersections for traversals across the lines of history's intents. I have happened upon the ones gathered here in part accidentally, but on some level always motivated by professional as well as personal curiosity about how we see sites, how we read place. The stories that each place harbors also speak to my own training as a literary and an American studies scholar; like others in the trade, I cannot help but pull at loose threads, pick up scattered fragments seemingly insignificant, the details that shimmer so irresistibly. All of the five sites can in one way or other be approached precisely according to such loose threads and fragments. They emerge from various degrees of obscurity – whether from underneath new structures and parking lots, from under nature's own habitual overlayering of what is no longer in use, or in the dusty repositories of forgotten letters, journals, records. Let us consider them now in a little more detail so the reader has an idea of where this sojourn will take us:

Sometimes the stories are there, but their places are lost, as the first chapter will focus on. Let us here briefly consider the ballad "3rd Base, Dodger Stadium" on Ry Cooder's *Chavez Ravine* concept album from 2005 as a small example: In the soft voice of Hawaiian singer Bla Pahinui, the singer/narrator tells us how he sees his grandma sitting in her rocking chair where 2nd base is now. She is watching the linens dry in the breeze and kids getting ready for a game. It may be that the neighborhood known as Chavez Ravine was bulldozed out of existence, but its traces remain, as Wallace Stegner says, in memory, in songs. Cooder's album, fictional for the most part, configures into existence a narratological layer that forces onto the concrete site of the stadium in Chavez Ravine a presence of the past that imprints on our perception. As I return to in detail in "The Time of Loss," the musical re-visitation on site creates and carves out according to a specific perspective a scene that widens, loudly, in a soundscape extending well beyond its own moment.

And then at other times the places are there, but their stories are lost, or, so it seems. On the way back to the coast from a trip out West, I made a quick stop in Chinese Camp, mostly just curious about the name on the map. The short visit to what turned out to be an overgrown semi-ghost town in the Gold Country was well worth the bumpy roads. I had optimistic hopes of finding someone to talk to, perhaps even a small library, but all I could find in the small visitor's center was a pamphlet from 1977. It is published by the local historical society of Tuolumne County, and over about four-five pages, late local resident Dolores Nicolini details the families and businesses that once made up Chinese Camp between roughly 1870 and the 1960s. The booklet chronicles names of Anglo and Italian sounding descent; the ones the town clearly takes its name after are, however, referred to only in passing. "The Time of Ghosts" sets out to excavate from under the branches and wildflowers the story of Chinese Camp, suggesting that the figure it presents to us today analogizes a very particular cultural landscape, a Landschaft, in the sense of being "a way of seeing that has its own history" (Cosgrove quoted in Pearson 2006, 10). That way of seeing huddles close to nostalgia, but it is unclear who is being nostalgic. Is it the pamphlet, or is it just us, the audience, watching the "staging" of the past that Chinese Camp presents before us? Both? I want to suggest that the site maybe does more than to analogize a cultural landscape, and that the nostalgia that shrouds it muddles our perceptions of its spatial challenge. That is to say, the site tests our ability to comprehend this fabric of history as simply opaque; faced with opacity, we may feel the need to choose. That choice may be between what Svetlana Boym describes as reflective versus restorative nostalgia (2001), between the longing itself, or the longing that seeks to restore what is perceived as origin.

To most readers, David Wilson is unknown, and there is no good reason he should not be. His story is, however, closely related to the history of Chinese Camp and is recorded in the letters he wrote home to his mother in Maryland in the 1850s. As thousands of others from all corners of the world he had set out to get rich. And, as so many of the others he saw none of the riches but instead happened upon bad luck and bad decisions. At the end of the letter series, the sentiment reflected in Marx and Engels' previously quoted proclamation of California as "one of the most beautiful and fertile in the world" is wearing thin. As we traverse this space of promise along with Wilson, we must also bear I mind the nature of the epistolary itself. The interlocutor in the series is for the most part the mother, but it is also the perspective of the East and the old left behind, a space with its own ideas of what progress and success is. Both are the invisible but insistent correctives according to which David's responses are oriented. What this means for the letters' depiction of the actual space he

crisscrosses in the Gold country is interesting, and as with so many letters sent "back" from the "new world," renditions of place lend themselves to some questioning. Despite his multiple promises to return to help his mother on the dairy farm, Wilson's letters stop mid-story, with no gesture of a return or keeping his promise. His is "The Time of Hope," indelibly Californian, and, in its ceaseless ambition, for all ages.

Sometimes we are so accustomed to one particular performance of and on a given site that we have become insensitive to the possible web of other, alternative performances. Such is, I suggest, the case with Sarah Winchester's "mystery house" in San Jose. From ways away we drive by the billboards advertising tours of the house, Halloween events, wedding specials and so on, but completely forget that Sarah's is a route that emulates and repeats that of countless others, albeit less spectacular ones. In the tale of the genesis of the house her design is often classified as that of a mad woman, but in fact it emblematizes a much larger, and perhaps specifically Californian one. Sarah's is a performance on site that compellingly reaches forth as a perpetual search for meaning and new beginnings, and her bizarre construction, as truly a site of performance, should consequently be seen for what it is, an escape. Popular culture has given us several versions of this particular story, most recently in the movie *Winchester: House of Ghosts* (2018). The story figures also in Alexandra Teague's collection of poetry, *The Wise and Foolish Builders* (2016). But here, too, the insistence on the ghostly in Sarah's story detracts from its potentially more interesting role in a much bigger story of unfettered progress whose "insanity" resides elsewhere. The monumental house espouses all of the original meanings of the word monument – but what is it that it warns against, and reminds us of? Here, too, nostalgia rears its head, for the relationship between monument and nostalgia is precarious, and the specific location of the Winchester House in the heart of Silicon Valley complicates this relation further.

The final stop on this California sojourn is a site that hosts a romance between a count and a commander's daughter, and oddly finds its place in a similar dreamscape of fated aspiration as what both David Wilson and Sarah Winchester maneuver. "The Time of Romance" traces the Russian Empire's ideas of the role they would come to assume in the New World, with a Russian basin collapsing the northern waters of the eastern Pacific into the empire and securing trade routes to Asia. In 1803 the Czar's envoi Nikolai Rezanov boldly sailed into San Francisco Bay, ignoring the Spanish ban on foreign vessels in an attempt at both securing supplies for his starving compatriots further north in Sitka, and to negotiate the border between the two empires. Fort Ross would eventually materialize from these talks as the southernmost marker of

the Russians' presence in Alta, or Nueva California, but is today but a vague reminder of presences long gone.

And yet, the scene it stages for those who care to linger offers a spectacular view of an inordinately complex region. Bearing in mind the idea of region as what Edward Casey describes as "an area concatenated by peregrinations between the places it connects" (Casey 1996, 24), inherently fluid and heterochronic (Bal 2011), the emerging borderscapes bring to our attention a truly momentous global network. This is nowhere more compellingly recorded than in the notes Rezanov's doctor himself recorded on the journey itself. The romance itself is furthermore not forgotten and lives on in the Russian rock opera *Juno and Avos* (1981), based on the poem "Juno and Avos" by Andrei Voznesensky from 1970. The relatively recent dates of poem as well as opera speak to the place that the original story and the stage on which it played out holds in a peculiar Russian American imaginary. Indeed, when Fort Ross' survival as State Park was under financial threat some years ago, Russian investors came to the rescue. Not only does this part of California history speak of a lesser known encounter between empires, it is also a captivating demonstration of the performativity of place, its narrativization into spatial and temporal reenactments and, hence, memorializations. Fort Ross, like the sites in the other chapters, is a site-specific performance on a much larger stage, and playing its part in much greater plays.

I will return to the last site we visit in the Conclusion; for now I go back to loose threads and fragments, because in addition to being hosted by the same region, California, all five stories and sites share in common that they are pieces of larger wholes. In Chavez Ravine where the Dodger Stadium lies, a few houses are quite literally left over from the neighborhood that once existed. They give away the existence of a different story than that of baseball games and the fans' coming and going to their spectacles. As literally, Chinese Camp, the name on the sign and on the map, is one of a few remaining indicators left visible from a time when the adjective and what it described was a town with a trajectory and existence to be reckoned with in the region. Similar observations could be made for the other sites. Precisely because we are dealing with fragments and their relation to the sites where they are located, our visiting and deciphering of them is very much a readerly exercise, a literary undertaking. It bears keeping in mind here what the word "read" actually means. To most of us reading is so second-nature to our lives that, like breathing and sleeping we tend not to consider that there are actual, original senses of the word. I remind my students, however, and with the help of a good dictionary, that the word "read" is "cognate with the Old Frisian *rēda* to advise, to deliberate, to help, Middle Dutch *rāden* to advise, to suggest, to convince, to devise,

to guess, to think, to plot (Dutch *raden*), Old Saxon *rādan* to advise, to plan, to arrange (Middle Low German *rāden*, also in senses 'to rule', 'to predict', 'to relate')" (*OED*). We could go on with similar significations in other languages; for instance, in Norwegian and German the commonly used verbs for giving advice to or council someone are *råde* and *raten* respectively. The word for advisor in Norwegian is "rådgiver," and translates literally as "the giver of advice" – in other words, someone who gives readings.

I mention this because the approach to the stories and the places they tell in this sojourn is informed by all of the above senses of the word *read*: they must be arranged, interpreted, and they must be related to a series of other stories and other places for their full bearings. The reader who takes upon herself to do this arrangement, elucidation, and tracing of relations thus functions as something akin to a guide, or director, advising and giving readings on how to understand and respond to what comes before us. There is also a more general impetus behind this readerly tactic, because to see sites is, as mentioned, invariably also to engage the practice of storytelling, a kind of "deep map" thinking and writing, "marked by attention to the ways in which *the smallest, most closely circumscribed locale eventuates from the deepest recesses of time*, [...] subject to attention in the most diverse, disparate terms from the widest array of perspectives" (Randall Roorda quoted in Maher 2009, 1). The coinage of deep maps comes as we recall from William Least Heat-Moon's *PrairyErth: A Deep Map* (1991). *PrairyErth* is a work of travel writing from just *one* county in Kansas, and it takes it over six hundred pages to cover the space and to "test the grid," as Heat-Moon says: "Standing here, thinking of grids and what's under them, their depths and their light and darkness [...]" (ibid., 15). Deep maps consequently work vertically every bit as much as horizontally, but differently from *PrairyErth* and for our purposes here I will add that the "deepest recesses of time" in relation to the sojourns in this book will not extend to geological, planetary time. Instead I want to focus on the layered "scripts" that are most prominently influential on the surface of the present, composed as it is by what lies underneath, as a palimpsest. This brings us to the narrative character of place. In Barbara Jonstone's straightforward phrase, "our sense of place [...] is rooted in narration" (quoted in Kent C. Ryden 1993, 42). In a similar observation Yi-Fu Tuan reflects that worlds are made, places located through words and speech, which "can direct attention, organize insignificant entities into significant composite wholes, and in so doing, make things formerly overlooked – and hence invisible and nonexistent – visible and real" (1991, 685). Places are created, not only from the perspective of economics and material forces (five roads generating business and exchange), nor from geological history and

happenstance alone, but as deriving their deepest import from and in our discourses and stories *about* them.

Nowhere is this formulated more astutely and lyrically than in Wallace Stegner's essay "The Sense of Place" where he synthesizes all of the above as follows: "The truth is, a place is more than half memory. No place is a place until things that have happened in it are remembered in history, ballads, yarns, legends, or monuments. Fictions serve as well as facts" (Stegner 1986, 4). Stegner takes Rip Van Winkle and the Catskills, Faulkner's Yoknapatawpha and the South as examples of the amplifying power narrative has for a sense of place, but then goes on to suggest that, "the process of cumulative association has gone a good way by now in stable, settled, and especially rural areas – New England, the Midwest, the South – but hardly any way at all in the raw, migrant west" (ibid.). An important reason for the lack of such associations and subsequent place-making, he adds, has to do with the inherently exploitative nature of migration west, and the short-lived existence of a great many small towns and settlements. I am, however, not entirely sure about the distinction Stegner makes. The explosive and amplified intensity of place-making in, for instance, the California Gold Country during the 1850s and 1860s begot a correspondingly dramatic imprint – in actual places as well as in in the stories that arose. As the readings of the five sites and their stories illustrate, they accumulate into variously sedimented and lasting forms. We shall see the corrido genre on Cooder's *Chavez Ravine* as one example of such preservation, but letters like Wilson's, local histories like Nicoloni's, and journals like Rezanov's are also brimming with the refractions of lasting and hardening tropes that reach back to their more or less distant pasts. As fragments in their diverse figurations, there is always a larger web in which that fragment has a place, a place always precisely *in* place. I come back to Stegner's view of the "story-less" migrant West in later chapters.

The reading of sites and their stories is moreover not an entirely innocent exercise, for, as George Perkins March warns, "in general [the eye] sees only what it seeks. Like a mirror, it reflects objects presented to it; but it may be as insensible as a mirror, and it does not necessarily perceive what it reflects" (quoted in Olwig 1996, 645). The digging down, the unearthing of what stories and traces may exist in the different locales must strive to avoid letting some fragments and remnants, and some performances, outdo and replace others. In this sense, the seeing and reading and finally the writing of sites approximate the practice of chorography; in fact, it is surprisingly similar. A short version of chorography's traditional aim is the seeking to understand and represent "the unique character of place" (Cosgrove in Pearson 2006, 9). I will, however, here be working with and through a kind of *literary* chorography in order to

emphasize the explicitly readerly and aesthetic components in the approach to site that I take. As I come back to below, I would like to treat them as performances of site-specificity in their own right, and this means factoring into our own site-seeing the distinctly aesthetic, the figural, and the symbolic, all to do with literary practices, but piloted by a methodological approach that draws on the writing of place.

1 Literary Chorography

The ancient tradition of chorography – *choros*, space or place, and *graphy*, writing – has roots as far back as Homer, but would disappear in the 5th century and make its return only in the Renaissance with the rediscovery of Strabo and Ptolemy (Rohl 2011, 2). The discipline can be described quite simply as the "representation of space or place" (Rohl 2011, 1), but there is a lot more to it, testified to by the increased interest in the past few decades across several fields of research, the interest often described as the spatial turn. This coinage can generally be understood as what Denis Cosgrove describes as "a shift away from the structural explanations and grand narratives that dominated so much twentieth-century scholarship, with its emphasis on universal theories and systematic studies, and a move toward more culturally and geographically nuanced work, sensitive to difference and specificity, and thus to the contingencies of event and locale" (Cosgrove 2004, 57). What lies at the core of the spatial turn is consequently a de-privileging of time over place, a re-orientation toward the pivotal role played by locales, and by actual situatedness and relational emplacement as generators of space, hence also time. As Cosgrove goes on to say, "[t]hus any space is contingent upon the specific objects and processes through which it is constructed and observed. Questions of space become epistemological rather than ontological" (ibid., 58). Inquiries into spatiality is, however, not a concern for geographers or archeologists alone, and from architects and historians and curators and philosophers to artists and literary scholars we ask about place in a recognition that, as Franco Moretti says in his *Atlas of the European Novel 1800–1900,* "geography is not an inert container, is not a box where cultural history 'happens,' but an active force, that pervades the literary field and shapes it in depth" (1999, 3). Finally, we perhaps also ask about place from a deep desire to salvage it from its conceptual enemies driven by fluid modernity's technological, capitalist, political currents – non-place, no-place, placeless-ness.

Andreas Huyssen wrote about the practices of museualization several years ago in a vein that is even more timely now than in the early 2000s. He suggests

that our obsession with musealization and, necessarily memory, "are enlisted [...] to counter our deep anxiety about the speed of change and the ever shrinking horizons of time and space" (Huyssen 2003, 71). Similarly, in their introduction to a special edition of *Michigan Quarterly Review* in 2001 titled "Reimagining Place," the editors begin by asking, "Why are we drawn to particular places? What gives them identity and meaning for us? How do we reimagine places in different times and circumstances? How do cultural influences and the history of human interaction with a place shape our perception? How do memory and cumulative experience affect our reactions to place?" (Grese and Knott 2001). Since the beginning of the 21st century, then, place and the meaning of place in more concrete ways also seem to have assumed an increasingly more critical position. In the myriad political discourses across the world, the question of place and the right to place energize a number of extremist and not-so extremist platforms. Ideas of social cohesion once taken for granted in more or less homogenous cultures are seen as being under attack, and in each and every case we find looming variations on the claim to emplaced origin. They are showing no sign of vanishing as the world is increasingly on the move, and borders designed to protect places (Massey's "safe retreats") are perceived as being under attack. Questions of place come trailing complicated questions of values and traditions, a further and enforced complication of Stegner's take on place, memory, and narrative. They are inseparable, and so the claim to place is also the claim to story and history. We will have the chance of coming back to this triad on a number of occasions throughout the book and will return to its more far-reaching implications in the final chapter.

The danger of the one, avowed claim to place is closely related to what Chimamanda Adichie warns of when she talks about the danger of "the single story," saying that "it is impossible to engage properly with a place or a person without engaging with all of the stories of that place and that person." (TEDGlobal 2009) If such obliviousness to multiplicity and diversity is the "danger of the single *story*," it is similarly also the danger of the single claim to place. Casey's point that place is not static bears repeating; we cannot imagine a place absolutely isolated from other places and with no anchoring in structures of the larger region. Key here is the kind of relativity that comes in relation to region as the more complex fabric that holds place. When that fabric is experienced as unraveling, it has significant consequences for our sense of belonging, our feeling of rooted emplacement. The turn to place thus expresses a more general and fundamental anxiety in the midst of late modernity's "rapid social transformation and a search for roots, of time-space compression as well as people looking for a past seemingly removed from the unrelenting social–political–economic forces that have come to be called globalization"

(Hoelscher & Alderman 2004, 374). The many pitfalls of nostalgia in its various and precarious guises have a lot to do with all of this, but we shall return to its pressures and motivations a little later.

It is consequently no wonder that, in a climate of worrying about place, the ancient and pre-disciplinary tradition of chorography has been revived, a field of inquiry intent on writing place in all its hues and colors. A good place to begin understanding what chorography is, would be with performance scholar and artist Mike Pearson's description:

> The nature of *chorography* is to distinguish and espouse the unique character of individual *places*. At particular scales of apprehension, it identifies and differentiates sites of significance as, potentially at least, places to visit within a given *region*. Chorography attends to the local: it concerns specificities, particularities and peculiarities. [...] [Chorographies] involve the systematic description of a region's natural and man-made attributes, its emplaced *things*. Its scenic features. Its inhabitants, their histories, laws, traditions, and customs. Ancient sites and relics. Property rights, and the etymology of names.
>
> 2010, 31, emphases in original

Chorography, in other words, and as geographer Darrell Rohl summarizes it, is the representation of space or place (2011), with methods of explorations drawing on a range of different disciplines and originating long before the concept of trans-disciplinarity or multi-disciplinarity had been conceived. Archeologist Michael Shanks thus refers to chorography as "an old genre of descriptive topography that subsumed geography, archeology, mapping, travel writing, place-name study, and natural history" (quoted in Rohl 2012, 23). The *graphia* (writing) of *choros* (space or place) is, as Rohl notes, pre-disciplinary, the significance of which we should note, but not necessarily comment on any further here. At this point we should pay attention to the fact that chorographies were not entirely as innocent as Pearson's description above might give the impression of, nor necessarily as regional. A broader and more political perspective in this respect can be found in Cosgrove's observation on evolving and cultural meanings of the idea of landscape, where he observes that "[c]horographies were popular among educated and scholarly groups in early modern England as celebrations of their own city or local region. In emerging nation-states such as seventeenth-century England, descriptions of individual counties were gathered together to create a picture that was 'national' but remained sensitive to regional variation" (Cosgrove 2004, 60). There is no contradiction here, but we should keep in mind that chorographies, because

they are both emplaced and embodied, necessarily come trailing the hand of their composers. They are in the end the carvings and translations of ways of seeing into concrete words, into narrative, and by someone with perspectives and ideas, likes and dislikes.

The clearly narrative and composerly aspect of the chorographic tradition is worth dwelling on, and to think further about what that entails in relation to our contemplating the representation of place/space, we should consider the list of elements Rohl considers as fundamental to the discipline's practice. They are all important to the site-specific performances of place that we will engage with here. Aside from the fundamental point about the representation of space/place, the comments Rohl makes about "chorographic thinking" include the following points: multi-mediality (such as also visual and performative modes of representation); the privileging of place over time (following here the spatial turn) – time as a feature of place; temporalities of past and present as mediated through space; the interconnection of the human and its environment; the re-orientation of received perceptions of center and periphery ("the particular place or region [...] to which all roads lead"); an authorial voice, that is to say, a narrator; the concern with "real emplaced experiences"; the sedimentation of meanings into stories about place; transdisciplinarity; and finally, emphasis on knowledge derived from "personal observation and examination" (Rohl 2011, 6). All factors are not necessarily present in every work of chorographic making, but most will be.

The points above are all of great interest to the particularities of the sojourns in this book, but I will for now direct our attention to two of the elements on the list. The first is the process of "de-and re-centering" of center and peripheries and the concomitant shifting of emphasis away from traditionally held locales of import to those neglected and ignored. I am especially interested in the idea of seeing "all roads leading to," because, as we saw initially in these pages, naming a place where five roads meet to constitute themselves into a center is also giving name to a locus of departure *from* where all roads lead. Rohl's point about de-and re-centering thus goes to the heart of the centripetal-centrifugal dialectics. In both, opposing forces of energy are indelibly linked and doomed to vie for survival, the first to remain in the "single story," the second to keep alive alternate stories which at some point or other will also come to claim their place. We are thus reminded of geographer Edward Relph's idea of place, the essence of which, he says, "lies in the largely unselfconscious intentionality that defines places as profound centers of human existence" (quoted in Shaugnessy 2012, 112). Relph's point bridges naturally into the second point from Rohl's list we will look closer at here, namely how the "sedimentation of meanings" develop into stories about place, a recognition

that "landscape is [...] shaped as much by story as topography [...] layer upon layer of meaning collects around us to form this place" (William Bossing quoted in Rohl 2011, 6). Such processes of sedimentation play a major part in the shifting of balance between peripheries and centers. In the case of for instance Chavez Ravine we consequently see the reassignment of meanings originally attached to a minority and working-class neighborhood, a fairly classic case of the marginalized, into the victorious story of big money and prestigious ballpark. The stories carrying the neighborhood thus go silent, and those telling tales of the city's new pride, the Dodgers, come to impose and inscribe a new layer in their stead. This is merely another way of circling the significance of narratives; as Stegner says, place carried and remembered in history, songs, legends, monuments, stories.

Very similar to both Relph and Stegner's perspectives are those offered by Michael Shanks and Christopher Wittmore in their discussion of the antiquarian disciplines of chorography and topography. Here is a view of place closely related to Stegner's more poetical take, and similarly leaning interestingly toward the performative. Their observations in relation to both chorographic thinking and to how we reflect on place/space today is worth quoting in full:

> Reviewing the genealogy of these engagements [by chorography and topography] with land and community in the predisciplinary eighteenth century reveals, however, the subtlety of the political negotiation over the voice and authority of the author in relation to their chosen constituency, and the different ways of engaging history and the materiality of the past, many of which have been lost in modernist crystallization of disciplines and genres. Central to such a review is the concept of performance, with its wide valency. *Engagements* with place, land and the relics of the past: the *work* of writing and illustration, through walking, riding: the *tools* or props of measurement and documentation such as pencil, notebook, pocketwatch, compass, theodolite, camera lucida: the *materialities* of manuscript, voice and song, boots, horse, wheelchair.
>
> SHANKS and WITTMORE 2010, 105–106

The description contains most of the elements that at some point or other also comes into play on site as it enacts its own being, invariably dependent on what Shanks and Wittmore refer to as the "materiality of the past." In all of the five instances we will focus on here, materiality and engagement mean differently, but always in intimate and close quarters of intricate and webbed relations. They are variables of citation that produce site in its past, present, and futurizing potential. For the sheer concreteness of place – the actual

"where" – cannot be disentangled from the ways its materiality is both the product of and producer of local cultures' ways of life, communities' conceptions of self as distinct from others, their ideas and memories of who they were and who they are – the "why" and, not least, the "when" of place. This string of relative pronouns speaks directly to the simultaneously volatile nature of place as at any moment tearing loose from its assumed position as permanently settled, instead entering into the flow of time, and again, narrative. I am consequently here interested in places as sites that perpetuate their capacity for storytelling, for making "visible and real," as Tuan says, what may elude us in our passing through.

Of course, as soon as we begin to respond to terms of relationality we are once again already "practicing," as de Certeau says, "place," turning it into space as "composed of intersections of mobile elements" (de Certeau 1984, 117). He clarifies: "Space occurs as the effect produced by the operations that orient it, situate it, temporalize it, and make it function in a polyvalent unity of conflictual programs or contractual proximities. [...] In relation to place, space is like the word when it is spoken" (ibid). The description resonates with Stegner's "sense of place;" in fact, there is little discernible difference between the former's view on place and the latter's on space. Complementing both in this respect is performance studies scholar Nick Kaye's comment that, "a single 'place' will be realized in successive, multiple, and even irreconcilable spaces" (Kaye 2000, 5). The seemingly straightforward remark will here conclude the thread so far of various disciplines' and scholars' perspectives on place and helps now to segue over into the explicit field of performativity and site-specificity. I would like to move us now from chorographic thinking in and of itself, and over to the question of what precisely it is this kind of thinking will focus on.

I propose that we see the sites on this book's itinerary in terms of their performances before us, as spectacles on a stage configured out of their particular histories and stories. Could we then not approach them similarly to how we approach site-specific performances? The theatrical genre is of course different, but keeping in mind the exploration so far of chorographic thinking, there may be enough methodological and theoretical overlap for that transposition to make sense. A more or less standard definition of site-specific performance is for instance: "Site-specific performance is produced in non-theatre sites, and aims to engage with the meaning and history or creative impetus of those sites, and reach audiences who might not come to the theatre" (*Routledge Performance Archive* 2019). The definition captures the essence of turning a non-theatrical site, with all its layers of history and story, into a stage and reaching out to spectators who are by the same token "non-theatrical." Emerging in earnest in the 1980s, site-specific theatre, as it was then called, was more

precisely understood as what *The Guardian*'s critic Andy Field describes as a "'performance specifically generated from or for one site,' with the inference being that layers of the site would be carefully peeled back through a performance that was not an imposition upon the location but sprung forth from it" (Field 2008). The genre thus pivots around the meaning of place *cum* site in its capacity to arrange and configure into and within its own space new constructs that add to the existing shape. We should note in Field's comment the explicit reference to a performance that originates in and with the site in question, and the excavation of, or scrubbing off of, the sediments that overlayer it. From this earlier and concrete understanding, site-specific theatre has, however, gone through a number of modifications, including changes to the name itself. A whole register of inter-related terms has emerged over the past couple of decades, such as the " 'site-determined', the 'site-referenced', 'site-conscious', 'site- responsive', 'context-specific' " (Pearson, 2010, 8). The range of labels is also symptomatic of what many see as a watering down of the original sense of the concept and practice, and to some, like Field himself, even depriving the genre of its original edge and promise. He thus worries that, "straight theatre is merely reproducing itself, dressing itself in radical trappings and passing itself off as its other; meanwhile those authentically experimenting with site are left struggling in relative silence" (ibid.). A similar concern is echoed in Bertie Ferdman's more blunt accusation, that "site specificity has become so common, so banal, that we no longer label it as such" (Ferdman 2018, 5). However, rather than dismissing the form entirely, she advocates for taking the myriad of approaches and forms as a call "for a more open and diverse approach to site-specific and site-based practices" (ibid.).

I take Ferdman's comments as some consolation, because I am acutely aware that my proposition to approach the five sites in this book as site-specific performances in their own right, without the staging of an actual performance, can be seen as only one more contribution to further dilution of the genre. I will, however, suggest that there is a case to be made for a "readerly" releasing of a site, immobilized as it often stands before us by the shackles of the single story. In a cultural, historical, social and aesthetic context there is good reason to bring out the forgotten, hidden, neglected layers through a process of reading affiliated first and foremost with literary traditions. Sites are, as I think we have established by now, fabrics of signification invariably carried in narratives, in stories, and hence to read a place should be understood quite literally. Reading, let us be reminded, is that activity of arranging what lies before one, making sense of and extracting from it an apprehension that ideally brings out new understandings. This means situating the reading of place as site-specific performance in the chorographic tradition, an

exercise which, as Shanks and Wittmore point out, may have virtue beyond the examination itself:

> current disposition towards inter- or transdisciplinary spaces needs to be set in such a genealogical understanding; connecting current experimental hybrid practices in the academy and culture industries with the pre-disciplinary world of early modernity is a profound enrichment, because it opens us up to all kinds of creative possibility in this charged field of the representation of region and community.
>
> SHANKS and WITTMORE 2010, 97

In addition to their astute formulation of strategies for true interdisciplinarity, Shanks and Wittmore here also perceptively engage with contemporary tenets in social and political discourses of origin and the right to place. They can be witnessed in territorial and cultural conflicts across the entire world, and invariably what we see happening is a process that I think can be described fairly comprehensively in the vocabulary of site-specific performance. It is particularly the emphasis on *haunting* associated with the genre that makes thinking about site in terms of performativity so relevant. Pearson uses the very compelling analogy to hosts and ghosts when he describes the site as stage, suggesting that performances on site "rely upon the complex superimposition and co-existence of a number of narratives and architectures, historical and contemporary These fall into two groups: those that pre-exist the work – of the host – and those which are of the work – of the ghost" (Pearson quoted in Turner 374). Cathy Turner's further elaboration on the analogy is helpful to our own, more literary seeing of site and its performance. She says that "the 'host' comprises not only the ordering vocabulary of place but the resonances of its former articulations. The 'host' is already the layered 'space' formed by lived experience, so that the givens of site- specific performance comprise not only the machinery of 'place', but also the patina it has acquired with past use" (Turner 2004, 374). Turner here speaks to all of the sites we shall visit on our sojourn in this book, deepening the affective dynamics of erasure, forgetting, and retrieval that characterize them. The ghostly presences of past stories, never entirely erased and buried, linger or emerge in fragments and continue to inform their sites. They are sometimes awaiting their time on the stage, not unlike how Bakhtin reflects on the memory of genre: "Nothing is absolutely dead," he says, "every meaning will have its homecoming festival. The problem of great time" (Bakhtin 1986, 170). As with genre, so with performances. However, in both cases it ultimately falls on the reader and spectator to make sense of what is brought to the stage, be that a text, a play, or, the

site itself; it is we who enable the return. We are consequently in some ways ourselves like ghosts visiting again and again the hosts *cum* site in various co-constitutive and successive realizations. Every visit to a given place is different, just as every reading of a book returns to us something not noticed before, however small the detail.

We will not leave the host and the ghost in site-specific performance just yet. In relation to literary studies, and hence to the literary chorographic thinking I propose, we should also spend a little time on the resonances with palimpsests and palimpsestings that Pearson's idea of "ghostly traces" evoke. For what is the palimpsest but a host overlayered with the inscriptions of past "ghosts"? The palimpsest in its historical understanding is, as we know, "a parchment or other writing surface on which the original text has been effaced or partially erased, and then overwritten by another" (*OED*). In its more figurative and extended meaning, it is "a thing likened to such a writing surface, esp. in having been reused or altered while still retaining traces of its earlier form; a multilayered record" (ibid). The affinity between the palimpsest and Pearson's host/ghost analogy is immediately obvious: in both, erasure and subsequent overlayerings are defining characteristics for their internal dynamics, literally and figuratively speaking. Palimpsests are engaged in the process of representation of intricate practices and attitudes to memory and remembering, collapsing onto its parchment the temporary pause, but at any time awaiting its unraveling onto other layers and scripts. To complicate this further, but at the same time make the comparison to the host/ghost on site even more compelling, we may turn to the neologism palimpsestuousness. It differs from the more commonly adjective palimpsestic in that, as Sarah Dillon points out, it highlights "the structure that one is presented with as the result of that process [of layering], and the subsequent reappearance of the underlying script" (Dillon 2005, 254). More specifically, she says, the palimpsestuous

> seeks to trace the incestuous and encrypted texts that constitute the palimpsest's fabric. Since those texts bear no necessary relation to each other, palimpsestuous reading is an inventive process of creating relations where there may, or should, be none; hence the appropriateness of its epithet's phonetic similarity to the incestuous.
> ibid.

And so, while the palimpsest proper tells us something about archeology's "law of super-position," the principle of digging down, the palimpsestuous allows past performances onto the imprint of the present figure, a mode of figuration we will see numerous examples of as we visit with the different sites. For now,

suffice it to say that the concept, disturbingly echoing the relation that should not be, offers itself as a powerful tool for site-specific analysis.

Now, if chorography furnishes the broader analytic framework for this book's readings of place as palimpsested and palimpsestuous sites, of the site as host to the ghostly presences of its past visitations, we need to add to that reading the kind of material which composes place in the five chapters. For, the site of Chavez Ravine is mobilized into its performance on the grounds of the Dodger stadium through Ry Cooder's album, it itself a form of musicological writing, perhaps even a musical chorography. The little pamphlet that describes fragments of what today presents itself as Chinese Camp carries in itself traces of the chorographic – the local historian attending to the specificities, particularities and peculiarities of the local. David Wilson's letter series from the Gold Country in the 1850s comes close to a chorography in its own right, with detailed descriptions, maps, observations of flora and fauna, of the shifting landscape the letter writer sees on his itinerary; granted, always steered by the main objective of his travels. The Winchester House is the bizarre result of a life spent adding to the structure small and larger rooms, hallways, stairs, and stands before the visitor-audience as an enigmatic manifestation of a vision we speculate about. The complexity that underlies the structure steers our viewing of the performance it stages before us and illustrates how chorographic thinking leads to "new forms of research and new kinds of texts," with the author "located within an intertextual network of cultural references" (Pearson 2006, 9). This observation bears even more poignantly on Fort Ross and the material that brings it into its performance, including among other a naturalist's journal entries and fictional retellings of the famous romance which threaten to overtake the political and cultural significance of its narrative.

Thus, we already see how these sites and the stories peculiar to their performances lend themselves to the activity of reading. Hence the specification of the *literary* in relation to chorography, inviting the nod to the aesthetics of place as inextricably linked to its performativity. Aesthetics here does of course not apply in terms of the classic conceptions of what is beautiful or worthy, but rather according to an object's aesthetic function, which Winfried Fluck proposes be considered as follows:

> Properly understood, however, the term of the aesthetic describes not a quality of an object – so that some objects, called art, possess this quality and others do not – but a possible function of an object, so that, by taking an aesthetic attitude toward an object, any object or, for that matter, any spatial representation – building, subway map, landscape or a picture – can become an aesthetic object. This redefinition as aesthetic object

changes the object's function: we do not look at it any longer in terms of its referential representativeness but regard it as a form of representation that has the freedom to redefine and transform reality or even to invent it anew.

FLUCK 2005, 26

Taking this approach to site as brought forth by the stories that mobilize it into an aesthetic performance of its "being," can consequently also invite the possibility of telling its story again, to loosen the confines of its staging-so-far. Assuming an aesthetic attitude furthermore returns us to the readerly, and to the figurative, that we may be able to explore more carefully the figures that orchestrate the different performances.

True to literary methods, then, the spectacles that the sites present can be apprehended more carefully according to the specific figurations, or tropes, that surface from their performances. Certain figures and motifs enter to take center stage, gradually and sometimes obliquely, as is often the case in complex texts and fabrics of significations. Metaphors, metonymies and synecdoches come before us, asking to be read, that is to say, to be made sense of and consulted over and with. This narrower circling does not limit the reach of the performances, quite the contrary, because in figurative flight, place also tears loose to speak to the region that holds it. The double movement can be related to something Casey says about the generation and regeneration of place: "Place is the geneatrix for the collection, and recollection, of all that occurs in the lives of sentient beings, and even the trajectories of inanimate things. Its power consists in gathering these lives and things, each with its own space and time, into one arena of common engagement" (Casey 1996, 26). Casey's formulation of the collective and the recollective give expression to a key concern in relation to the writing of place and the seeing of site: both must be predicated on situatedness and perspective. We will consequently see how Chavez Ravine, Chinese Camp, the letters from the Gold Country, the Winchester House, Fort Ross and in the concluding chapter Abbeville SC all emerge out of different degrees and kinds of otherness. Their performances of the histories and outcomes of their sense of variation and disparity in turn reflect a continuous tension between different spatial practices that inform the same place differently. If, as Kaye argues, spatial practices "operate as ordering activities" (Kaye 2000, 5), then we need to also pay attention to the multiple imaginaries that such activities arise from. To actually *see* the sites in these terms consequently means to appreciate their "thick descriptions," to carefully excavate and disclose hidden sedimentations, to allow the range of performances that crystalize their due time.

As hinted at, the site-seeing in the conclusion, "Tangled Figurations," takes a differently orchestrated region and place as its focus for site-specificity and site-seeing aesthetics, and shifts the literary chorography to a small town in southern South Carolina. If the five sites in the California sojourns are marked by multiple and complicated encounters and more or less successful and meaningful negotiations of otherness, they in many ways also describe the larger region they pertain to. This is also the case with the representations that are on display on the court square in Abbeville, SC: A monument and a memorial warn and remind the spectator of a history that extends far beyond the modest square, and invite to a performance of a bleak cultural memory that stretches into present as well as future. This is a different kind of site-specificity, one that acutely engages the history of now and which cannot, as can the five other sites, sink back into their variously orchestrated pasts.

Between the confederate monument and the memorial plaque erected by Equal Justice Initiative to Anthony Crawford who was lynched in 1916, a space of haunting opens up. It produces a figure that emerges from painful intertwinings of history and culture and which bears every bit as much on the present as it does on the past. Despite the differences between this southern site and the California ones, their literary chorographies bring out how fundamentally singular the figures that define them are, and how absolutely tangled they are in the imaginaries they pertain to, and to the spatial coordinates those in turn relate to. As with all the sites in this book, however, there is no artist, no director behind the "performance" that takes place on the Abbeville square; instead, the script and figure that emerge do so by virtue of the spectator's or reader's perspective. However disturbing, the relationality that transpires between monument and memorial do so, because we are summoned to make it so.

It is, finally, and to conclude these introductory remarks, no coincidence that the chapters all have titles denoting temporality – The Time of Loss, The Time of Ghosts, The Time of Hope, The Time of Desire, The Time of Romance. In each and every instance of their performances on and of site, their site-seeings and narratives illustrate, to return to Stegner again, how our sense of place is all about memory and story – always in time.

CHAPTER 1

The Time of Loss: Chavez Ravine

> What archeologists do is work with material traces, with evidence,
> in order to create something – a meaning, a narrative, an image –
> which stands for the past in the present.
>
> PEARSON and SHANKS 2001, 11

∴

We begin with Dodger Stadium in Los Angeles. The third oldest ballpark in the country, it is to many fans also known as Blue Heaven, and with the stands donning their stunning color scheme from yellow, light orange, turquoise, to sky blue, it presents itself as a unique sight, and site.[1] The shimmer from the colors effuse a readiness of anticipation for the games that are played there, a kind of purity appropriate to the national pastime which in memories and in popular culture is forever associated with the incorruptibility of childhood and play. My own interest in the stadium as a site in and of itself was sparked several years ago. A friend took me there in the middle of the day, when no one else was there, and I was able to admire the serenity of the construction and its color scheme with no interruption whatsoever. On the way out of the park we passed a few small, modest-looking houses, and my friend commented that those were leftovers from a time before there was a baseball park there. About the same time, I had been listening to Ry Cooder's album *Chavez Ravine* from 2005, but without really hearing what its series of tracks spoke of. In the ballpark the album came to life as what it really is, a sonic performance of and on a specific place hidden by the monumental stadium that now inhabits that space, and extending, in words as well as music, well beyond the number of songs on the cover. In its disentombing of sounds and stories originating in the past, *Chavez Ravine* obliquely echoes, on the one hand, the practices of archeology as "a contemporary practice which works on and with the traces of the past [...] in order to create something – a meaning, a narrative an

1 Part of the discussion of "Corrido de Boxeo" appears in "Regional Singularity and Decolonial Chicana/o Studies." 2018. *Routledge Handbook of Chicana/o Studies*, edited by Lomelí, Francisco A.; Segura, Denise A.; Benjamin-Labarthe, Elyette. Abingdon: Routledge.

image – which stands for the past in the present" (Pearson and Shanks 2001, 11). On the other hand, the album also emulates the working of the palimpsest, for while even the simplest and most innocent of palimpsests in one way or other signals the domination and privileging of new inscription over old, it also paradoxically "preserved [ancient texts] for posterity" (Dillon 2007, 7). Those small houses near the stadium are fragments precisely of a script that has been overwritten, and like all fragments, they are broken-off pieces of something larger, reminders of something once complete, intact. And so, the houses invite speculation, encourage inquiry and beckon into presence the whole they were once parts of. The story of that whole could begin as follows:

If unknowing archeologists should start digging under the baseball stadium, they might be quite surprised to find an elementary school; it, too, incidentally, the symbol of innocence and childhood. The fractions of walls, perhaps some shards of window glass, maybe the remains of some water pipes and sewage drains, would appear not essentially different from how the remains of the pyramids, Viking settlements, or remnants of Roman walls have materialized in other contexts. The unknowing archeologists might then wonder what had happened, that an entire school came to be buried under sediments of dirt, and they might wonder what had happened to all the children. Most likely they would conclude that this was the work of the San Andreas Fault, and the excavation site only one more testimony to California's precariously unstable foundations. The hypothetical moment of discovery at Dodger Stadium would, as already hinted at, confirm the code of excavation, what Shanks and Pearson call "the law of super-position, the basic principle of geology and archeology [...] layer upon layer, the deeper you go, the older it gets – to dig down is to dig into the past" (Shanks and Pearson 2001, 134). The moment would also, as mentioned, resonate with the sifting through layers in the palimpsest, the scraping off of already inscribed surfaces to discover that there are other, older scripts underneath. Of course, excavation and palimpsesting face each other in silent appreciation. Intimately connected, the one performs the act of hollowing out from under ground, the other that of scraping veneers off of a surface, both keenly intent on bringing what is hidden to light. Both are also captives to the darker workings of history as what Matthew Battles calls "a bloody palimpsest, a record of devourings – of rubbings-out, innumerable and imperfect" (Battles 2015, 11). And, we might add, a record of the unpredictable.

We know, however, perfectly well what happened in the case of Dodger Stadium, that there is a schoolhouse and other remnants under its structure, and it has nothing to do with earthquakes, or bloodiness, although it has everything to do with rubbings-out. The traces are simply reminders of what is known as the "Battle of Chavez Ravine," where a predominantly Mexican

community struggled to defend what was known as a poor man's Shangri-La against the City of LA's plans of demolition. In 1949 the Federal Housing Act had opened up for federal funding to Americas big cities for financing much-needed housing projects, and the City promptly started planning for a comprehensive lower income project of more than 10 000 units to be built in among other the three neighborhoods of La Loma, Bishop, and Palo Verde, known collectively as Chavez Ravine. Despite its relative poverty, Chavez Ravine was a bit of a success story at the time, with a tight-knit community of unusually many homeowners who looked after its roughly 1100 families. Ironically, this very fact would also pit many of the residents of Chavez Ravine against the county's general Mexican American and other American minority groups, for whom the housing project was most urgent. As Mario Garcia remarks, "Americans of Mexican decent, like their middle-class contemporaries, were now sufficiently acculturated to recognize and demand their rights as US citizens. Rather than leading to conformity, Americanization or acculturation gave rise to protests in pursuit of American principles of democracy" (Garcia 1989, 463). Partly fueling the residents' protests and reactions was precisely the conviction that homeowners could not be ousted just like that, and that principles of fair pay for property owned should not be dismissed. The residents' protest against the City Council would consequently develop into an unlikely alliance with a predominantly white, middle class Home Owner Association against other, more radical Mexican American associations at the time. None of this would have any consequence, though. The city's plans were thwarted by the Red Scare of the McCarthy era, and head of the planning committee for the housing project, Frank Wilkinson, was accused of "creeping socialism." When he refused to explain himself to the Committee of Un-American Activities he was fired from his job, and the project stalled.

Meanwhile, two New York baseball teams were looking to relocate to the West Coast. With Wilkinson gone and a new city administration hostile to anything that smacked of collectivism in place, the housing project had come to a full stop. However, in 1958 the Angeleños voted yes to selling the public lands once intended for housing back to the city: "The federal government would sell Los Angeles the land it had acquired for public housing and stipulate only that it be used for a 'public purpose'" (McCue 2012, 50). That purpose would be a new ballpark for Walter O'Malley's Brooklyn Dodgers: "To sate the tumescent urban pride of the Los Angeles City Council, Chavez Ravine was delivered as a promisory note to Walter O'Malley, who then owned the Brooklyn Dodgers baseball team, in return for assurances that he would shift the Dodgers from New York to the self-proclaimed 'City of Angels'" (Starrs 2007, 414). And, so it went. The neighborhood of Chavez Ravine was bulldozed out of existence and

construction on the stadium began. Part of the construction work involved cutting down the hill and filling in the ravine with that dirt. On the hillside had stood the Palo Verde School, but rather than tearing it down the city simply buried it: "Only its roof was removed. The rooms and hallways were then filled with dirt bulldozed down form the surrounding hills. The school stands there yet under the parking lots of Dodger Stadium" (Normark 1999, 76). And that is why, if you start digging under the Dodger Stadium and its parking lot, you will find a schoolhouse.

The story is of course not a particularly unique one. Neighborhoods, communities, buildings, large and small, are torn out every day everywhere to make room for new and what to administrations at any given point are considered more important, useful and worthy than what is already there. Sometimes such projects get a lot of attention, and protests in a few cases lead to their reversals, but for the most part erasures take place without much ado, and what is torn out or demolished is soon forgotten. We all know how we react to seeing a house on a street block being torn down, and how astonishingly quickly the memory of that house fades, until not that long after we have trouble visualizing its form. Not entirely different is what happened to the memory of the neighborhood of Chavez Ravine, and for most people, and for a long time, its story was as buried and forgotten as were the houses that once made up the community. That is to say, to the people who had been forced to move in the late 1950s nothing had been forgotten, but their tales had been muffled in the years following the demolishing. What would bring this silencing to an end were three, related events that took place several decades later. The first, and in many ways the most important one, was photographer Don Normark's belated publication of his photo-documentary *Chavez Ravine, 1949. A Los Angeles Story* (1999). The book was the result of its own kind of excavation, with its own genealogy. Normark's own introductory words explain the book's genesis best:

> One rare clear day in November 1948 I was looking for a high point to get a postcard view of Los Angeles. I didn't find that view but when I looked over the other side of the hill I was standing on, I saw a village I never knew was there. Hiking down into it, I began to think I had found a poor man's Shangri-La. It was mostly Mexican and certainly poor, but I sensed a unity to the place, and it was peacefully remote. The people seemed like refugees – people superior to the circumstances they were living in. I liked them, and stayed to photograph. I didn't know it at the time, but I was in Chávez Ravine
>
> NORMARK 1999,11

30 CHAPTER 1

In the years following his fieldwork, Normark had no luck in getting his book about Chavez Ravine published, and it was only in 1997, when he came across a newspaper interview with a former resident of the neighborhood, that he revisited the project. Normark tracked down many of the people he had photographed and known in the late 1940s, and his conversations with them about the photos and the memories they evoked was in 1999 finally accepted into the published form we know it as today.

There may have been a half century or so delay, but the ball started rolling. Soon after the book came out, filmmaker Jordan Mechner met Normark more or less by coincidence, and a three-year long collaborative project of turning the story of Chavez Ravine into a documentary film began. The film was made with practically no funding, but as Mechner says, they got something better: "Ry Cooder, on seeing the rough cut, offered to contribute a musical score (which he went on to develop into a stand-alone album) and Cheech Marin volunteered to do the narration" (Jordan Mechner n.d). The 24-minute documentary went on to win several awards, and was also, significantly, picked up by PBS. Maybe as importantly, Ry Cooder would continue to work on and produce his own version of the Chavez Ravine story, and his is the work that forms the basis for our site-seeing in this chapter. In Cooder's sonic re-visitation we encounter a complicated staging that is music, text, history, as well as cultural archeology brought into one, intricate demonstration of memory, monument, and nostalgia.

This is also why Dodger Stadium is an appropriate place to begin the tour of site seeings in this book, especially in relation to how we think about place and performativity, stage and staging. For in the grand, historical scheme of things, the diamond and the lot it sits on is in some ways but a veneer, a modification. It exemplifies the overlayered stagings that history performs, and as mentioned, in its blue-ish and vintage display the stadium also evokes the principle of the palimpsest. What I call a veneer literally presents itself as but the most recent layer in a longer history of erasures and overwritings on the same surface. The palimpsest, originally and concretely referring to the practice of erasing writings on scarce to come by vellum or parchment in order to make room for new writings also applies to the practice of other kinds of overwritings and erasures. Dillon thus points out that "[p]alimpsests are of such interest [...] because although the first writing on the vellum seemed to have been eradicated after treatment, it was often imperfectly erased. Its ghostly trace then reappeared in the following centuries as the iron in the remaining ink reacted with the oxygen in the air, producing a reddish-brown oxide" (Dillon 2005, 244).

Awareness of that which hides just under the surface, under any surface, is a timeless allure across all media: What lies there, what awaits, what can

THE TIME OF LOSS: CHAVEZ RAVINE

only be partially known if indeed known at all beckons to us, and this is also the irresistible temptation of palimpsests and palimpsestings. After all, the great surprise of the Archimedes palimpsest was that underneath the script of a Greek liturgical book from the 12th century lay awaiting its time "the earliest known transcription of mathematical treatises by Archimedes," as well as two unknown speeches by Athenian orator and politician Hyperides (Dillon 2005, 11–12). While the Dodger Stadium does not hold quite as radical secrets as did the Archimedes palimpsest, it, too, is an overwriting of surfaces once vibrant, once essential to the ones whose scripts they were. What Cooder's album does is to chronicle and spatialize the once-intact and once-present. Borrowing from performance scholar Dee Heddon, we may think of the tracks on the album as constituting an "autotopography," rendering "the self of the place, and the place of the self, transparent," a kind of writing that juxtaposes " 'the factual with the fictional, event with imagination, history with story, narrative with fragment, past with present [...] in order to 'write place' " (Heddon quoted in Pearson 2010, 11). This is an almost uncannily precise description of the work that *Chavez Ravine* does, and its performance can consequently also be aligned with the ancient tradition of chorography, as we touched upon in the Introduction, the combination of the Greek *chora* (land) or *choros* (space of place) with *graphia* (writing). The description of chorography as simply the representation of space or place (2011, 1) works very naturally with Heddon's definition of autotopography, and together they will serve as a platform for us to see the site-specific performance in its most general presence. For, on the album *Chavez Ravine* the neighborhood gets to write itself, choreographed and chorographed under the direction of Cooder and his musical ensemble. This doubling begs another layer, for without the audience – the listeners, me writing its "writing" and you reading it, both of us fulfilling precisely that role – there can be no performance.

In the site-seeing that follows, the album's staging and the stage itself are thus brought together in a series of readings with particular focus on the site-specific performance that results from our "seeing" and "hearing" a selection of the album's songs. That performance is a combination of "history with story, narrative with fragment, past with present" (Pearson 2010, 11), and what transpires from the sounding of depths that Cooder's work does, is a resurrection from underneath the concrete of another layer. It is evoked by the houses that fragmentarily remain, and that we began with. I will also suggest that as site-specific performance, the work comes trailing a rather knotty version of nostalgia, and one that hovers uneasily between what Svetlana Boym calls reflective and restorative (2001). For if, as site-specific performance, *Chavez Ravine* stages a longing for the return home, where, and not least, *when* is that home?

Surging from these kinds of questions appear before us an inordinately complex fabric of historical vectors that continue to do their work in the storying of California, and in that process, they also add to the layered spatializing of its webbed and complicated reach as region.

Ry Cooder's long and distinguished career spans a vast register of musical traditions, and while *Chavez Ravine* was in some ways a nod to the blend of blues, country, and south-of-the border style that many will recall from his early work on albums such as *Bop till you Drop* and *Get Rhythm* from the 1970s and 80s, the concept album was also very much a return to his own personal geography. In the *Liner Notes* Cooder explains his own relationship to the neighborhood of Chavez Ravine as follows:

> I never went to Chavez Ravine. I heard about it in the early '50's: the evictions, the power struggle in city hall a scant mile away, the Pachuco Scare, the Red Scare, and the greasy handoff of the ravine to the Dodgers ball club. Occasionally there would be photographs in the paper of some poor Mexican family from the ravine watching some bulldozer tear up their little house while being harassed by the LAPD or lectured to by some city politician. I didn't understand any of this until later, long after the deal had gone down. In those days, they called such things "progress."
>
> COODER 2005

Cooder worked with a number of Mexican American and other Latino/a musicians to make the album, and through a range of musical genres and heritages that once constituted the community the result is a commemoration of a lost neighborhood and a testimony to its stories. The work is most certainly a concept album in all understandings of the word; staying with a clearly defined theme, namely that of telling the story of Chavez Ravine, the wide variety of musical traditions and mini-narratives come together to present the many-faceted life of the East Los Angeles neighborhood. Here are represented the conjunto, the corrido, R&B, Latin pop, jazz, rhumba, and more, all telling stories that hail from the different backgrounds, occupations, hopes, frustrations, and aspirations of the period and the place. As Paul Starrs notes,

> What Cooder has produced in the *Chavez Ravine* CD is, as Michael Stone puts it, "a conceptual project reflecting Cooder's astute political contrariness, his dogged L.A. street-corner and archival research, and eclectic musical inspiration [It] is the most idiosyncratic effort of a most singular career" (2005). This one album includes tunes in at least a half-dozen different cadences and styles: boleros, *corridos,* blues, ballads, rumbas,

not to mention a great use of Mexican American pop tunes, including elements of pachuco boogie – a style favored by Don Tosti and Lalo Guerrero, both of whom died after they recorded their pieces for this album but before its final release.

STARRS 2007, 415

The fullness of the performance as a concept album can be better grasped if we keep the following definition in mind: A concept album brings "together a body of music unified by something more than the simple presentation of a musical artist's or group's work" but must also "*represent* in the sense of standing for ideas like history, tradition, biography, or religion. And [it does] this by *representing* texts, tunes, and the facts that accompany them [...]" (Rosenberg in Elicker 1999, 228). There are fifteen tracks on *Chavez Ravine*, with lyrics of extremely varying genres and lengths, carried in musical styles, as mentioned, equally heterogeneous. And as Starrs appropriately goes on to note, "[w]hat's unusual is to have an album that exhorts the attentive listener to look more closely at the surrounding landscape, to watch for change and corruption and enriching life that can loom anywhere" (Starrs 2007, 405). For while it may not be immediately clear how the tracks come together around a "concept," it is precisely the emphasis on *represent* in Rosenberg's description above that invites the label of concept album, and not just of anything, but of what Starrs calls the "surrounding landscape." The songs re-present stories as carriers of a larger history, tradition and culture, and in their representations of that culture the songs insist on telling their stories – again. Even if many are imaginary, their deep anchoring, musically and textually in a very specific time and place brings to life for the viewer/listener a play that appears almost more like a historical play, and feels every bit as real.

This emphasis on telling stories again can be brought over also into the literary field. After all, Heddon's idea of autotopography must involve some attention to the last part of the word, *graphein*, writing, the act of putting words together into a meaningful fabric of signification For, surely, the "self-place-writing" that Heddon's neologism literally means presupposes a script that we may access and assess. Thus, the concept album's literary and close relative is the composite novel. Its common description immediately reveals the connection: "the composite novel is a literary work composed of shorter texts that – though individually complete and autonomous – are interrelated in a coherent whole according to one or more organizing principles" (Dunn and Morris 1995, 2). The interrelation between the songs on *Chavez Ravine* is rooted in the shared effort of all of the songs to tell the story again, and to bring to light what has resided in darkness. As an organizing principle for narration we find

that of re-presenting a diversity of sounds as well as meanings of the neighborhood in the 1950s. Alternatively, we could say that in their diverse generic array, the lyrics themselves can be heard or read as poems, or vignettes, or as very short stories with the organizing principle being the communal voice and life of the neighborhood. In such a reading the central, narrative consciousness and point of view are not limited to one, but instead multiple protagonists and narratives whose collective memorialization generates a curious collapse between past and present, between the many scripts that form the layers of the palimpsest of Dodger Stadium. Thus, to think of *Chavez Ravine* as a concept album with definite affinities to the composite novel makes clear the tight connection between the sedimentations that make up the site the album "sings," on the one hand, and, on the other, the attention to its constituent parts, the composite – what is "made up of various parts or elements; compound; not simple in structure" (*OED*). Indeed, no matter how we listen to and/or read the performance that Cooder's work is, it is definitely not "simple in structure."

There is also a sense of chronology at work on the album: The introductory "Poor Man's Shangri-La," taking its title from a comment Normark heard and put in his photography book, signals a certain nostalgia for a place "up a road that's lost in time," as the lyrics puts it. This is followed by the track "Onda Callejera's" account of the pachuco riots in the early 1940s, and specifically the zoot-suit riot that had soldiers on leave arrive in taxis in Chavez Ravine hunting for their prey. The violence of that story is weirdly contrasted by the song's measured cha-cha-ish rhythm and an almost upbeat vocal rendition. "Don't Call Me Red" opens with Frank Wilkinson in Ry Cooder's vocal delivery, imploring the audience: "Don't call me red, don't turn me down, I've got a plan." The song has a middle section that is kept in a kind of free jazz style, with a male voice-over radio recording that lists the phrases and dialogues we recognize from what we know of the HUAC hearings: "what political organizations have you belonged to since 1931?" "I refuse to answer that question." The contrast between the quick and quickening part of the recorded hearings on "Don't Call me Red" and the slow, nearly faltering lines where "Wilkinson" sings creates a strange, and tense soundscape. In his review of the album *Guardian* journalist Robin Denselow fittingly describes this song as "menacing, theatrical," commenting that " 'Don't Call Me Red' [...] sounds like an excerpt from a jazz musical influenced by Kurt Weill" (Denselow 2005). I will not go through all of the songs, but to readers not familiar with the album, it is worth noting that in sound and words they eclectically present themselves as story tellers that form their own parts of a greater whole. While they do so on a site that may be no more, this comes to life as we listen our way through. In all of its performances *Chavez Ravine* compiles enactments of a past that is supposed to

be gone and done with, and to the audience they interrupt the smooth surface of the ballpark. Borrowing from Nick Kaye's description of site-specific performance, we could say that these enactments "trouble the oppositions between the site and the work" (Kaye 2000, 11). They bring the past into the present in a production that raises our awareness of some of the threads that go into the social fabric and which extend well beyond their own moment and origin in Chavez Ravine. For this is not a spectacle that merely shows the audience the composite nature of the moment it commemorates and comments on, but more crucially one that engages with the myriad moments that precede it and from various directions filter into the composite. All of this only to agree with Starrs when he notes that, "Cooder's album [...] is a carefully composed insertion into a place and a time" (Starrs 2007, 407), posing before us, we must add, as a chronicle inconceivable outside the site it performs on.

1 Sonic Excavations

A good place to begin a more detailed listening is with "3rd Base, Dodger Stadium," a beautiful and melancholy ballad sung by Hawaiian guitarist and singer Bla Pahinui. Pahinui's soft voice narrates the "part" of a man working as parking lot attendant, and as he shows a newly arrived spectator to the stands, he tells him about family and friends and their former homes according to bases and infield/outfield positions: "2nd base, right over there/I see grandma in her rocking chair/Watching linens flapping in the breeze/And all the fellows choosing up their teams." To the listener, the lines construct a very tangible, visual representation, and the retrieval and folding of images of the village onto the ongoing spectacle of the game has a curious effect where the underlying script now shines through in an "over-sounding" that activates lived history. We can think of the audio layer as a soundscape, bearing in mind the suffix's dual signification. The first meaning describes the term as a perspective, the artistic representation of a specified type of view or a scene. The second meaning has to do with the sense of creation itself, the original meaning of *-scape*, namely, to shape or carve something, a meaning that survives in for instance the Scandinavian and German words for creating, *skape*, or *schaffen*. In this case the audio serves both significations. It is a perspective, but also a shaping for the audience of the figure of a very particular memory. This act of figuration hovers uneasily between absence and presence, beckoning the audience to fill in what is missing, and hence engage in a similar process of storytelling as the one the song as well as its protagonist-singer are involved in. The site, figured now into uneasy being as suspended between past and present, consequently

transcends its lodging in history and concrete location, and takes on a strange quality of *over-writing again* of what is in fact not really there anymore. I will come back to the particular tenor that binds audience, site, and performer together in this case.

The above kind of ghostly traces orchestrate the entirety of "3rd Base Dodger Stadium," and to the point that the past commands concrete directions in the present: Taking the spectator to his seat, the protagonist-singer says that he/she can find the seat behind home plate where they used to meet, in effect letting the past mandate the present. The same is true of the line that gives the ballad its title: "And if you want to know where a local boy like me is coming from: 3rd base, Dodger Stadium." This track specifically, and the album generally, thus perform as a kind of sonic excavation: from underneath the concrete parking lot, the grassy ball field and the light blue, yellow, orange, and turquoise stands are unearthed sounds and images that for the duration of the performance momentarily blot out later erasures, and let the audience "see" the past. And yet it is more than just unearthing, more than a practice of "the law of super-position" (Pearson and Shanks 2001, 134). The disinterring of memories carried in sound moves us back in time, measuring down through history. However, this sounding out of past layers also teases out the idea in site-specific performance that "the site is a place where a piece should be but isn't" (Smith in Kaye 2000, 91). In Cooder's orchestration, the razed neighborhood temporally re-visits the stage of the present, activating an elasticity of history that permeates and overlayers again the site of the stadium. The dynamic resonates with Kaye's suggestion, nodding to de Certeau, that if "'space is like the word when it is spoken,' then a single 'place' will be realized in successive, multiple and even irreconcilable spaces. It follows that, paradoxically, 'space' cannot manifest the order and stability of its place" (ibid., 5). In the case of Chavez Ravine's activation on the stage it is performed, the bringing out of this one underlying script only summons further excavations and performances.

The multiplicity and instability which this realization of place leads to instigates yet other pursuits, of other remnants and legacies – forgotten but not erased from memory and hence revivable. The accumulative layered-ness wrought by the performance allows for a "reading of site [...] where 'a complex overlayering of *narratives*, historical and contemporary, [creates] a kind of *saturated space*, a scene of crime'" (Pearson quoted in Kaye 2000, 53, emphases in original). In relation to *Chavez Ravine* the performance and Chavez Ravine the site, the above is more relevant than we perhaps immediately grasp, but I'll return to this a little later. For now, and before I go on to other songs, I just want to bring in one more conceptualization to prepare the ground for the discussion that follows. Cliff McLucas, commenting on his own work, started using

the dichotomy of the ghost and the host, so as to better grasp and "describe the relationship between place and event. The host site is haunted for a time by a ghost that the theatre-makers create. Like all ghosts it is transparent and the host can be seen through the ghost. Add into this a third term – the witness, i.e., the audience – and we have a kind of trinity that constitutes the work" (McLucas in Turner 2004, 373). We immediately detect how well the sonic enactment of the past in "3rd Base, Dodger Stadium" lends itself to this vocabulary: in its ghostly visitation on the stage of the stadium, the song adds to the stage now the role as host, and coats it with a new layer in the form of a memory that modifies the host ever so slightly. As listeners and audience, to follow McLucas, we enter into a revisionary spectacle, where actual place, the stadium, yields to the ordering activities described in the ballad. They are carried over into the reappearance of the underlying script in a successive narrative where the veneer of the stadium gradually yields to the imaginary of what lies beneath.

This resurfacing of an absence, of a ghost that modulates the stage it performs on eventually also brings us back to Dillon's idea of palimpsestuousness, a neologism whose description bears repeating: " 'Palimpsestuous' does not name something as, or as making, a palimpsest. Rather, it describes the complex (textual) relationality embodied in the palimpsest. Where 'palimpsestic' refers to the process of layering that produces a palimpsest, 'palimpsestuous' describes the structure with which one is presented as a result of that process, and the subsequent reappearance of the underlying script" (Dillon 2005, 245). This idea of the involuted and unintentionally tangled parallels Michel Serre's caption of temporal turbulence, namely that "time doesn't flow, it percolates" (Serre in Pearson and Shanks 2001, 178). And so, as a performance on a specific site, Cooder's *Chavez Ravine*-the album summons traces and histories of Chavez Ravine-the place that "percolate" through the grey concrete and the blue metal stands into a complicated archeological-aesthetic visitation. Its "involuted" quality echoes McLucas' "trinity" in that it falls on us as spectators to make sense of the structure and spectacle that emerge, of the relationality between the ghost and the host cohabiting, uneasily, in a relation that should not be. Intended absence here becomes unintended presence, creating a spatial and temporal entanglement that also hints at the illicit: "Since those texts [that constitute the palimpsest's fabric] bear no necessary relation to each other, palimpsestuous reading is an inventive process of creating relations where there may, or should, be none; hence the appropriateness of its epithet's phonetic similarity to the incestuous" (Dillon 2005, 254). The hint that lies embedded in the palimpsestuous of a relation that should not be, indeed, *must* not, *cannot* be, intensifies the depth of Cooder's sounding and staging: In bringing to light the erased, the uneasy relation between past and present, absence and

presence come into play as a site-specific performance of cultural memory. As our visits to other tracks on the album will only consolidate, that memory is but one example of the less pleasant transgressions and violations that often lie beneath the sites we see, and which must therefore be hidden.

So far in these explorations we are "digging down," as Pearson and Shank put it. But the lyrics on the album also embark on excavations and overwritings of a slightly different kind, where genres present themselves as sites for performances very similarly to how actual sites function. One track especially comes to mind, and it is the haunting "Corrido de Boxeo," sung by legendary Lalo Guerrero who passed away before the album was completed. His son, Mark Guerrero, recalls that "[t]he lyrics were based on an idea by Ry Cooder. My dad happened to remember the names of two boxers who had lived in Chavez Ravine by the name of Carlos and Fabela Chávez. He personalized the song by bringing in real people" (Mark Guerrero 2019) "Corrido de Boxeo" places itself squarely in a long-standing tradition of story-telling in music whose trajectory takes us much further back in time than to the battle of Chavez Ravine itself. The inclusion of this corrido on the album is moreover generically significant, because the space it opens up broadens the concrete site on which it performs and extends temporally as well as spatially to span continents.

"Corrido de Boxeo" opens with the singer introducing the two Chavez brothers the song is about, Carlos and Fabela, who were both successful boxers from Chavez Ravine. The singer pits their motto, that "If you fight clean/You'll always win, never loose/" against the futility of their struggle to save the neighborhood in the lawsuit that followed. While serving the brothers well in their boxing matches downtown, their honorable ethos in boxing could, however, not help them "win the fight for Chavez Ravine." The last stanza concludes that, while in boxing there are clear victors and losers, in the case of Chavez Ravine this was left to oblivion: "Nobody knows the secrets that stayed hidden. They'll settle it with God, the bunch of thieves." If we saw "3rd Base Dodger Stadium" stage its performance as a narrative form of memory projection, "Corrido de Boxeo" brings to life a very particular kind of cultural template for remembering and telling about it, and it is specifically that of the border corrido.

Genres are not innocent, and genres have long memories; as Bakhtin puts it: "A genre lives in the present, but always remembers its past, its beginning. Genre is a representative of creative memory in the process of literary development. Precisely for this reason genre is capable of guaranteeing the unity and uninterrupted continuity of this development" (Bakhtin 1984, 106). Bakhtin talks of literary genres, but his words apply also to other kinds of "kinds," of genres in the sense of templates based in and developed according to kin and kinship. This is not

THE TIME OF LOSS: CHAVEZ RAVINE 39

to say that genre is fixed, once and for all, for at the heart of the argument is the accentuation of the always present contemporization of genre's archaic elements. These elements pertain to originary, often ritualistic strategies for understanding, maneuvering in, and inhabiting the world, strategies that are organized around certain temporal and spatial connecting points circumscribing and defining the hero. Elsewhere Bakhtin thus comments that, "genres are of a special significance. Genres (of literature and speech) throughout the centuries of their life accumulate ways of seeing and interpreting particular aspects of the world" (Bakhtin 1986, 5). Equally important, genre is not "random," for as Hayden White observes:

> Cultural and social genres belong to culture and not to nature, [...] cultural genres do not represent genetically related classes of phenomena, [...] they are constructed for identifiable reasons and to serve specific purposes, and [...] genre systems can be used for destructive as well as for constructive purposes. So, genre is both "unnatural" and dangerous.
>
> WHITE 2003, 367

Returning to Guerrero's "Corrido de Boxeo," we see it beckoning to the audience in a sounding of the depths of the genre on which his song performs precisely to "serve specific purposes." Genre here becomes a site in its own right, and the song a modification of that site, strangely paralleling the concrete site Guerrero sings about. For while "Corrido de Boxeo" tells a of a specific moment in history, the genre on which it performs reaches back centuries.

The corrido genre survives from its romance ballad origin in Arabic Medieval Spain, through 16th century colonial transpositions to New Spain and later Mexico, until in the latter half of the 19th century it surfaces as border corrido in the areas north and south of the US – Mexican border. From that point on the tradition also takes on the character of an American music. Some critics claim that the corrido is to the Mexican American what blues is for the African American, a claim based in the role it has had and continues to have as a cultural and aesthetic form. But the two also share other elements: Both underwent long journeys, both have an intimate relation to the oral traditions of more "archaic" times, and both have persevered in the midst of modernity's progress and the onslaught of the technologizing of popular culture forms. Américo Paredes in his seminal *Folklore and Culture on the Texas-American Border* describes the border corrido as follows:

> certain elements of the Texas-Mexican repertoire (in folklore) [...] are part of the shared traditions of Greater Mexico, [but] this is only half the picture, for a significant portion of the repertoire, the most distinctive

portion, is generated by the stark social oppositions of the border region, a response to differential – *not* shared – identity.

PAREDES 1993, p. xiv

Paredes emphasis on "*not* shared identity" is in many ways the premise for Guerrero's "Corrido de Boxeo," but more than that it also conforms to the main revisions the corrido genre underwent on its way to becoming the border corrido. José Limón describes these as follows: The corrido goes from serious and restrained to overflowing, as though "its wider melodic range were musically equipping the corrido to respond to a socially energetic moment" (Limón 1992, 18–20). The form also changes from a detached, silent narrator to a first- or third person narrator who acts as witness to the events described, as a kind of news source. Thematically the corrido furthermore shifts from celebrating fiestas, love affairs, and tournaments, into praising the heroic deed with its main emphasis falling on male confrontations, until eventually the hero's struggle must take place, as the title of Paredes' work on the corrido tradition is titled, "With the Pistol in his Hand."

Chavez Ravine's "Corrido de Boxeo" places itself squarely into this account. When it sings the story of clean and honorable fighters who are powerless against the City, and who "were crushed with lies until the end/They rolled in the mud until all was lost," it conforms to the pattern of one of the border corrido's longstanding thematic emphases. Ramon Saldívar describes this as the positing of "a common, peaceful workingman into an uncommon situation by the power of cultural and historical forces beyond his control. [...] In the process of this attempt to win social justice, his concern for his own personal life and his solitary fate must be put aside for the good of the collective life of his social group" (Saldívar 1990, 35). That trope is in "Corrido de Boxeo" formulated as the brothers' clean fighting against the City's lies, ending in the brothers' destruction by deceit and eventual loss of everything. However, rather than positing an end to the story, as the border corrido traditionally does, the singer in this case leaves off on a note of suspension – someone will have to pay a price.

It is worth noting here the longevity of the corrido genre into our own times, as witnessed on Guerrero's song, because the conflict Saldívar points out has not gone anywhere very far. Indeed, if anything the border corrido, if we understand it as a ballad not only from the border, but also as one *of* the border, has lately attained to new and urgent significations. It bears reminding here of music's peculiar capacity for spatializing its reach. As Elena Dell'agnese writes, "[g]iven its political hints, its role in the making of place and identity, and its capacity for spatial representation, popular music can also be considered a powerful vehicle of geopolitical discourse, and so be considered a research

subject for popular geopolitics as well" (Dell'agnese 2015, 172). In "Corrido de Boxeo" the capacity for such spatial representation operates not only retroactively by assuming its place in a tradition that quite literally spans continents. Its denouement, if you will, also speaks to the silence following the Battle of Chavez Ravine: "Nobody knows the secrets that stayed hidden/They'll settle it with God, the bunch of thieves." The open-ended note that justice will eventually be done which the corrido consequently ends on, signals a hope, or an expectation, that the secrets that are hidden will someday be revealed.

The tenor of suspension also echoes the code of the palimpsest, where intended absence awaits the coming into being of what was once present, as indeed the very existence of the concept album and the song itself testify to. "Corrido de Boxeo" consequently stays remarkably true to the cultural imaginary that the genre of the border corrido originated with and in, namely as a genre steeped in and negotiating conflict internally as well as externally. If we agree with Peter Seitel that genres are "storehouses of cultural knowledge and possibility" (Seitel 2003, 279), it is easy to see how seamlessly "Corrido de Boxeo" finds its place in just such a storehouse. It is a very specific generic world with certain roots and routes – a site that as we see in this particular case has remained remarkably unchanged. As site-specific performance "Corrido de Boxeo" furthermore also repeats rather than re-interprets and brings a particular event into the fold of the border corrido tradition, thus locating it squarely within a much broader, Mexican American history. In this process the site of the ballpark comes to figure before us as a very peculiar carrier of aesthetic operations. We may bring back de Certeau again, who notes that "[s]pace occurs as the effect produced by the operations that orient it, situate it, temporalize it [...]" (de Certeau 1984, 117). The spatialization of history and of time itself that "Corrido de Boxeo" performs for us here is undeniable when we look at it this way, as a site-specific performance that absorbs into its spectacle past performances on the same site of the genre of the corrido. The imaginary site of the genre here converges with the actual site of the stadium, and the result presents itself to us not all that differently from how Turner describes the stage in site specific performance, namely as a host. That description bears repeating, namely that "the 'host' comprises not only the ordering vocabulary of place but the resonances of its former articulations. The 'host' is already the layered 'space' formed by lived experience, so that the givens of site- specific performance comprise not only the machinery of 'place', but also the patina it has acquired with past use" (Turner 2004, 374). Seeing the site of the Dodger Stadium through "Corrido de Boxeo" accomplishes an effect very much like what Turner here lays out. The performance of the corrido that brings to life the "stage" of Chavez Ravine, residing beneath the present stage

of the stadium, absolutely "comprises the machinery of 'place." More than that, it in fact doubles the reach of that machinery. The mode of visitation is carried in "resonances of its former articulations" – the long and complicated journey of the corrido itself, and in so doing brings to the site of the stadium an ordering vocabulary specific to this mode. Site and performance thus complement each other in their equally overlayered fullness to produce perhaps one of the album's most striking performances of cultural memory.

The discussion so far shows that "Corrido de Boxeo" performs on a genre with a very long memory, and one that trails the particular performance on site that Guerrero makes happen. The song and its function on Cooder's album are thus excellent expressions of the capacity for spatializion that popular music has, and this will be seen also in other songs, other performances on the same site as the stage that used to be Chavez Ravine. This element resonates quite profoundly with Battles' afore mentioned observation, that "[h]istory is a bloody palimpsest, a record of devourings – of rubbings-out, innumerable and imperfect" (2015, 11). Again, to this list should be added the disorderly and unpredictable, all of which come into play in another track the album, "Chinito, Chinito."

This particular song is performed by Carla and Juliette Commagere and stands as a veritable monument to the complex history that the structure of the Stadium overwrites, and to what the razed neighborhood in its very early years was home to. The singer-narrators of "Chinito" are a couple of young women presumably standing on a corner and teasing the Chinese laundry man who walks by asking him or telling him to "toca la malaca," to not worry (no plecupes) and to " la lopa." At first, the lyrics seems like mere nonsense, a nursery rhyme-like chant to instrumentals that here and there feature what is sometimes referred to as the "Chinese riff," a particular sound pattern signaling stereotyped conceptions of what the "oriental" sounds like. However, if we are reasonably tuned into Spanish our ears soon pick up on the mispronunciations, where r's are replaced with l's, same as we know from the stereotyping of Chinese in English. Thus, for instance, "Toca la Malaka" stand in for "toca la maraca," and "lava mi lopa" for "lava mi ropa." The song, in sound as well as words, consequently finds its place under the rubric of "yellowface," a term that captures how stereotypical representation of East Asians mark "the oriental body as 'inferior and foreign'" (Solomon 2014, 150). We recall Pearson's vocabulary of stage and performance, the stage as host and the events created and the plays as ghost. Cathy Turner adds to this an observation that is fitting to the performance that "Chinito" does: "The term 'ghost,'" she says, "also seems to encompass those events, narratives, and performances arising from these structures and the spaces they represent" (Turner 2004, 374). The site

that the song invites us to see encompasses a number of such ghosts, and the "encounter" it stages between the two women and the Chinese summons at least two cultural and historical itineraries converging onto the same site.

Both routes take us to Mexico. We can begin with the song itself, which, as far as I have been able to establish, was first performed in the Mexican movie *El Angel Caido* ("The Fallen Angel") from 1949. It was then sung to a slower beat and featured as a dance number where twenty or so actors dressed and made up as Chinese characters complement the lead singer. That image, echoing blackface, speaks to a strange thread, not only in the Chavez Ravine fabric but also the more general Californian, and American cultural tapestry. Like the US, Mexico welcomed Chinese workers to, among other things, build their railroads. And, like the US, Mexico had a change of heart. Although never passing an act like the infamous Exclusion Act in the US, anti-Chinese sentiments in the early 20th century often made conditions for Chinese in Mexico insufferable. Erika Lee writes that,

> [l]ike their fellow migrants in the north, the Chinese in Mexico also faced racial hostility, and an organized anti-Chinese movement developed in the early 1900s, reaching a climax during the 1930s. However, it did not result in the legal restriction of Chinese immigration. One reason was that though Mexican officials found Chinese immigrants 'undesirable,' they also admitted that Chinese labor was beneficial and necessary.
>
> LEE 2002, 59

Mexico had signed a treaty with China in 1899, after which immigration from China increased. One problem, and from the point of view of the US, a big problem, was that many used Mexico as a launching place for crossing the border. This, by the way, also happened across the northern border with Canada, as well as from around the Caribbean into ports along the southern seaboard. Lee thus notes that an estimated 80% of Chinese arriving in Mexican seaports would in the end reach the US Border. However, and here is where it gets interesting in the context of "the site-specific performance" that "Chinito" presents, in order to cross the border, and given the anti-Chinese sentiments in the US at the time, a whole industry catering to helping Chinese pass as Mexicans would develop. Lee tells the story as follows and I quote her in full:

> In 1907 special government inspectors reported on a highly organized, Chinese- and Mexican-run illegal immigration business headed by the Chinese Mexican Jose Chang in Guaymas. Chinese immigrants landed in Mexico on the pretense that they had been hired to work in the cotton

fields there. Chang then brought them to his headquarters in Guaymas, where letters from the immigrants' United States relatives were distributed and further preparations for the border journey were made. One of the most important steps in Chang's operation involved disguising the newly arrived Chinese as Mexican residents. The Chinese cut their queues and exchanged their "blue jeans and felt slippers" for "the most picturesque Mexican dress." They received fraudulent Mexican citizenship papers, and they also learned to say a few words of Spanish, especially "Yo soy mexicano" (I am Mexican). As in the case of the Native American disguise, the Mexican one was supposed to protect Chinese should they be "held up by some American citizen" while attempting to cross the border.

LEE 2002, 61

In relation to the "yellowface" in the original Mexican movie where the song and dance number "Chinito" figures, and to the lighthearted stereotyping in the track on Cooder's album, a little-known story of passing, of race as well as of borders, thus surfaces to the stage. With an already existing Chinese presence, California was the most natural place for many of these "Mexican-Chinese" to go to. That "Chinito" is included on *Chavez Ravine* thus has its own general trajectory, that is to say, a trajectory that specifically involves the encounter of two cultures in the context of a third. A performance in its own right, the fragment of the cultural encounter and relation that transpires in "Chinito, Chinito" is thus rather remarkable. For whether or not the teasing of the Chinese laundryman speaks to underlying hostility, the history of cultural relations that this fragment recalls is not generally well known.

However, finding documentation of how the Chinese and Mexican communities co-habited in southern California in the period we are here talking about is difficult, and in great part so because most of those sources, letter and journals for instance, would likely be in other languages than English or Spanish. Or, and this is perhaps the most probable reason, interaction between the two was probably scarce enough that there simply are not many documentations. The latter point fits well with another detail from the history of Chavez Ravine: In the last decades of the 19th century, southern California was plagued by several outbreaks of smallpox, and especially hard was the one that hit in the 1880s. In historical documents from the County of Los Angeles one can read that, "[Chavez Ravine] was used as the county 'pest farm' to care for a number of Chinese and Mexicans who suffered from the scourge." ("Enriching Lives, Julian Chavez"). I have not been able to locate traces from this sinister cohabitation in the "pest farm," but it is not hard to imagine what it would have meant both inside and outside of the "farm." Already stigmatized, the added

stigmatization of a contagious decease would not have helped anti-Chinese prejudice, and perhaps the kind of stories that one must assume were generated are better left to oblivion. This, too, has a certain relation to "passing."

Already performative in nature, the crossing of borders, literally in two senses of the word, also alerts us to the larger site of California as a long series of overwritings, erasures, and in many cases and as witnessed on Cooder's album and what it resurrects, resurfacings. The seriality of what Battle above calls the "devourings" of history runs through all the chapters in this book. In the particular case of "Chinito, Chinito" we come close to an aspect of the site as host to site-specific performances that disturbingly elicit the illicit associated with the palimpsestuous. It speaks to the relation that must not, cannot, be. In a climate of racial purity on both sides of the border, passing, already deeply problematic as so powerfully fronted in literature like Fanny Hurst's *Imitation of Life* and Nella Larsen's *Passing*, must never be disclosed. The whole point of the performance of passing is to stave of certain kinds of futures. Pearson and Shanks write that "[s]ite-specific performances are conceived of, mounted within and conditioned by the particulars of found spaces, existing social situations or locations, both used and disused [...]" (Pearson and Shanks 2001, 23). Bearing this description in mind we can perhaps appreciate just how detailed and specifically "Chinito, Chinito" in this capacity performs in relation to the concrete location, the site, on which it is brought forth.

As is amply clear by now, however, the stage widens, and the performance brings into our purview a much larger horizon than what is confined by the Dodger Stadium and the neighborhood buried under it. As host this site now expands to include the history of immigration in this, one part of the Americas, and a rather unknown history at that, to enact ghostly tanglements on the stage of Chavez Ravine, brought there via very differently originated paths. Further, "Chinito, Chinito" is, as mentioned, but a fragment of this history. However, as Pearson and Shanks comment, "the fragment of the past evokes." "We can work on the archeological fragment," they continue, "to reveal what is missing; the shattered remnant invites us to reconstruct, to suppose that which is no longer there. The fragment refers us to the rediscovery of what was lost" (Pearson and Shanks 2001, 94). And herein lies the performative potential of the staging of this precise song: it evokes, and in so doing it opens up for the audience the possibility of seeing a route that once was, and whose echoes remain, however muffled. The story might be told again.

So far, the materializations brought forth by the tracks on *Chavez Ravine* that we have listened to are all excavatory in their performances. "3rd Base Dodger Stadium," "Corrido de Boxeo" and "Chinito, Chinito" all emerge from different moments in the history of the site of the neighborhood, staging for

us dramas that precede its razing. The album, however, also contains tracks that are contemporary with that very moment; that is to say, they speak from within the political and social imaginary of the decision to discontinue the neighborhood. The song "In My Town" figures about two thirds into the album, and opens on a slow, melodical note carried by a soft guitar and vocal, with the percussion emulating the rain coming down: "Up here on the hill, it's starting to rain/The sun's disappearing through my windowpane/And everything's still in my room." The lyrics continue to describe what is outside the speaker's window, and gradually changes its tenor to give "his" town a list of adjectives, from "old" and "crook," to "wop," "spic," "black," "shack" and "hick" – a list that depicts the entirety of Los Angeles, we are led to believe. The unhurried rhythm, and the soft vocal sauntering his way through the lyrics remain unchanged, and as in other songs on the album creates a strange dissonance between the increasingly aggressive-sounding content and their musical accompaniment.

That changes, however, about mid-way through the song, and rhythm and vocal quicken, the voice now assuming a raspy and airy quality, at times almost growling, and insistently and rapidly offers the listener a completely different "speech:" "Well, I like a town that's flat, I like a street that's tame/You take out the trash; they all do the same/But get back inside and remain, until notified/I want a town that's clean and I want a rule that's maintained" ("In My Town"). Gone are the piano and percussion echoing the soothing background of drizzling rain, and instead there is a cymbal-sounding and marching-like beat accompanied by the notes from a single guitar. Interestingly, its melody calls up the famed figure of Edward Grieg's "In the Hall of the Mountain King." That association adds an extra layer of threat to this section of the song, underscoring the sense of imminent danger carried in Cooder's own increasingly menacing voice. As mentioned, on a couple of occasions this voice assumes the tenor of a growl, which against the faint backdrop of the notes evoking the mountain king and Peer Gynt's fated visit to his hall assumes the quality of peril it rightfully should have. As in Henrik Ibsen's play *Peer Gynt* which Grieg made the music for, the scene in the Mountain King's hall is also a moment of truth, where the main protagonist, Peer Gynt assumes the trolls' proclamation of selfishness, carried in the motto, "to thy own self be enough." The lyrics of "In My Town" resonate with this, describing now destruction and insisting on the town being "his." The singer-narrator lashes out against everyone trying to stop the leveling of the neighborhood so that "his" town can become what he wants it to be, flat, with tame and clean streets and rules that are obeyed. Denselow describes "In My Town" as "cool late-night jazz [...] (including a half-spoken section with echoes of Tom Waits)" (*Guardian* 2005), and the laidback soundscape that dominates the track strangely accords with the message we are left with, that

THE TIME OF LOSS: CHAVEZ RAVINE 47

the singer-narrator is ultimately indifferent to what happens to "his" town, as long as everyone follows "his" rules: "there goes your old neighborhood."

"In My Town" is consequently a different kind of performance from the other songs we have considered, and it takes upon itself the task of presenting the voice of policy making and urban renewal. Pearson and Shanks remind us that music also plays its role in site-specific performances, and that "the musical soundtrack might carry emotional responsibility, the sung libretto all narrative information and the physical action be released from any story-telling role" (Pearson and Shanks 2001, 25). "In My Town" fits this description well, with the soundscape of the vocal and instruments in a sense confusing its audience with the oscillation between soothing reassurance and violent attack. The lyrics equally waver between the harmless and ominous, and, similarly, the action that the song actually describes tears loose from its place in a specific time and place to transcend into a comment on erasure and destruction beyond Chavez Ravine. In this way and as a site-specific performance the cultural memory that the song represents comes uncomfortably close to lives and memories anywhere. The motif of indifference furthermore comes to characterize the entirety of the song, and the stark contrast between its cool shrug and the emotional import we hear on "3rd base Dodger Stadium" and "Corrido de Boxeo" speaks volumes about the nature of the battle of Chavez Ravine. Taken together, these songs can now be appreciated in the context of the performance in its fullness, bringing to the stage the reverberations of the deeper recesses of opposing sides: Cool capital is unmoved by the passions of living communities, expendable in the series of history's devourings.

In his *Site-Specific Performance* Pearson goes through the history of the concept of site-specificity, pointing to the development of his own artistic collaboration with Mike Brookes as one that has reflected "a shift away from architectural concerns with enclosure and modelling within bound spaces, to performance as place-making" (Pearson 2010, 5). His comment bears meaningfully also on Cooder's performance of Chavez Ravine the site on *Chavez Ravine* the album: this is place-making, but more than that, it is the making *again* of a place that has been. In this way the work also comes to us as a kind of memorial, a monument to the past. On the other hand, this description at the same does not quite fit, since the site of Dodger Stadium holds within its own genesis and existence that very story, and in this way insisting on its own overlayering. To grasp the complexity of this kind of site we may turn to Fiona Wilke and her observation that,

> site specific performance engages with site as symbol, site as story-teller. Site as structure [...] Layers of the site are revealed through reference

to: historical documentation; site usage (past and present); found text, objects, actions, sounds etc.; anecdotal guidance; personal association; half-truths and lies; site morphology (physical and vocal explorations of site).

WILKE in PEARSON 2010, 8

The register of these different properties that explain and define site are all represented on *Chavez Ravine*: history is documented in songs such as "Don't Call Me Red" and "Corrido de Boxeo;" the depictions of and guidance according to coordinates buried under the stadium present on "3rd Base Dodger Stadium;" the summoning to life of memories of sounds and personal associations on all of the above. And, not least, the traversals of the buried neighborhood that its imaginary scaffoldings direct can be detected in nearly all of the tracks. Thus, if we continue now to consider the site-specificity of the concept album in its totality, I want to return to Heddon's idea of "autotopography." The capturing of the "self of the place" that I discussed briefly in the beginning of this chapter, converses intriguingly with Pierre Nora's seminal conceptualization of lieux de memoire. That juxtaposition will in turn bring us to the question of nostalgia, for we must also consider the role it plays in the orchestration we as audience participate in might be.

In most of the writing on site-specific performance we come across, site is understood to literally refer to a concrete locale, as a place functioning as host to enactmnets of various kinds. *Chavez Ravine*/Dodger Stadium is and is also not such a concrete locale. The ambiguity resides in the gap that opens up between the figure the site presents in a doubling as both actual and imaginary. As a piece of autotopography the album, just like the composite novel, arranges for the listener-audience a performance represented through a narrative consciousness and point of view deriving from that very ambiguity. As alluded to earlier in this chapter, what happens to our perception of the site itself is the strange, almost uncanny collapse between present and past shape. I deliberately use the word shape here. The sounding down through the layers of history that the album undertakes creates a soundscape that both stands before us in its performative form, but at the same time it also shapes our response. That response is fueled by a desire to remember and preserve, and to catch a glimpse of what paradoxically can and cannot be shown. The resurrection in words and music of the lost neighborhood consequently and in several ways evokes Nora's formulation that we need sites of memory because there are no longer real "environments of memory" (Nora 1989, 7). Can we then not also suggest that the kind of self-place-writing that the album does attains to a memorial, a material site of and for memory? And if this is the case, then the

imaginary that *Chavez Ravine* summons to life transitions, strangely, into a performance most tangible, attaining to a definite classification of a site no longer quite as ambiguous. It bears reminding here again of how Pearson and Shanks describe the conception and interpretation of site-specific performances, namely as relying

> upon the complex coexistence of, superimposition, and interpenetration of a number of narratives and architectures, historical and contemporary, of two basic orders: that which is of the site, its fixtures and fittings. And that which is brought to the site, the performances and its scenography: of that which is pre-exists the work and that which is of the work: of the past and of the present.
>
> PEARSON and SHANKS 2001, 23

In light of this characterization it is not hard to see that *Chavez Ravine* the album commemorates Chavez Ravine the site in an intricate enactment of history's web. Into the mesh of the site's "fixtures and fittings," like the references to present overlayerings by bases and diamonds of a living neighborhood, are brought the retellings in music and words of past stories that come into their own *only* in the context of this, concrete staging. Thus, the sedimentation of scripts past and present palimpsestuously come to lay before us in an unquestionable performativity, that we may engage the past on the stage of the present and remember along with it.

One question has to be asked, however, and it is exactly what kind of remembering this is. In his discussion of Cooder's *Chavez Ravine* George Lipsitz is absolutely right to bring up the aspect of nostalgia. Almost in passing he mentions that Cooder's "characteristic nostalgia for little known 'other worlds' permeates the production" (Lipsitz 2007, 126). The habit of immersing himself in musical traditions far away from his own, Lipsitz suggests, can be found throughout the musician's career, turning Cooder into a "romantic white interpreter of 'lost' music created by people of color." (ibid.) This, he goes on to say, is a bent that "bears uncomfortable resemblance to colonial, anthropological, and folkloric efforts by whites to use the cultures of aggrieved groups for uplift, insight, and emotional renewal" (ibid). At the same time, however, Lipsitz also praises *Chavez Ravine* for keeping "alive memories of social sites that have been destroyed by urban renewal. They present testimony about the destruction of the emotional ecosystems of entire communities" (ibid.). The remembering that the album brings to the site thus hovers a little uneasily, perhaps, between the two elements making up the word nostalgia itself. On the one hand, there is the longing itself – *algia*; on the other is the return

home – *nostos*. Algia, Svetlana Boym says, is what gives rise to what she terms reflective nostalgia, a sentiment dwelling in "longing and loss" (Boym 2008, 41). Nostos on the other hand begets restorative nostalgia, proposing to "rebuild the lost home and patch up the memory gaps" (ibid.). It is fair to say that as a site-specific performance *Chavez Ravine* enlists the former, not the latter, and in its autotopography we as audience are invited to partake in a remembering that Boym describes as lingering "on ruins, the patina of time and history, in the dreams of another place and another time" (ibid.). Reflective nostalgia thus fits the tone of *Chavez Ravine*'s performance well; it literally dwells in and on ruins and the temporally dislodged.

Ending here would, however, lock performance as well as site again into the passivity of a musealized past, and this is not quite the work Cooder's album does. We may consequently do well in consulting another version of nostalgia, one that sounds alongside the notes of reflectiveness, namely counter-nostalgia. Counter-nostalgia is Jennifer Ladino's term for what she in *Reclaiming Nostalgia* describes as "nostalgia with a critical edge" (Ladino 2012, 15). This kind can take up in itself both the restorative and reflective, employing creativity as well as performativity, but it goes one step further to revisit "a dynamic past in a way that challenges dominant histories and reflects critically on the present" (Ladino 2012, 16). As site-specific performance, Cooder's album accomplishes these objectives, and leaves the listener/audience with a figuration of the past that reaches into the present. Another and quite striking way the sonic shaping also responds to counter-nostalgia lies in the overarching criticism of the price of progress itself: counter-nostalgia is namely also "strategically deployed to challenge a progressivist ethos" (Ladino 2012, 15). While melancholic and reflective *algia* suffuses many of the albums' tracks, condemnation of historical context is never far away. In this manner, what the album's counter-nostalgia brings to the stage of the buried neighborhood is also something akin to a memorial, a commemoration that lasts, just like stone markers or plaques do. Memorials testify, as Ladino says elsewhere, to "a messier past" (Ladino 2019, xiii). As this chapter's excursions into the multiple paths that cohabit in *Chavez Ravine*'s performance on site show, the past they gesture to is indeed a disorderly one. Ultimately then, as a memorial that re-calls this fact, the album acknowledges history and its stories as tangled and complex, as never obeying by the single story, and always reaching into our present.

CHAPTER 2

The Time of Ghosts: Chinese Camp

> [...] temporality [must] be described as *actuality*, the return of the past in the present, but in different guise. Something once inconsequential may turn out to be heavily charged with cultural significance for later people. So conspicuously in old places layered in archeological traces, and artefact, building or ruin for the past does not hold comfortably some point in a linear flow of time from past through to present. It is not just a dated event in the past. Instead the past bubbles around us. This is the life of things in the present, the life-cycle of artefacts and buildings, enfolded in a multitemporal mix which is the fundamental texture of our human social experience.
>
> PEARSON and SHANKS 2001, xvii

∴

Before entering Chinese Camp, a semi-ghost town in California's Gold Country, I want to return for a minute to Stegner's "The Sense of Place." The distinction he makes there between the West and other parts of the country goes via what he refers to as "cumulative association," essentially a process by which a place gets told, remembered, and secured into a continuous and lasting narrative and memory of its being. It is a process, he writes, that "has gone a good way by now in stable, settled, and especially rural areas – New England, the Midwest, the South [...]" (Stegner 1986, 4). However, you don't see the same kind of cumulation in the "raw migrant West," because, Stegner says, "[f]or one thing, the West has been raided more often than settled, and raiders move on when they have got what they came for. Many western towns never lasted a single human lifetime. Many others have changed so fast that memory cannot cling to them; they are unrecognizable to anyone who knew them twenty years ago" (ibid.). Much of California landscapes refract the kind of restlessness Stegner here describes. The myriad ghost- and semi-ghost towns that sprinkle the region testify to his point, remnants and leftovers from a time when the discovery of gold and riches beckoned to the world, and the world answered. As we shall see also in the next chapter's site seeing through much of the Gold Country, towns

© KONINKLIJKE BRILL NV, LEIDEN, 2021 | DOI:10.1163/9789004438002_004

could come up practically overnight and were left behind just as abruptly, so Stegner's point is well taken. California 49ers did not particularly care to linger once the mines were emptied out, but moved on to the next promise of more.

And yet, and yet. I think we can take a perspective on the dynamics of hastiness and sudden shifts that may render a slightly different view of and "sense of place." The numerous abandoned towns and camps, the traces of many which remain, mark landscapes in their own, peculiar way. However dismantled, however much but in fragments, they gesture to us, the onlookers and visitors, that we fill in the gaps in the stories they nod to. The work of the fragment is precisely to invite completion of what was once a whole to "reconstruct, to suppose that which is no longer there. The fragment refers us to the rediscovery of what was lost" (Pearson and Shanks 2001, 94). I wonder therefore if we may perhaps think about what Stegner calls "cumulative association" from a slightly different angle, one where the amassing of stories and memories into layered stability and habitation over generational continuity takes place on a different level, yet in its own manner also generating stability and settlement. Maybe such cumulative association does not necessarily have to go through a vertical digging down through layers and layers of memories and tales that a locality bounded by successive generations of stories can produce. Maybe it can also be conceived of as a kind of sideways process, a sequence of additions orchestrated around a node of the more elusive and un-grounded point of evocation. In the continuous invitation to the audience, to in a sense co-write, or co-create the story again, a sideways cumulative association takes place in a tropological order that adheres to metonymy's insistence on contiguity. More of that in a little while; for now, let us just posit that, eventually and similarly to more settled places, from the decaying remnants of other times emerge real and imagined stories that gravitate around the ruinous in a longing for an indeterminate past. As Andreas Huyssen puts it, "[i]n the body of the ruin the past is both present in its residues and yet no longer accessible, making the ruin an especially powerful trigger for nostalgia" (Huyssen 2006, 7). To introduce some of the challenging nuances in the site-seeing of the ghostly in the to many unknown town of Chinese Camp this chapter centers on, it is helpful to consider a more familiar ghost town, namely Bodie. The two places direct our gaze in different ways, and directions, and the distinction between them is, as we will see in detail, grounded in a cultural ambiguity toward the sites' very hosting which, like a text, fronts certain figures and motifs.

Bodie, in the eastern foothills of the Sierras near Mono Lake, is commonly known as one of the most prominent ghost towns California has to offer, and a very genuine one. This claim to authenticity is based in the fact that the former mining town, which at one point could boast about 10 000 residents,

lies there, as the website of what is now a State Park puts it, "preserved in a state of 'arrested decay'" (Bodie State Park n.d.). Perceived authenticity and wholeness are going to be important benchmarks for the argument about sideways cumulative association and cultural nostalgia that I want to make in this chapter, and Bodie works well as an indicator of a kind of unproblematic performance of this. Marguerite Sprague's description in her book-length study *Bodie's Gold: Tall Tales and True History from a California Mining Town* takes a slightly different approach to Bodie's intactness, and her perspective is a good place to begin the exploration of the concrete storying of place that deserted structures like Bodie perform. In what begins much in the same tenor as the above description from the Bodie website, she writes:

Bodie sits as Bodie was left. There are no gussied-up storefronts, no actors in cowboy duds, no player pianos tinkling out atmosphere. When you come to Bodie, you peer through windows, forced to keep a respectful distance from what was once a big, booming, dangerous gold town of the western frontier. You explore Bodie the same way you paw through Grandpa's dresser drawer: looking for another time, another life, and trying to step into it, to know what it was like to be *them*, to be *there*. (Sprague 2011, 2)

The town is a major tourist attraction and offers guided tours during the season's opening hours (the roads are closed in winter). As Sprague says, we may not find the typical cast of cowboys and miners, but the Park still cannot resist advertising ghost walks with the "spirits of the past," as they put it. This is all fine; after all, Bodie is a self-curated outdoors museum commemorating a many-faceted and often troubling past. What I think is interesting in the context of place writing, of chorography and performativity, is how a site like Bodie gets to be defined by ephemerality and elusiveness. That is to say, however far a book like Sprague's brings to Bodie a revival and reminder of its concrete history (mark the title: *Tall Tales and True History*), the myriad visitors' sightseeing gaze want what they want, and this more often than not tends more toward the speculative rather than accurate history. The impulse is reflected in Sprague's description of the visitor's perspective as we approach and try to grasp Bodie. The emphasis on the desire to "step into it, to know what it was like to be *them*, to be *there*" is the invitation to imagine, and to bring to the site a fuller story.

It is furthermore in the continuous invitation to "step in" and imagine what *was* that a sequence of "sideways" additions into cumulative associations resides. Bodie is a "text" that welcomes its audience, its "readers" to complete for it what its fragments leave open. The designation of *ghost* consequently works on more levels than as merely describing a place abandoned by living beings; in terms of the literary component to site-seeing, the notion of ghost also

evokes the unknown and unseen writer, penning the story on behalf of someone else. In this case we the visitors are those writers, narrating to ourselves the story which we hear and see the site tell us. The ghostly in the ghost town is consequently both immateriality and manifestation, a reciprocal relation that we can now consider more concretely in terms of the performance that results. Bodie's ghostliness paradoxically amalgamates into a solidification of definite place, because for each visit the sedimentation of its place-ness in Stegner's "stories, song, and memory" only consolidates further. The arrestation of the town's "natural" history, the final closing down of the mines in connection with World War II, has been replaced by its role now as State Park and host to visitors eager to experience up close the eeriness of its deserted pose. Fragmentation continues to invite site seers' imagination, for as Sprague points out, "we [...] rely on a combination of facts documented in records of the time, on information that is the consensus of those who have studied the area in depth, and on reminiscences of those who were there" (Sprague 2011, 2). There is in other words plenty of room for the site-seer's own imaginative filling in of the gaps, to create her own version of a presence that the absence she peers into, "steps into," can allow. Herein lies also the performative function that a site such as Bodie embodies. Absences and fragments thus constitute one of the nodes in the triangularity of work–site–audience; they *make* the work, with the ghost town in its totality as site, and us the visitors as the audience.

The multiplicity of perceptions that occur in this kind of site-specificity is perhaps not all that different from how Benjamin D. Powell and Tracy Stephenson Shaffer suggest that the ontology of performance can be reimagined and reframed via hauntology. With reference to Derrida and his *Specter of Marx* they say: "Truth is not found in the identity of the thing as the thing itself but through our interactions with that thing. For example, a box is not a box simply because others say it is, but it becomes a certain kind of box once we paint the walls black, hang lights in it, and start moving around inside. Therefore, perspective is shaped by interaction and how each interaction differs" (Powell and Shaffer 2009, 1). Similarly, the visitors to the ghost town are not seeing the same object, the same "truth;" instead and in close cooperation with the work and the site, we co-create and co-design narratives bounded by the specificity of the site, yet varying greatly depending on the singularities of our viewpoints. The ghostly in the ghost town thus functions as a patina for endless additions to the story about Bodie, not rooted in the continuity and stability of lived emplacement, but in a horizontal and at heart metonymical figuration. This is different from the cumulative association of for instance the stable and settled South that Stegner refers to, which I will suggest tends toward the figure of the synecdoche, the narratives of the place never straying too far from the totality

of its perceived truth about itself with partial stories and memories complementing a core narrative. Synecdoches, James Duncan writes in *The City as Text*, "are powerful signifiers because they parsimoniously conjure up in the mind of the observer a whole narrative. Such allusions are fundamental in the operation of landscape as rhetorical practice" (Duncan 2004, 20). His point here is that for the whole to function coherently and convincingly, it must rest on the non-contradiction of its myriad parts. Anybody hailing from a small place will testify to the uncomfortable truth of this observation: one's individual story should agree with the story of the whole, lest that whole begins to unravel.

The tropes of synecdoche and metonymy are extremely close; some would treat them as the same. However, it matters greatly to this particular discussion that metonymy specifically functions according to contiguity, that is to say, according to nearness. There is an important difference here, for in metonymy the demand for the absolute correspondence that synecdoche wants is broken. Sideways cumulative association orchestrated around the principle of metonymy consequently allows for some variation, for the insertion into the process of co-creation of a second node of identification, namely the singularity of the viewpoint. Hence, the many gazes upon Bodie in its arrested decay will not yield multiple stories whose trajectories can all be traced in a part-for-whole or whole-for-part symmetry across that multiplicity; instead, there will be a myriad of such trajectories, commanded by the interpretation of what counts as nearness. That is to say, the viewing itself of the arrested decay allows for, precisely, association. Contiguity resides in metonymy, as Roman Jakobson showed in his seminal essay on the two kinds of language in aphasia, a memory disorder whose manifestation must be understood and explained according to the singularity of the mind who suffers from it. The process of identification and storying that organizes itself around the trope of metonymy is certainly not free, but it is less bounded than is synecdoche. To conclude now this line of thought and bring it back to Bodie, we could say that, frozen forever in the moment of its ending, it may be that the "natural" history of the town is broken. There is no more sequential accumulation to be had other than through the work of the historian and archeologist, always working backwards, digging down. At the same time, as the host to endless yet related (contiguous) viewings, Bodie in all its arrest remains very much alive as performative place, as site, and it accumulates as such.

Multiplicity of perspectives does, however, not equal unfettered disparity of perception, and in addition to the site itself requiring the contiguous to transpire in interpretation, there is also an overarching template for seeing and reading that in the end steers that variety into a fold of some sameness. The

figure that orchestrates this function is nostalgia, summoning a kind of collective disposition that seeks in the ruinous the vicarious sensation of wistful longing to what is irretrievably past. In relation to the case of a ghost town such as Bodie one may well ask what kind of home the longing here is directed at, for this was at no point the home of any of the tourist visitors. But then, on the other hand, home can be many things:

> Home may mean the people of the neighborhood, community, town, state, or country. When in another town one may be very happy to meet a person who is a total stranger if that person is from his home town. [...] Home may mean one's close friends, or one's neighbors. [...] Home may mean the way in which things are done, the characteristic patterns of behavior, the customs, the attitudes, the beliefs, and the mode of living
>
> MCCANN in JANELLE WILSON 1999, 302

The passage circle ideas of sameness and mores and traditions as they serve to bind a collective, and the glimpse of an object or performance that evokes associations of home in this sense can be a very powerful thing. I am not saying that this is what Bodie deliberately does, but I will suggest that a significant component of its attraction has to do with a collectively felt nostalgia for the story of its being, and its pastness in and of itself. This is neither restorative or reflective, nor counter-nostalgia, but instead more akin to what Boym calls prospective nostalgia. She unpacks the paradoxical orientation that inheres in the phrase as a meeting between "the irreversibility of time, and a striving beyond the temporal and spatial confines of the present" (Boym 2017, 39). Prospective nostalgia is about a certain sense of choice, of projecting "the specter of freedom into history, which often requires a slower pace of making meaning against the grain of the current culture of access and speed" (Ibid.). The attraction of a site like Bodie is perhaps nothing more than this, a pause on a stage we sort of know, its performance told enough times that it resounds familiarly enough. At the same time its ruinous decay and arrest accommodate multiple projections into sideways cumulative associations – patiently obliging our tentative, longing gaze.

In the previous chapter we briefly touched on Adichie's warning of the danger of the single story as also relating to the danger of the claim to the single place, one that seeks to border a place off from contesting versions of its placeness; indeed, from its sense of place. The nostalgia that Bodie's performance evokes in its audience can be seen in this context. Huyssen again: "[i]n the body of the ruin the past is both present in its residues and yet no longer accessible, making the ruin an especially powerful trigger for nostalgia" (Huyssen 2006, 7).

THE TIME OF GHOSTS: CHINESE CAMP 57

Triggering is, however, never random, never not conditioned and not primed, and in the case of the example of Bodie, we must recognize that the "stepping into" that the ruin prompts is to a very certain kind of past. Most of the time that past presents itself to our nostalgic gaze in the form it has been primed for in popular and romanticized conceptions of, in this case, the West. Triggering is always a question of identification, and a place like Bodie makes the algia for nostos easy for us. Casey touches on this precise aspect when he comments on Levinas' critique of nostalgia as being a "retrograde return to sameness." He elaborates, saying that, "'[t]he same' is the realm of self-identification and ip-seity, a region of self-concern that is distinctly egoistic in orientation. From the same, which is exemplified in the enjoyment of sensibility and in the sense of possession that goes with dwelling somewhere, all radical otherness has been expelled" (Casey 1987, 366). Ghost towns are doubly interesting as triggers for nostalgia in this sense: On the one hand, their very existence as site is a testi-mony to ultimate and total expulsion to the point where no living being is left. On the other hand, they more often than not come trailing the histories of domination over and removal of what would have posed as other to its sense of sameness while still being a living place. "Retrograde return to sameness" in nostalgic re-visitation thus unwittingly rehearses an original act of making "same." I hasten to add that this is not a critique of visitors to Bodie, but simply the recognition of how the aesthetics of site-seeing can be quite tricky once we look more closely at what goes into the act of what we are in fact looking at. More importantly, I spend time on Bodie and the metonymic, sideways cumu-lative association it invites in its performance of collective nostalgia to prepare for the site-seeing to the main "work" in this chapter, Chinese Camp. Smaller and much less famous, unknown to most, this semi-ghost town on the other side of the Sierra foothills invites to a very different experience from that of Bodie. The contrast goes to the core of nostalgia's capacity for identification, and to the tropology of cumulative association into settled-ness of site. Here is the fragmented story of a fragmented place.

1 Staging Chinese Camp

Chinese Camp lies in Tuolumne County, in what used to be known as the Moth-er Lode, an extraordinarily rich vein of gold in California covering about 120 miles of linked veins. (The mines here are referred to as the Southern Mines, an indication of how geographical orientation has changed, because today many would say the area tends to a more northern province). Among the counties the Mother Lode comprised are Calaveras County, made famous by Mark Twain

in his short story about the jumping frog, specifically from Angels Camp, and neighbor to Tuolumne County. As thousands and thousands of excited 49ers descended on the state, mining camps and small settlements, towns in becoming, emerged out of nowhere, and sometimes overnight. Many disappeared just as suddenly. Some of them, like Angels Camp, survive as regular towns, others have long since receded back into various degrees of ghostliness. They are scattered throughout the landscape, reminders of other stories, other pasts. Chinese Camp is at first glance very much like any one of these: Houses more or less overgrown are lining some of the few streets, no signs of occupants. If you look more closely, however, what is hidden underneath the luscious ferns and wildflowers do not resemble the other ghost towns at all. The site of Chinese Camp, as its name suggests, tells of one of the less glorious chapters in California history, and its performance to the visitor comes trailing a complicated script. Its overgrown structures are shrouded in local as well as global movements and moments, and they carry their own time, their own cultural moments of remembering. Chinese Camp is consequently a node in a tangled and palimpsested imaginary of American history generally and California history specifically, and paradoxically its performance of past-ness, like the workings of all palimpsests, brings into presence precisely what was supposed to be absent.

I happened on Chinese Camp almost by accident, curious by the name on the map. Whatever hopes I naively may have had of finding a library or the like were (of course) disappointed, and the best I could do was go to the small visitor's center, which advertises for Yosemite more than for itself. What they had there was, however, quite interesting, namely a small pamphlet from 1977 published by the local historical society of Tuolumne County. It is written by late resident and local town historian Dolores Nicolini and provides the reader with a detailed walking tour through town. (I come back to the pamphlet in more detail below.) Chinese Camp is, however, not a ghost town like Bodie, and is listed in the 2018 census with 135 inhabitants. In its heyday, however, this was a bustling town of about 5000 people, and before we look more closely at its site-specific performance, some background to the history of the town is helpful. It is actually also quite necessary in order to see the symbolism its tropology carries.

Attracted by the lure of what they called Gold Mountain and fleeing war and poverty at home, the Chinese joined the thousands of others from around the world flocking to California. After all, in those early days and before the transcontinental railroad was in place, crossing the Pacific from the west was sometimes easier than crossing the continent from the east or sailing around it. Indeed, before the railroad, "China was nearer to the shores of California than was the eastern portion of the United States" (Métraux 2010, 100). In history

books, Chinese Camp is referred to only in passing here and there, and mostly in relation to its current listing among California's many ghost towns. *Wikipedia* has it on its long list as a semi-ghost town, so do commercial websites like *Ghost Towns.Com*. It is not entirely easy to pinpoint exactly how or when the Chinese came to the camp that would take their name, but there seems to be general consensus that a group of about thirty-five Cantonese working for English speculators from Hong Kong arrived in nearby Camp Salvado in 1849, the first Chinese to the California mines (Gudde 2009, 58). One version of what happened goes like this: "They were first directed to a dry tributary of Woods Creek by Mexican miners. Soon they were driven out by white miners, and the camp became known as old Chinese Diggings or Camp Salvado" (Ibid.). In a book from 1955, however, titled *The Big Oak Flat Road; an Account of Freighting from Stockton to Yosemite Valley* by Irene D. Paden and Margaret E. Schlichtmann, a whole chapter is devoted to Chinese Camp and here we find more information. Based on archival newspaper clippings and letters, they write that "early in the Gold Rush it occurred to a ship's captain to persuade some Chinese from the crew of a stranded ship to wash gold for him. He brought them to a hilltop encampment called Campo Salvador because it was founded by a group of San Salvadorians" (Paden and Schlichtmann 1955, 68). As reported also elsewhere, the success of these Chinese immediately attracted other miners, and "[n]aturally the Caucasians at once pushed in to Campo Salvador to see if the Chinese had uncovered anything worthwhile; saw the gleam of gold and stayed. Whereupon, in 1850, the Orientals moved out" (ibid.) Where they moved to would be the beginning of Chinese Camp, but it was only a matter of time before the success of the Chinese miners here, too, again would attract "Caucasians." According to Paden and Schlichtmann's account it seems, however, that because of the substantial number of Chinese in Chinese Camp there was relative peaceful relations between them and the Anglo Americans who soon established their businesses there. The two groups were of course thoroughly segregated: "The town was sharply divided into two elements: Chinatown, peaceful and law-abiding in the main but with a fringe of rough hangers-on, and the families of merchants, doctors, lawyers and other professional men" (Paden and Schlichtmann 1955, 77). Segregation does, however, not seem to have extended to the children, for Paden and Schlichtmann also note that "[i]n 1854 a school was built close to the site of the present one and here the small, pig-tailed sons of the Chinese residents played with the other boys, were taught to read by the teacher, Benjamin Butler" (ibid.).

In a more recent work, *Driven Out: The Forgotten War Against Chinese Americans,* Jean Pfaelzer confirms this part of the history, recounting how word came out that a group of Chinese miners who had settled in Salvado Camp

had struck gold. They were immediately assaulted by "a gang of white miners," and most of the Chinese fled the area. Pfaelzer writes: "The remaining miners trekked over the mountain into Tuolumne County. There they built Chinese Camp, likely the first all-Chinese town in the United States. The roundup at Camp Salvado ignited the brutal firestorm of purges that burned in the West for fifty years" (Pfaelzer 2008, 9). There was, however, a small camp already in place when the Chinese came, and as Nicolini points out in the pamphlet from the visitor center, it "was called Camp Washington before the surge of Orientals hit California in 1849" (Nicolini 1977, 561). Erwin Gudde confirms the name change in his entry on "Camp Washington" in *California Gold Camps*, saying that Camp Washington "became the nucleus of Chinese Camp," with the original name living on in the name of one street, Washington Street (Gudde 2009, 59). The precise history of the town's naming hardly matters, though, because neither Camp Salvado nor Camp Washington exists, and for our purposes here the main point of interest is the fact that Chinese Camp would develop into one of the largest Chinese settlements in California and for a while fulfil the role of a safe haven to a persecuted community. The town prospered and became an important crossroads for traffic between the coast and the inlands, and was known initially as Chinee, Chinese Diggings or Chinese Camp. When the post office opened in 1854 the town was, however, officially named Chinese Camp and was home to the largest Chinese population of any of the camps in California. It is estimated that a total of 2.5 million dollars' worth of gold was extracted from the nearby mines.

We can assume that once the gold ran out, many of the Chinese in Chinese Camp as in the rest of the area would follow the railroad constructions. Leland Stanford, one of Central Pacific's Big Four, had made clear that he favored Chinese laborers, as reflected in this report:

> As a class they are quiet, peaceable, patient, industrious and economical – ready and apt to learn all the different kinds of work required in railroad building, they soon become as efficient as white laborers. More prudent and economical, they are contented with less wages. We find them organized into societies for mutual aid and assistance. These societies, that count their numbers by thousands, are conducted by shrewd, intelligent business men, who promptly advise their subordinates where employment can be found on the most favorable terms.
>
> STANFORD 1865

Stanford's tone is framed in a perspective that recognizes the Chinese as inherently other in a kind of racist embrace; they are conceived of as a uniform

THE TIME OF GHOSTS: CHINESE CAMP 61

and anonymous labor force first and last. His colleague, Charles Crocker, made a similar gesture, but for very different reasons: "I believe," Crocker said, "that the effect of Chinese labor upon white labor has an elevating instead of degrading effect" (quoted in Takaki 2008, 187). His reasoning was that by having the Chinese do the most menial work, white workers would be reassured of their superiority and a division of labor would result that benefited all parties. That plan did not quite pan out, and in 1882 Congress passed the rather unique Exclusion Act, banning Chinese immigration altogether.

The hostilities that had spread across the region are still not fully accounted for but works such as Phaelzer's *Driven Out* go a long way to fill in what until recently was only randomly present in the history of the American West. The purges, as Phaelzer calls the attacks on the Chinese, were so rampant, so violent and extensive that she suggests they "bring to mind *Kristallnacht*, the night in 1938 when Nazi Germany violently exposed it intention to remove the Jews" (Phaelzer 2008, xxviii). She also shows that soon after the annexation of California in 1848, Anglo-American calls for domination over the region could be heard to the detriment of the Mexican, the Native American, and the Chinese. Thus, already in 1849, a white mob in Mariposa declared that "a 'Chinaman' who mined for gold must 'leave on twenty-four hours notice, otherwise the miners will inflict such punishment as they deem proper" (ibid., 9). In a separate section of *Driven Out* composed almost like a memorial, Phaelzer provides a list of all the purges along with the acts of resistance that happened in the decade between1880 and 1890. It is a disturbingly long list, and as she says, "[it] is impossible to represent the totality of the rage and brutality, and no words can fully capture the atrocity. But perhaps in the aggregate, in the naming, in the listing, we can witness how widespread and fluid was the movement to purge the Chinese" (ibid., 254). We know that the Chinese in 1880 made up .002 % of the US population, so the Exclusion Act stands out as one of the more extreme responses in US history of immigration, based in fear and ferried in a rampant racialism. Ronald Takaki suggests that one reason for this reaction may have come down to something as simple as this: "Something had gone wrong in America," he says, "and an age of economic opportunity seemed to be coming to an end. This country had been a place where an abundance of land and jobs had always been available." (Takaki 2008, 189–90) What he refers to as "the discovery of unemployment" lead to scapegoating, and in California, where the Chinese stood out as the more Other even in the company of the Native American and the Mexican, the choice was simple. The Exclusion Act was renewed in 1892 and then extended in 1902. It was not lifted until 1943, and then the quota system only allowed a minimal number to enter the US.

Such is the short version of the history of the Chinese in California in the 19the century, and if for a long time it remained shrouded in the silence that veiled a great many groups of Others to the perceived sameness of the single story of America's being, that history has in later decades been told more complete. This does, however, not help us retrieve the full history of Chinese Camp. The name typically comes up in connection with the Tong wars, and the State Historical Marker No 423 in the town states: "First Chinese Tong war in state fought here between Sam Yap and Yan Woo tongs" (Marker No. 423). Several sources mention this war; the *Union Democrat* in a short write-up in 2009 recounting that "'[t]hey were hysterical with exultation,' wrote an eyewitness. 'There was no discipline nor order. Everybody marched as he pleased, or ran about hooting and shouting.' Despite the raucous, only four people died in the battle" (Damschroder, 2009). Apart from such occasional mentions, it is difficult to locate specific and coherent stories from Chinese Camp. In their brief reference to the town, the website Sierra Nevada Geoturism, for instance, tells us that "[t]he gold lay just below the surface of the ground but the work was hard because there was no water nearby. All the gold had to be hauled to a creek to be washed. The Chinese worked the mines and were successful where other miners had given up" (Sierra Nevada Geoturism, n.d.). It is unclear exactly when the Chinese left Chinese Camp, but Daniel Métraux suggests that the last remaining ones departed for San Francisco in the 1920s (Métraux 2010, 110).

I spend a little time on the town's fragmented history because it plays a significant role to how we visit the site in its present figuration. One aspect is of course that Chinese Camp is only *partly* a ghost town. The crumbling houses, the overgrown yards and porches, the partly hidden fronts of structures coexisting with the remaining inhabitants that surround the center, already present a complicated template for reading and viewing. On the one hand, there is definitely the ruinous about the part of town that has for so long been abandoned (Huyssen's trigger for nostalgia), but it does not at all have the same effect on the visitor that the intact Bodie has. Perhaps Boym's reflections on what she calls "ruinophilia" can serve as an entry point into the performance we have before us. I quote her at some length:

> "Ruin" literally means "collapse," but actually, ruins are more about remainders and reminders. A tour of ruin leads you into a labyrinth of ambivalent temporal adverbs – "no longer" and "not yet," "nevertheless" and "albeit" – that play tricks with causality. Ruins make us think of the past that could have been and the future that never took place, tantalizing us with utopian dreams of escaping the irreversibility of time. In *The Origin of German Tragic Drama* Walter Benjamin saw ruins as "allegories of

> thinking itself (177-1789," a meditation on ambivalence. At the same time, the fascination for ruins is not merely intellectual, but also sensual. Ruins give us a shock of vanishing materiality.
>
> BOYM 2017, 43

The site that Chinese Camp presents is challenging no matter how we approach it, because unlike Bodie, caught in motionless and arrested permanence awaiting its audience and the "stepping in" that follows from its performance, Chinese Camp, a semi-ghost town, is only partially arrested. It is in other words already projecting ambivalence, and its invitation to the audience has everything to do with Boym's no longer and not yet, and the what if. That ambiguity furthermore extends beyond the site's partial abandonment, for while this town, like Bodie, in many ways lies there as it was left, the details of that leaving is as shrouded and overlayered as are many of the buildings.

What visitors to Chinese Camp feel is perhaps something akin to what Ladino specifically in relation to memory sites calls *affective dissonance* to describe the "unsettled state in which we experience more than one feeling at the same time, often with a sense of conflictedness or irony but not necessarily with a consciously 'storied' understanding of what we are feeling" (Ladino 2019, 22). In Chinese Camp as a site of profound ambiguity and almost but not quite ghostliness, it is precisely such unsettledness that complicates our "stepping in." The desire to imagine one's way into a different time and a different life takes instead on a foreboding, a bewildered hesitation that in itself, I think, contributes to a different kind of eerie site-specificity. Consider the list of adverbs in the quote from Boym above: "no longer," "not yet," "nevertheless," and "albeit;" they all speak of uncertainty and unsettledness, and suspension. The ruins before us in Chinese Camp (again, not ruins proper, as in those of the Roman walls) make for a difficult read, and it is this perplexity I will devote the remainder of this chapter to. I am struck by how differently our viewing of a place like Chinese Camp is from that of Bodie, and I will suggest that the difference has to do with the more troubling nature of the arrestations and absences in the former, ambivalent because unresolved, closed off because silent, and silenced. For this following excursion Dolores Nicolini's invitation to her reader on what she calls a "mental tour" of Chinese Camp is helpful.

Her description is taken from *Volume 16 no 4* of the local historical society's quarterly *Chispa,* and Nicolini opens her tour as follows: "Chinese Camp was called Washington before the surge of Orientals hit California in 1849. It is the only town settled by the Chinese in the Mother Lode" (Nicolini 1977, 561). This is written in 1977, before wording such as a "surge of Orientals" would have drawn attention, and the disposition it refracts toward the past and the

Chinese consequently not only stands in for the history described above, it also strikes a note that pervades the rest of the article. Nicolini's brief piece of writing is therefore interesting for a number of reasons. One element is her mapping and narration of her hometown, an effort that carries in itself definite affinities with the tradition of chorography. Here we see the local historian attending to fragments, in drawings and photos, in remembered conversations and impressions, to narrate as fully as possible the place as she wants it to be seen also by her readers. In significant ways her "Chinese Camp" thus resonates with Denis Cosgrove's comment on chorography as concerned with "specific regions or locales understood without necessary relation to any larger spatial (geographical) frame. The role of chorography was to understand and represent the unique character of individual places" (Cosgrove 2004, 59). Nicolini's tour is most certainly the representation of what she sees just in this sense; here is no concern with what lies beyond the small town, but a steadfast intent on providing a picture of a very specific place as she lives it.

As mentioned, Nicolini takes her reader on what she calls a "mental tour of Chinese Camp as it stands today, i.e. 1977, with much of its physical history crumbling away" (Nicolini 1977, 561). The emphasis here on *physical* strikes a note of an initial awareness of what does not as easily lend itself to a tour; however the remains of the pages do not reflect this inclination. Nicolini begins by matter-of-factly correcting the dates of the Tong wars and the Catholic Church given on the State Historical Marker, then proceeds to take us to Main Street. Here she "walks" past a number of buildings and describes each structure in some detail in a mix of architectural commenting and personal recollections of what does not always seem very relevantly linked: The post office, Wells Fargo, the Catholic Church, the general store, other stores (ten in total), the Casino Hall, the Miners Union Hall, the Odd Fellows Hall, the fandango house, etc. etc. – all are given their due attention according to whichever feature strikes the writer as most prominent. So, for instance, she notes that the iron doors of the post office are the original ones, the Casino Hall had a "most beautiful wooden floor," the blacksmith shop has three pairs of double doors, and so on. The inventory Nicolini lists for us speaks of an almost unimaginable, bustling past in a staged narrative and mobilizes it onto the "stage" she "walks" on.

The houses and businesses are moreover all described rather minutely in terms of their architectural characteristics, their past owners, and their professions. It is noticeable that these all have English or Italian last names, except the blacksmith who came from Germany in 1852. To his brief portrayal Nicolini adds that he had in his employ a young apprentice named John Studebaker; indeed, the very one who would later start the car company. Here and there she breaks off from the inventory of structures and sprinkles her tour with

THE TIME OF GHOSTS: CHINESE CAMP 65

recollections told to her by some of the then still living residents. For, remember, this was penned in 1977, so some of the older people born towards the end of the 19th century would still have been alive. Famous figures are also part of the story: "According to legend," Nicolini notes, "the colorful bandit Joaquin Murieta stopped by [the blacksmith shop] several times to have his horse shod. It is said that he was always in a hurry and paid well over the normal cost" (ibid., 563). At the end of the article-tour she also lists a few other publicly known figures who at some point made their sojourn through Chinese Camp; Thomas Lipton, U. S. Grant, and John Muir are among them.

One of the less dazzling recollections she includes comes via a man named Frank Lertora, who recalls finding gold on the school grounds as a kid, but the story as we hear it told to Nicoloni is quickly disrupted by a different memory, and one that seems oddly dissonant with the story of gold nuggets. I quote the continuation of Lertora's anecdotal recollections as Nicoloni tells it in full:

> [He] also recalls how the school boys used to tease old Jim Lee (a Chinaman) when he crossed the school grounds with his white donkey, Hoto, headed for the Shawmut Mine with a load of bootleg whiskey. On the numerous occasions Jim Lee got picked up he would tell his friends, "Go stay Sleeney (Sweeney) Hotel." William Sweeney was the county sheriff and the hotel was the county jail which now hosts the Tuolumne County Museum.
>
> Jim Lee always wore cowboy boots and had but one hand. He told the boys that he lost the other fishing, but forgot to mention that he fished with half sticks of dynamite. He would light the fuse in a stick and toss it into Woods Creek. After the explosion, he would pick up the fish killed by the concussion. One time he didn't throw the stick of powder fast enough and it went off in his hand. (ibid.)

The little anecdote is left uncommented, and Nicolini continues her tour of the town to describe three of the four cemeteries. I draw attention to it here, though, precisely because it seems such a random narrative detour. From the point of view of staging and performance, the excursion begs the question, what is its function in the context of the pamphlet? As we read on, we detect a kind of pattern emerging: While the rest of the account consists of factual renderings of objects, structures and individuals according to the time and place of their activities, the ones re-calling the Chinese come cloaked in a rhetoric of random-ness. The sketch about Jim Lee above is lighthearted and innocent, but its inclusion tells us something about the townspeople's perspective in 1977, as well as the one from the turn of the century. At both points in time

Jim Lee and other so-called Chinamen are framed as curiosities, as inherently other *in* and *to* the place that carries their name. This is even more evident in the second anecdote.

This one relates to the Chinese house of worship, the so-called Joss Houses (derived from the Portuguese word "Deus") of which there were three in Chinese Camp: "William Fairburn, who was born in Chinese Camp, recalled the celebration of Chinese New Year. He said, 'We used to peek in the church to see the strange rituals. They had pictures of dragons on the walls and figurines of gods on the altar. They always had firecrackers and they would give us candy and litchi nuts. You could smell the incense a block away" (ibid., 564). Here is an opportunity for the writer to describe and register the building like she does with the others, but instead the image remains bounded within the frame of an outsider's perspective looking from a distance, lightheartedly, but not coming too close. Granted, Nicolini does include a photo of the ruins of one of the houses, destroyed in one of the several fires in Chinatown, so one must also bear in mind the problem posed by a ruined neighborhood. Her narrative then proceeds to recount how the kids would steal the food that the Chinese put out for their ancestors after a funeral, and humorously comments on how they consequently were never hungry at dinner time on those days.

The third anecdotal incident is of a similar kind. Nicolini tells of someone who as a little girl would visit "China Mary," being "scared to death" by the interior all dark, but always coming "away with Chinese candy" (ibid.). This anecdote shares with the two others that they reflect and reflect on relations of distance, ferried in images of curiosity, borne of exoticism and leading to incomprehension, and ultimately fear. Again, this is not at all to blame Nicolini for what today would be labeled a slurred and racialist bias, and it should be emphasized that she also fully recognizes the work in the community that Chinese labor was responsible for: "Most of the rock fences seen throughout the Mother Lode were built with Chinese labor. [...] They were paid two bits (25 cents) a rod (16 ½ feet for this back breaking labor" (ibid.). We are, it bears repeating, interested here in the local historian's chronicle because it offers a perspective in the late 1970s on what is already vanished, but in so doing perpetuates the perspectives of a time much earlier. And it is this aspect of seeing the site of Chinese Camp that the focus is on when we now turn to its role in relation to performance and chorography.

What Nicolini offers the visitors is something very close to the kind of catalogue you pick up in a gallery. Hers is a listing that arranges for the spectator the order of the "works" on display – their owners, creators, certain details worth noting for the novice-appreciator, their relationships to each other; in a word, it is a museum or even an art display catalogue. By virtue of being the

one voice carrying the work in its totality as it is presented in the pamphlet, she is also for all practical purposes the curator of this "collection." One meaning of curator gives us the following explanation, and it bears reminding here even if we all sort of know what a curator does: "Latin *cūrātor* , *-ōrem* , overseer, guardian," from "*cūrāre* to care for, take care of" (*OED*) – from which our verb to cure also comes from. There is something very poignant about these significations, of guardian as well as the taking care of, for Dolores Nicolini was, as far as I can assess, the one who oversaw, who literally took care of Chinese Camp. It is said that every so often she had her own gardener tend to Main Street, and she was, as we have seen, a walking library of the town's history and a respected local historian. She died in 2011, but her legacy lives on, not least in the elementary school she herself designed in 1970. Shaped like a Chinese style pagoda, it stands out in the landscape. More on the school house later.

The historian *cum* curator must, like all curators make choices, and so, too, did Nicolini. They were, however, not based in the kind of careful and conscious balancing of aesthetic expressions and meanings that the trained museum curator does in the gallery, but a selection she made, nevertheless. Hers would be of a different kind, a conditioned, selective seeing and remembering prepared for and prefigured by decades, a training of the kind we do not really and consciously choose. For the rhetorical shifts in tone and attitude in the "catalogue's" mentioning of the individual "works" produce a double exposure of 1977 and the 19th century which glosses the location's past as innocent and cheerful, refracting thereby a thorough dissociation from the actual history of the town. Or rather, the catalogue sees what it wants to see, or can see. Hence, if as visitors we are somewhat at a loss wandering down Main Street in person, the catalogue gives us at least part of the story. But it is precisely this skewed version and discursively tilting presentation of the Chinese which the town, the "work," after all takes its name from that has us as audience somewhat stumped. The tension between absolute presence and equally absolute absence resounds with the afore mentioned hauntology, "an epistemology concerned with the treatment of the other as an ethics of difference," and particularly salient to the "representation of history on/as performance" (Powell and Shaffer, 2009, 10–11). We are also well advised in bringing back the vocabulary of host and ghost in relation to this particular site-specific performance: wandering through the "work" of Chinese Camp is a layered experience, temporally as well as spatially. As Pearson notes, "[s]ite-specific performances rely upon the complex superimposition and co-existence of a number of narratives and architectures, historical and contemporary," and these elements are all there. They produce a materiality of site in intricate and webbed relations which are further complicated by the added, ghostly presence of the host itself.

68 CHAPTER 2

For there are resonances, however feeble, and it does not matter that the
Joss houses are gone, that there are no remains of Chinatown in Chinese
Camp; the ghost comes to dominate the host. We now arrive at the last part of
Nicolini's "catalogue." She included for her tour also a map and a lithograph of
Chinese Camp. The map is the same hand drawn one we also find in Paden's
1955 book, and which is drawn by Paden's co-author Margaret E. Schlichtmann.
In relation to the performative aspect of Chinese Camp, and the pamphlet's
close kinship with traditions of cartography and chorography, both map and
lithograph are interesting to our discussion. The lithograph comments on a
moment in the history of the larger Gold Country; it is a photo collage listed
as coming from the Bancroft Library collection. It is titled "Chinese. Tolumne
County. Southern Mines California" (sic), and printed in 1858. The caption that
describes it says that it is "[a] birds-eye view of the mining town of Chinese
Camp, California, surrounded by 12 small views of local businesses and mining
scenes" (*Calisphere*). Some searching around for more details teaches us that
it is one of fifty-six motifs mainly from California, and produced by Charles
Kuchel and Emil Dresel in San Francisco during a rather short business en-
terprise lasting from 1855 to 1859 (Reps 1984, 187). The two men specialized in
representing views of communities and towns, and, as John William Reps com-
ments, "captured images of the Gold Rush settlements only a few years after
their creation, and they provide incomparable records of their urban and ar-
chitectural character" (ibid.). That the title of this particular image only carries
the name "Chinese" is, however, a little strange, since we recall that the post
office was officially named Chinese Camp already in 1854. We will not spend
too much time on this, but as far as I can tell from looking at the image, neither
the small vistas nor the main motif of Chinese Camp includes any sign of the
Chinese. Instead the pictorial representation projects scenes of everyday life
in a color scheme dominated by a soft corn and light green, with all the build-
ings in different degrees of cream. The figures populating the different frames
are dressed in red or blue attires and engaged in various activities relating to
the town and the mines around it. The scenes bear little resemblance to what
seems to have been the reality in Chinese Camp, but then again, there would
have been any number of good reasons to not depict the mines and their envi-
ronments entirely truthfully. In relation to Nicolini's curating catalogue, it un-
derscores the absence and silencing of the people whose name the site carries
and extends that silence into a more distant past. (We will come back to this
aspect also in the next chapter, where site-seeing and its aesthetics take on a
more radical form).

Let us focus now on the reproduced map. Titled "Approximate locations –
Early Chinese Camp," it is a schematic representation of the central part of

THE TIME OF GHOSTS: CHINESE CAMP 69

town where Highway 120, Webster street and Solinsky Alley cross Main Street and Washington Street. Written onto the map are also indicators of where surrounding "homes and orchards" were placed, where the road to "Salvado or Campo Salvador" was, the way to Sonora, a few notable rocky formations. Stores and buildings and their owners' names are clearly drawn up, again, just as the catalogue in a gallery will indicate the placement of the artifices of its collection. There is no indicator of Chinese homes, or temples, only a cabin drawn in on the outskirts of town named Chee Quat's cabin. The dwelling takes its name after the last remaining Chinese inhabitant and is mentioned in Paden and Schlichtmann's book. Drawings are always fascinating, and hand-drawn ones especially so as the very concrete imprint of someone's vision. It is tempting to think of this particular map as belonging in the cartographic tradition, the mapper representing as accurately as she can the landscape in front of her. Cartography differs from chorography in crucial respects, and one distinction has to do with temporality. In Howard Marchitello's succinct for-mulation, "cartography is interpretation ostensibly outside of, or in spite of, time" (Marchitello 1997, 85). The map fixates its coordinates in time and in place, seeking a position of truth, of objectivity of description. This is, however, not entirely the case with Schlichtmann's map and Nicolini's use of it a couple of decades later. They are both too narrative in nature, and even if maps are also commonly held to be narratives, they do not trail the diachronic impulse that chorography does (see Marchitello 13–15). The map of Chinese Camp, no matter how roughly it is drawn, thus presents a story of historical and ideolog-ical perceptions. In contrast to how the buildings are named and often dat-ed, thus reporting of temporality and relationality, the Chinese presence is a blank. The perspective that writes as well as draws is consequently steered by an impulse oriented according to a discursive point of view deeply embedded (cannot help but be) in ideologies and practices of its own time.

The complication does not stop there. Drawings are additionally complex as artifacts in the sense that they are intimately linking the one who sees and rep-resents to the representation itself: "The gestures of the moving hand register, one could say, the movement of the thinking eye" (Van Alphen 2017, 110). The map of Chinese camp vibrates uneasily with the implications of this relation, for here the hand clearly does not "see" the Chinese, neither in the original 1955 version nor the reproduced 1977 one. As a kind of appendix to the descriptive catalogue of the site, it enforces the instructions to the audience on how to view the site, and consequently both it and we as audience trail, literally, a blind spot, a void that in words as well as image paradoxically beckons to us. Like the site in site specific performances, this, too, relies on the spectrality of the history of its stage, a spectrality that transpires in the linking between

narrative, symbolism and concrete place. The presence of absence that both catalogue and map gesture toward can thus also be related to what Andrew Sofer in his use of the metaphor of dark matter describes as "the invisible dimensions of theater that escapes visual detection, even though its effects are felt everywhere in performance" (Sofer 2013, 3). Sofer's discussion of dark matter in relation to the theatre stage presents it as a mediation between the ghostly and the absolutely real, because as unseen force, dark matter on stage as well as in the universe is most tangibly felt; it is, after all, what holds the universe together even if we cannot see it. One observation in particular thus applies powerfully to the performance of Chinese Camp: "Dark matter comprises whatever is materially unpresented onstage but un-ignorable. It is not a finger pointing at the moon but the tidal force of gravity that pulls at us unseen" (Sofer 2013, 4). Guided by Nicolini's "Chinese Camp" and Schlichtmann's map as we walk around the ghost town, it is this manifestly felt absence, the unseen, that beckons to us and accounts for our sense of the ghostly. Let us here also bear in mind that haunting, as Powell and Shaffer say quoting Derrida, moreover "operates as a 'performative interpretation,' that is, of an interpretation that transforms the very thing it interprets [...]" (Powell and Shaffer 2009, 11). What consequently comes through in the discursive oscillation in Nicolini's "mental tour" of Chinese Camp can be read as such performative interpretation, inflected by the present absence of the Chinese. Her catalogue as well as the map are narrativizations of the simultaneously present and absent, enveloping the viewer, too, as we look for a performance of the past. But like a receding horizon it withdraws, and the most tangible trace left is the name of the town.

So, in what exactly does site-specificity here reside in? I repeat that we are not talking about the kind of performance that is deliberately created with a definite script or installation on site in co-production with the site as host. But there are enough similarities in how site, audience, and the resulting performance interact to bring in elements from site-specific performance for a better understanding of what Chinese Camp in fact configures into being in, for lack of a better word, its place-ness. Pearson writes that "[s]ite may be directly suggestive of subject matter, theme, dramatic structure; it will always be apparent as context, framing, sub-text" (Pearson 2010, 35). I am intrigued by the role site assumes in this description and will suggest that the idea can be quite compellingly transposed onto Chinese Camp. Could we perhaps suggest that, as we wander through the abandoned town contemplating the overgrown houses lining the streets through the lens of Nicolini's "script," that the site itself attains precisely to the function in all of the senses Pearson here lists? That, through the absences and blank spots on the map, the paradoxically absent

THE TIME OF GHOSTS: CHINESE CAMP 71

presence of the Chinese stands before us as subject matter as well as theme, and certainly as a running sub-text?

Further, if we agree that maps, and especially such hand-drawn ones as the one we are looking at here are registers of the "thinking eye," symbolic projections of world views rather than pure, objective representations, we are also edging closer to an appreciation of the aesthetics of this particular site seeing. The connection goes via cultural memory and its role in a trajectory where, as Jan Assman puts it, cultural memory is conceived as "exteriorized, objectified, and stored away in symbolic forms that, unlike the sounds of words or the sight of gestures, are stable and situation-transcendent [...] Our memory, which we possess as beings equipped with a human mind, exists only in constant interaction not only with other human memories, but also with 'things,' outward symbols" (Assman 2008, 111). The script and the map can be seen as the concretizations of a cultural memory instituted into "things;" however, this is not quite enough. We have to add that their function and effect are cemented only in ours, the visitors', mediations of their relationship. It is we as readers and audience who enable the performance on site into being in its full capacity as a staging of the presence of absence, constituted in the projection onto the abandoned structures by a flawed cultural memory. As audience we follow the mapped trajectory, and so we repeat the imaging, but in puzzlement.

Let us consider again the relation between host and ghost in site-specific performance as "the coexistence and overlay of two basic sets of architectures, those of the extant building or what [McLucas] later called the *host*, what which is at site [...] and those of the constructed scenography or the *ghost*, that which is temporarily brought *to* site" (Pearson 2010, 35–36). I hope the reader will accompany me when in light of this I propose the following: in relation to Chinese Camp as performance, the tables are now paradoxically turned, and it is we, the visitors looking as through a crooked glass at the structure in front of us, who become the ghost. More specifically, the projections that we create on and of the site, onto the *host*, become a successive sequence of ghostly visitations. In that encounter is created again and again a figure that I will venture to argue is the same in each visitation, each creation, and it is the figure of suspension. This is what finally accounts for our being at a loss, and it surfaces from a prevailing feature of the site/host and the performances we are invited into, namely in the shape of the trace. It resides not only in the name of the site, but in the various radiations and permeations of absent presence into the entirety of the stage we visit.

Like all traces, as Casey observes, this trace, too, can be said to "consist in a self-surpassing operation whereby its meaning of value *lies elsewhere* – namely, in that *of which* it is the trace, that which the trace signifies by a self-suspension

of its own being or happening" (Casey 1988, 241, italics in original). Chinese Camp's site-specific performance suspends its own happening in a move directed to what Casey refers to as the "value of meaning" that lies elsewhere. As trace the site thus allegorizes the larger history of the Chinese in California, whose register of exclusion and history of purges and expulsions in large measure has remained unaddressed, also suspended. Sprague comments that the "violent movement for 'white purity'" she attempts to catalogue in her book was "probably far more widespread that we may ever know" (Sprague 2011, 255). The trace furthermore strikes a note that forces to the site suspension as figure, and as such it now engages us in the question of aesthetics. Site-seeing in Bodie was carried, as we saw, in the figure of nostalgia brought into presence in metonymic, cumulative association. But what would such a principle of ordering for the cumulation of associations in Chinese Camp look like? It cannot be located in the mechanism of contiguity, of perceptions and performances that without veering too far circle the one story we are presented with. It also is not synecdochic, because there literally are no parts to fill in with in order to secure a cohesive narrative of the whole. Similarly, it cannot be metaphorical, for the pull of Sofer's dark matter holds that kind of imaginative leap in check. That leaves the question: What if, at the end of the trace there is only more trace, suspension indefinitely suspended? And what if, in the end, it is that very figure that the performance conveys to its audience? For it is quite possible that we must accept the site-specific performance that Chinese Camp invites as the symbolic concretization of the gaps of history, the wrongs of history, and their perpetuation in stories that fail to, or cannot, provide completion.

There is, however, more. In 1970 the same Dolores Nicolini designed the new schoolhouse for Chinese Camp. It sits a little on the outskirts of town, and historian Daniel Métraux describes it as follows: "Fittingly, the town's modern school is built in the shape of an old Chinese pagoda with a gaily painted Chinese-style roof. It seems that the area's largely white residents enjoy this quaint reminder of the village's lively past" (Métraux 2010, 162). One can of course see the schoolhouse like this, as a "quaint reminder," but there are other ways of looking at it. Maybe the structure is instead a very conscious effort to counter the "physical history crumbling away" that Nicolini talks about in her article. The school's design could then be read as a gesture to what is missing from the site itself. It remains, however, that as gesture it seems oddly out of place, even if it furnishes a visual correspondence to the name on the town's sign. But there are no Chinese here, so the school and its architecture makes sense as gesture only in the context of a nostalgic acknowledgment of a troubled past. In relation to nostalgia's capacity for identification and same-ness, however, so crucial to the performance that is Bodie, we have to take a slightly

THE TIME OF GHOSTS: CHINESE CAMP 73

different approach to nostalgia and Chinese Camp. Nostalgia, as Boym says, is "the disease of an afflicted imagination" (Boym 2008, 4), and the imagining that goes on in the design of the school as pagoda can be located more specifically to what she classifies as reflective nostalgia.

It is the kind of longing that puts its weight on *algia*, longing and loss, and in contrast to restorative nostalgia it does not seek "to rebuild the lost home and patch up the memory gaps" (Boym 2008, 41). Instead, reflective nostalgia dwells in "the imperfect process of remembrance," (ibid.), and is concerned with "the meditation on history and passage of time" (ibid., 49). The pagoda schoolhouse in Chinese Camp that caters to no Chinese can perhaps be seen as the manifestation of a reflective nostalgia in this sense. Unlike the "retrograde return to sameness" that we saw enshrouding the reception and performance of Bodie, tending to the restorative in its "return to the original stasis" (ibid., 49), the singular structure in Chinese Camp is a projection of reflective nostalgia's cherishing of "shattered fragments of memory" (ibid.). Viewed from this perspective, the school stands as a respectful gesture to a history erased, and in this way projects the recognition of the "cultural memory of another person" (ibid., 337). In her discussion of the two kinds of nostalgia Boym makes a fascinating comparison to afore mentioned Roman Jakobson and his treatise on the two kinds of language in relation to aphasia, the metonymical and metaphorical. The tendency toward metonymy is where the one afflicted comes to associations via contiguity, and towards the metaphorical when the process goes via displacement and substitution. When Boym compares the reflective and restorative types of nostalgia with Jakobson's two models, she notes that, "both, after all, are side effects of catastrophic forgetting and a desperate attempt at remaking the narrative out of losses" (Boym 2008 fn. 2, 362). This fits well when we bear in mind that the figure Chinese Camp as performance brings before us is that of suspension; to counter this, the pagoda becomes a singular gesture to "remake" the narrative that is otherwise lost, precisely to terminate suspension.

That staging does, however, not quite work, and the schoolhouse instead poses as one more fragment, superimposed onto the already over-written surface of the fragmented town. In another hundred years from now trees and ferns and flowers may well completely cover the abandoned structures, and they will become invisible to the visitor. In that future scenario there is a good chance that the pagoda structure paradoxically remains, perhaps overgrown like the other structures are now, and beckoning to the visitor who sojourns through. In a bizarre twist of historical happenstance, yet true to the logic of the palimpsest's erasures and overwritings, the relation between the name of the site and the sights seen will then somehow make sense.

CHAPTER 3

The Time of Hope: Letters from a 49er Everyman

> [B]etween the letter and the meaning, between what the poet has *written* and what he *thought*, there is a gap, a space, and like all space, it possesses a form. This form is called *figure*, and there will be as many figures as one can find forms in the space that is created on each occasion between the line of the signifier [...] and that of the signified [...]
>
> GENETTE 1982, 47

∴

Not surprisingly, the practice of writing place figures prominently in the tradition of letter writing, and perhaps especially so when the writer has embarked on longer journeys of uncertain ends. Immigrant letters addressed to the home place, for instance, provide us with unique perspectives on what in the moment of writing presents itself as a foreign site, to be understood, represented, and assessed to an audience far away.[1] In a great many cases, the addressee must thus rely on what the emigrant him/herself conveys, having little to measure against. Such letters thus function as veritable tour guides to a site-seeing from afar, alerting to the reader points of particular interest, demographics, natural history, geography, social norms, language, and all of what goes into Stegner's "sense of place." The site for the sojourn in this chapter belongs to this tradition and comes presented to us in a series of faded and brittle letters stored in a box in the Bancroft Special Collections at the University of California Berkeley. They were written by David E. Wilson, a name unknown to most, as he chronicled his traversals through the Gold Country in California between 1849 and 1855. We are consequently not moving all that far away from Chinese Camp, but will here be more concerned with the larger region in the moment of its narrative inception as that mythical destiny for dreamers it would so quickly aspire to be.

1 Sections of this essay appeared in "Materiality of the Invisible in David Wilson's 'California Letters'." 2019. *Invisibility in Visual and Material Culture*, edited by Asbjørn Grønstad Øyvind and Vågnes. London: Palgrave Macmillan.

© KONINKLIJKE BRILL NV, LEIDEN, 2021 | DOI:10.1163/9789004438002_005

If in the previous chapter we saw the aesthetics of site-seeing manifest itself in the performativity of chorographic figuration, on a concrete site and in the "catalogue" that accompanies it in the local historian's curation, here aesthetics and aesthetic function of performativity come about in a doubling of the writing of place. It is first and foremost Wilson's own depictions, his personal "chorography," if you will, that are in focus, but at the same time we as audience must provide our own interpretations of them, our complementary seeing *with*. To a large extent performativity here rests on our filling in what is rendered absent and invisible in a writerly and readerly movement that constitute into being the work of the letters as absolutely depending on the site they pertain to. These letters also, however, compellingly come to form a site in and of themselves, because their fragile and dimmed materiality stands in, so to speak, for the place they write. The opacity that shrouds Wilson's story, the many omissions and absences the letters quite concretely trail, and the graphics that give them a particular aesthetic shape spatialize for us a version of the site that most definitely carries the overtones of a performance. There are close affinities between this approach to the letters and how Fluck discusses aesthetic function and attitude, and as an introduction to the different site-seeings Wilson's letters stage for us, it is helpful to consult him again. Taking an aesthetic attitude toward an object, Fluck says, "does not mean, or, at least does not necessarily mean, that we disengage the object or ourselves from reality. What exactly does it mean, then, to take an aesthetic attitude? The concept refers to the capacity of any system of signification to draw attention to itself as a form of expression and to refer to itself as a sign, thus foregrounding the organizing and patterning principles by which the object is constituted" (Fluck 2005, 29–30). What is at play in this relation between aesthetic attitude and object, or rather, aesthetic object-in-becoming, is a careful balancing between perception and reality. When we take an aesthetic attitude towards Wilson's letters, this is not to deprive them of their ontological being as letters with all that that entails. Rather, it is to add to them a function that, ideally, brings to the fore a quality that already inheres and which deepens their power to signify. Fluck borrows from Jan Mukarovsky an example he uses of the concrete case of gymnastics and which illustrates this process well. I quote it at length, because it nicely conveys the reasoning behind the kind of site-seeing this chapter embarks on. Mukarovsky observes:

> As long as our perception of physical exercise [gymnastics] is dominated by practical functions (gaining strength, strengthening certain muscles etc.), we will focus on aspects which are helpful for achieving those goals and will judge the single exercise in relation to how well it helps to realize

the de- sired result. *Once the aesthetic function becomes dominant, on the other hand, the exercise takes on interest in itself as a performance or spectacle.* The various movements, the sequence of movements, and even the "useless" details of the periods between different exercises may now become objects of attention for their own sake. The significatory dimension of reality is foregrounded and the sign is of interest *sui generis.* Even the "wrong" movements may now be of interest as movements with a logic of their own, not just as "wrong" movements.

Quoted in FLUCK, 29, emphases mine

The letters we will spend time with here are primarily the most real recordings of a most real person in a specifically real time and place. I cannot emphasize this enough, for it is not my intention to let the words on these pages, words that sometimes ring with acute longing for home, the despair of failure, the dejection of defeat, become devoid of the import they were conceived in. I try to strike a balance, however, as indicated above, between referentiality, the reality of the letters' genesis and content, on the one hand, and, on the other, their transitioning in my reading into something more than that and which speaks more broadly from and to the region the writer traverses.

We will see in the following that referentiality thus takes flight and, like Mukarovsky's example of gymnastics, turn into a performance of the place they write that "become objects of attention for their own sake." In instance after instance, the letters' "wrong movements," the invisibilities that mark them, either as illegibility or in the writer's own omissions or oversights, can now be read, not as "wrong," but with "a logic of their own." Also, and as Fluck takes care to remind us,

the dominance of the aesthetic function does not mean that the reference of the object is cancelled. On the contrary, the new perspective on the object can only be experienced in its various possibilities of revelation, criticism, intensification of experience or pleasure as long as the reference is kept in view, so that we are constantly moving back and forth between the newly created world and the reference which has served as a point of departure for this reinterpretation.

FLUCK 2005, 30

Fluck refers primarily to works of fiction, but his caution in the context of Mukarovsky's deliberation can easily be brought into the realm of our present material. The aesthetic dimension of Wilson's letters can, however, only come to fruition as long as we keep steadily before us the fact of their referentiality;

THE TIME OF HOPE: LETTERS FROM A 49ER EVERYMAN 77

that is where the pervasive elements of absence and invisibility come to serve as the tropological steering of our own seeing.

In the following I will first spend some time on the actual narrative the letters tell, and then go into more detail concerning the figures that transpire on the site they bring to life before us. What is absent, what is invisible in this performance is every bit as compelling as what is there, and for this exploration a hand drawn map Wilson includes in one of the letters and the several cross-hatched pages in the series are of particular interest. Cross hatching, or cross writing is extremely difficult to decipher, but for my focus here on the seeing of site, their precise untangling and decoding is not a main concern. I take instead the map and the pages as an aestheticization of what can be only partly recognized, standing in for a broader context of cultural frenzy that leaves a lasting entanglement of the muddled in its wake. Related to invisibility/absence is also the off-stage presence that inflects on Wilson's addressee, namely the voice of his mother Rachel. Her influence can be heard not merely as that of the interlocutor's assigned function in any dialogue, it may also stand in for a set of expectations that extends beyond the merely personal.

1 "will be home as soon as I can"

The yellowed papers, thirty-two letters in all, offer a first-hand narration by one of the many 49ers in search of the rumored gold. They tell of an endeavor and energy that would transform the barely incorporated state of California in the early 1850s, and in their sheer form give shape to several figures that are all embedded in the rush. I have in mind the hasty and often cross-hatched pages, the sometimes illegible, a visualization of fleetness and urgency in the straining toward the next promise. They are interestingly enough in some ways closely related to Nicolini's pamphlet in terms of the curatorial and cartographical, projecting the region they move through in this one man's representation of a very specific time and place in California. Through the letters we are invited into the kind of sojourn that was by far more common than those represented in the victorious tales of Stanfords, Strausses and Sutters.

David Wilson left his home in Darlington, Maryland in 1849 to go to California "*to seek his fortune,*" as family friend Mr. Gilpin puts it in a letter of introduction to an acquaintance of his in San Francisco. Wilson sought, but as far as we can tell from what he wrote home, he did not find. The letters that are collected in the Bancroft Special Collection thus tell a story that is unfortunately not unique, not that special. The writer himself is unknown in terms of his role in this particular history, but that very feature is also what makes Wilson's such

an intriguing and worthwhile account: His is a story that surfaces suddenly, in a glimpse of a kind of Everyman '49er's tale. The letters emerge from their life in a closed and stored-away box as witnesses to a part of history, and a way of being in history that we for good reasons do not hear much about. They are often lost, as is also partly the one David Wilson tells. I came across his letters by sheer accident while looking for something else, but as soon as I started reading, I became absorbed. It is not only the letters' content, it is also their condition and structure that caught my attention at the reading desk – so yellowed, faded and brittle. Their fragile texture, the way the epistolary account begins in medias res, and just as abruptly ends, leaving no indication of where the writer went, of what happened to him; all of this beckons to the audience to imagine our way into the world Wilson sees and describes. The opacity that surrounds the story lends a strange tenor to the reading experience, yet that element works well for an exploration where literal and figurative forms and functions of what is left out get to speak from and in this very specific time and place in American history.

Most of the letters are addressed to the mother Rachel in Darlington, Maryland, a few to the brother Bill, and a couple to one Mr. Gilpin who seems to have been a family friend with connections in California. David Wilson sets out to California in 1849, "to seek his fortune [...] in that distant land," as it says in one of the letters of introduction Wilson brings with him (unfortunately the names of the writer and addressee are incomplete and indecipherable) (*Letters*, 24 Jan 1849). He arrives in San Francisco via Panama in June of the same year, carrying one of the letters where Mr. Harlan, another family friend, one presumes, writes to one Julius Gilliam. M. D.: "Permit me to introduce Mr. D. E. Wilson to you, and to say I will regard it as a special favor if you help smooth the young gentleman's entrance into California" (*Letters*, Jan 1849). Between this and the final letter, which is dated 22 April 1855, Wilson will traverse an area that today comprises four or five counties in the Sierra foothills, located roughly between Yosemite and the Stanislaus National forest. The last line in the last letter to his mother reads: "Know of nothing to interest you my love to you to you all all all all am in good health and will be home just as soon as I possibly can. Your affection Dave" (*Letters* 22 April 1855). In the six years prior to this, there is, however, much to interest the reader.

The first letter Wilson sends home is to his brother Bill, written from Panama where he awaits the passage to "the promised land" (*Letters*, 14 March 1849). He says that he is homesick already, as if he has been gone a year when it has only been 40 days and implores his brother to write him often. The detailed descriptions of what he and his fellow passengers eat and can purchase, where they sleep, what the country around looks like, what the ship looks like are

interspersed with more general observations, like for instance this one which very nicely creates for us an image of the dynamic among the passengers: "The yankees all seem to be in fine spirits and generally very sociable often hear them asking each other where they come from but never inquire where they are going as it seems understood that all are going to the same place..." (ibid.). The comment reflects on the unidirectionality of the journey, an early gesture to the locust-like descent on California that by the end of 1852 had added to the new state more than 300 000 people. If we bear in mind that the region prior to 1848 was home to ca 6500 Californios, 700 foreigners of whom most were Americans, and ca 150 000 Native Americans, we realize the magnitude of the stampede. Wilson was in other words part of the first waves, and his letters ring with the mixed tenor of anticipation, uncertainty, and homesickness.

In his first letter to his mother, dated 19 June 1849 and running over four densely written pages, Wilson complains that he has not received any news from her, despite the fact that he has written two letters home himself. Assuming that they must not have arrived, he recounts his passage from Panama to San Francisco again, entering the days and whatever events have transpired in a form resembling a ship log. He tells of sightings of whales, birds, of catching fish and running out of water and food, and of finally arriving in San Francisco: "We are here right in the gold" (*Letter* 19 June 1849). Wilson also makes a note of how sailors are jumping ships in the San Francisco harbor and leaving captains without a crew. Thus, he writes, "one ship offers 1000 dols for sailors to go to Boston" (ibid). This first report back to Rachel is cheery and optimistic in tone and enthusiastically tells of various goings on, good and bad ones, but always with the unmistakable spark of the newcomer's excitement. To readers today it is a compelling glimpse into the eye of the storm, so to speak, the moment where everything and everyone is gearing up toward the pursuit of success, of the possibility of possibility. We notice for instance the line saying that "houses are going up in every direction" in San Francisco (ibid.), whereby we also tap directly into the energy and force that would propel this town of about 1000 inhabitants in 1849 into a city of about 50 000 a mere six years later. The explosive expansion is almost hard to imagine, but Wilson's letters in their unmediated impressionist renderings offer us a sense of the exceptional flurry he would have been surrounded by.

Already a little over a month later we find Wilson in full swing mining, and if he has not struck it rich yet he is very hopeful that he soon will. This second letter to Rachel is addressed from "mouth of woods creek on the Rio Tuolumne," and Wilson says he has never felt "half as well" (*Letters* 5 Aug 1849.). Here we are privy to another hint of the masses descending on the mountains in 49, for he also writes that, even if he has not had much luck yet, "he expects to do

better there is plenty of gold here, but tis scattered over a large tract of country, the people are arriving every day but plenty of room for a few thousand more yet" (ibid.). These lines tentatively introduce a motif that will orchestrate the rest of the letters, an oscillation between, on the one hand, unwavering faith in the promise of next week, the next camp, and, on the other, great hesitation and doubt.

Sometimes the reader despairs a little at the kind of rumors Wilson takes seriously, like for instance in this account where he has "joined a company to the mountains where tis said the gold lays on the ground in 20lbs lumps" (ibid.). Chasing the prospect of riches, Wilson goes to a great many corners of the Gold Country, and his letters are optimistic all through 1849, one also claiming that this country is "as safe or safer than the old" (*Letters*, 31 Oct 1849). Gradually, however, it becomes clear that he is making some poor investments and several poor judgements. He writes in some detail to his mother in June of 1850 about how he had placed gold with someone in San Francisco who was going to invest it in a lot in that town. The lot proves to be worthless, and Wilson apologizes to his mother for not being able to help her pay *his* debts. (We can only guess that the debt he is referring to here must be related to the expenses of his passage to California). He continually seems to run into bad luck with the mines and the company he keeps, and reports in an earlier letter of having left a mule with someone who, when Wilson comes back to get the animal, is of course gone and has taken the mule with him. He notes that he is constantly on the move, and in the summer of 1850 writes to his mother from a camp called Horse Shoe Bend in the Sierra Foothills that he "has been to the headwaters of the Mercedes on both sides of the river found nothing" (*Letters,* 1 June 1850).

Actually, none of the letters tell of striking rich mines or diggings, and in the same June letter Wilson also for the first time indicates when he plans on returning to Maryland: he will be home in "less than two years more," but only when he can come back as "well off" as he was when he left. It is a sign that the journey West already at this early point is not going quite as hoped for, and indeed, already later that same fall Wilson has amassed a debt that makes it impossible for him to leave: "I've been very unfortunate in some of my speculations and am now about five hun dollars in debt" (*Letters,* 1 Oct 1850). This is also the point where he begins promising in more detail that he will come home as soon as he can, saying that "I think I can leave here by the middle of December as I will go to work in earnest till I make enough to start on" (ibid.). Meanwhile it becomes clear from his responses to his mother that there are hardships at home. His brother Bill has died, and if he himself does not come back, his mother may have to sell part of their farm. Wilson advices her to get

THE TIME OF HOPE: LETTERS FROM A 49ER EVERYMAN 81

someone he himself knows and recommends to work the mills, pleading with his mother to stay well until he can make the passage back east two to three months later. However, a letter in January of 1851 reflects the rapid disappearance of surface gold in the area, as he has "made little more than expenses lately as four dollars a day is considered good wages here now," adding that "it would look bad to go from Cal poorer than [he] came in" (*Letters*, 6 Jan 1851).

In the next exchange in March, a very short letter written in Don Pedro's Bar in Tuolumne, we learn that Rachel via Mr. Gilpin has arranged for a return ticket that awaits her son in San Francisco. Wilson promises that he will make use of it in "a few weeks or perhaps a month or two" as he has "some affairs to arrange" (*Letters,* 19 March 1851). A letter sent from him to Mr. Gilpin around that same date expresses a similar sentiment. However, nothing comes from the promise and in May he writes to his mother that, "I am anxious to let you know that I will not be ready to leave for sometime and of course will not use the ticket you were so kind as to send me" (*Letters*, 12 May 1851). In July the talk of return again changes, now adjusted to a plan of coming home for Christmas; however, a mere month later Wilson expresses his firm intent of making money for the passage home sooner, as he believes he "never will make anything" (*Letters*, 23 July 1851). By now Mr. Gilpin has "drawn the money advances for [his] ticket," which Wilson understands, given how indecisive he has been in the matter. In this particular letter he is also surprisingly frank about his own person, correcting to his mother Mr. Gilpin's impression conveyed to her that he had distinguished himself in an Indian fight, explaining that "[he is] afraid of Indians and kept home" (ibid.). He also admits to another failure in his prospecting. If in January of 1852 he says that he "will not make more promises about coming home," nearly all of the remaining letters in the series contain that very promise: will be home as soon as I possibly can (*Letters*, 13 January 1852).

The wavering between the intention of coming home and the continued urge to persist in the quest forms a kind of motif that orchestrates the letter series. This motif makes itself increasingly insistent in the letters written from 1851 and onwards; for instance, that summer Wilson is back at what he calls the old place (Horse Shoe Bend), "almost dead broke but with good health and intend to dig enough to bring me home as soon as possible as I believe I have seen enough of this little elephant anyway" (*Letters,* 5 July 1851). The sentiment here seems earnest, and yet, only a few months later we read that, "there is a chance of my making something yet" (*Letters,* 13 January 1852). And, so it goes, back and forth, and we can only imagine the strain on the recipient of the letters. We hear less and less about actual doings and diggings, and increasingly Wilson instead tells of boredom, of waiting for rains, of loss and homesickness,

and towards the end of the series letters will often end with phrases like "know of nothing to write to interest you," "I have no news to write" (*Letters,* 10 December 1854; 10 February 1855; 20 April 1855). As mentioned initially, the very last letter to Rachel is brief, and ends on a note of hollow reassurance: "Know of nothing to interest you my love to you all all all all am in good health and will be home just as soon as I possibly can" (*Letters,* 20 April 1855).

We could spend more time on the content of the letter series and on what and not least how they communicate. Let us however conclude for now by noticing that, unfortunately, and so far, Wilson fits all too well into what Scott Sandage in his *Born Losers: A History of Failure in America* describes as "the go-ahead system:" "A man with 'nothing in prospect' blew the chance to speculate on the future, to bet on himself" (Sandage 2006, 88). The wavering between the desire to return to the "old" country and the pull of the next promise in the new is fueled by ever more and receding promises of prospect. Wilson's letters are in many ways brimming with the urge to speculate in that unstoppable chase of what Thoreau called "life on the stretch" (ibid., 5). The region he crisscrosses is crawling with participants just like himself, and when we see with him, when we follow Van Alphen's "register of the thinking eye," we are also allowed into this unique perspective.

The more pressing concern in relation to how the letter series performs on site and the connection that this has to the tradition of chorography, however, lies elsewhere. In the remains of the chapter we shall turn our attention to what is *not* being said, what is *not* being communicated or identified, for David Wilson's pages and his depiction of the places he traverses resound with silences, erasures, and absences. To introduce this theme, I want to turn to an observation the German artist Gerhard Richter makes about, precisely, what is not:

> It makes no sense to expect a claim to make the invisible visible, or the unknown known or the unthinkable thinkable. We can draw conclusions about the invisible; we can postulate its existence with relative certainty. But all we can represent is an analogy, which stands for the invisible but is it not.
>
> RICHTER 2009, 14

And so, we cannot with any kind of certainty assess the nature of the story Wilson's letter series is *not* telling. We can make any number of more or less qualified guesses but at the end of the day what is rendered invisible is beyond our reach. What is available to us is the letter series and the story told therein. They are made public by virtue of their storage in a library, and as manuscript they invite interpretations within a definable spatiality. I need to emphasize

that while it may well be possible, and probably *is* possible, to trace and locate Wilson's path beyond the final letter via local histories and genealogy sites, this is not the primary interest of this chapter's sojourn. I am interested here in the kind of site-seeing and performativity that the letters *as they exist* in the box in the Bancroft have to offer. Richter's observation above, that in relation to the problem of invisibility, unknowability, and the unthinkable, "all we can represent is an analogy, which stands for the invisible but is it not," thus invites a curious challenge in relation to the letter series and what they perform on that "site." Our inferences about what lies beyond the writing on the pages have to be made based in a sense of ratio, a kind of correspondence between what we are allowed to see and hear and what we are not, a guessing at the only potentially there.

There is consequently a doubled chorographic impulse at work: the letter writer himself recording what he sees and perceives, and our trying to make sense, years later, of what exactly that is, and what it is not. At stake, then, is very much the presence of what is excluded, and the figure of the invisible thus suffuses the site in several crucial ways. If Chinese Camp came to stand before us as a symbol of incompletion and exclusion ferried in the trope of suspension, then the site-seeing that this letter series undertakes provides us with a glimpse into the very processes that created that symbol in the first place. In terms of spatial practices there are moreover several connections between the letters and the sojourns and excavations in the previous chapter, one being that Chinese Camp is in fact mentioned in Wilson itinerary, albeit in passing. A crucial *dis*-connect is, however, the angle of reflection, and if our perspective as audience was previously steered by the figure of suspension, it is here dominated by that of the absolutely absent in its various indexes.

Instances of the presence of absence furthermore invite a multilayered reading always circling, as we shall see, the *potentially* there. The letters come before us in a flash of illumination of someone's existence, a partial and sudden presence, but it is precisely what is made visible and present to us in that flash that makes what is *not* the more pressing; as Vivian Sobchack comments on Merleau-Ponty's example with the backside of the lamp: "The back of the lamp is not absent. Rather, it is invisible. It exists in vision as that which cannot be presently seen but is yet available for seeing presently. It exists in vision as an excess of visibility" (Sobchack 1992, 292). It is this kind of excess, a mere promise of possible excavation, that throughout the letters forms the figure of the invisible, the result of an epistemic chiaroscuro, whereby what is in the dark persistently glimmers with its potential for presence and recognition. The letters are thus emblematic of a historical happenstance and a kind of aesthetics of chance, coming to us as a momentary flicker of light

84 CHAPTER 3

into the relative opacity of the many unknown participants in the very known
Gold Rush.

To understand the gestalting of the figure of the invisible in Wilson's letters
and the way it bears on the region he creates for us, it is helpful to look to the
arts. In 2016 the Van Eyck Akademie hosted an exhibit titled "The Materiality
of the Invisible," which brought archeology and art together. Its objective was
to engage with such themes as residues, landscape, disappearance, monumen-
talization etc. as they are refracted in contemporary art. The description reads
as follows:

> Everything is temporary and disappears under the surface into the sedi-
> ments of passing time. These layers play with our imagination as we at-
> tempt to lay them bare with varying methodologies such as psychoanal-
> ysis, archaeology, geology, forensics, history and art. What we dig up we
> assign a place in our every growing archives, museums, collections, publi-
> cations, displays, reports and digital files. Within these dizzying sedimen-
> tary systems exists what we could term the 'materiality of the invisible.'
> VAN EYCK 2017

The description brings together the kind of archeological perspective that
we explored in the discussion of Chavez Ravine in Chapter 1 and our present
concern with the aesthetics of the excavationary and sedimented. It bears re-
peating here what Pearson and Shanks say about archeology, that it can be
considered as "a contemporary practice which works on and with the traces of
the past [...] in order to create something – a meaning, a narrative an image –
which stands for the past in the present" (Pearson and Shanks, 11). To read the
160 years old yellowed papers is not entirely unlike such archeological excava-
tion, a sifting through the traces of a presence in a specific time and place of
the long-ago. The letters are archived, but to my knowledge no one has paid the
kind of attention to them that this chapter does, and they thus exist precisely
within what the Van Eyck description calls sedimentary systems. They illus-
trate what is passed by, overlooked, not seen, but they continue to hold their
past in their moment of creation. It is this moment that comes to us when we
assume an aesthetic attitude toward the letters, allowing them status as a per-
formance bounded by the site they transpire from.

A concrete example of the aesthetics of seeing that we can follow in Wil-
son's traversals is a crudely drawn map he made himself and included in a let-
ter from the summer of 1850. The exact date cannot be deciphered, and the
name of the addressee is missing. It is most likely written to his brother Bill,
since it is signed without the customary promise of the return home and "my

THE TIME OF HOPE: LETTERS FROM A 49ER EVERYMAN 85

love to you all all all" which always conclude the letters to Rachel. The brief note that accompanies the map states that it "is made altogether by guess and intended to show [...] on which side and into which river the creeks empty" (*Letters,* 1850). It is an interesting, if plain representation of Wilson's visualization of the region, spatialized not so much according to actual cartographical coordinates as to perceived locations and their relative importance as he sees it. Four rivers dominate the map, the Joaquin, Stanislaus, Tuolumne and Merced River (called Mercedes on the map). From each of the former three Wilson has marked and named the tributary creeks with numbered names of camps placed carefully at the end of each. Some of the names are known to us, such as Campo Sonora, Chinese Diggins (before it became Chinese Camp), but most are unfamiliar. And they are so for the simple reason that many of these places are gone: Don Pedro Camp and Jacksonville are both at the bottom of Don Pedro Reservoir in the Stanislaus National Forest, the former barely surviving in the reservoir name. Curtis, Yorktown, Sullivan's have faded from our view, the same is true of Paines Bar. Horse Shoe Bend (what Wilson often calls his "old place") rests at the bottom of Lake McClure. Most of the many creeks, Russel, Solomon, Pee, and Indian creeks have long since been folded into dams and elaborate irrigation systems. One also notices on the map two rows of place names, clearly signaling different categories. The ones on the right side are all locations lined up along what is today Tuolumne River, and marked in more elaborate letters, which perhaps signals that to Wilson they were set off according to a sense of status and function – maybe as hosts to a bank or post office. The other row makes use of numbers, and the names seem more hastily jotted down, although here dwellings are marked off, and the system of rivers and creeks very meticulously drawn.

Consider for a moment the Van Eyck-description of the materiality of the invisible: "Everything is temporary and disappears under the surface into the sediments of passing time. [...] Within these dizzying sedimentary systems exists what we could term the 'materiality of the invisible.'" Wilson's map concretizes the fleeting nature of manmade things, showing what once was, but is now overlayered or erased. Of course, we are still dealing with Sobchack's "backside of the lamp," invisibility rather than absence, for, as any palimpsest will confirm, complete erasure is rarely obtainable. In theory you could dive to the bottom of Lake McClure and probably find residues, traces of Horse Shoe Bend. In some cases, adhering to the paradoxical principle of any palimpsest as preserving what is supposed to be erased, making present what is supposed to be absent, what has been rendered invisible becomes visible, and the trace resurfaces and reclaims. This happened as a result of the 2014 California drought, when a mine near Jacksonville established in 1849 appeared out of the Don

Pedro Reservoir, a ghostly presence indeed. In anticipation of more structures appearing from underneath the water, Jeff Jardine wrote in a personal memory from the area that "with the lake levels dropping, the foundations of old mining operations, stores and houses could offer a glimpse into the past. They've been underwater a long, long time – really underwater – with history and heritage being included in the mortgage" (Jardine 2014).

What is, however, more intriguing about Wilson's map is, again, what it leaves out, all that resides in obscurity beyond his purview. Sobchack reflects:

> what is taken up as seen by the act of seeing is taken from what will remain unseen; the invisible thus provides the grounds for the visible, and is not only a condition but also a content of the act of seeing. The invisible is as much a term of vision as is the visible. Seeing is therefore a structuring action which is structured.
>
> SOBCHACK 1992, 86

Wilson explicitly tells the recipient of the map what he wants to show, namely the waterway system in this part of the Mother Lode. We already have a good sense from reading the letters the extent to which water would orchestrate every single aspect of the miner's every day. In many of his reports home Wilson can be heard frustrated and sometimes despondent that they have to wait for the rains in order to begin work, or wait for rivers to get lower; either way the question of water in some capacity tends to stop the projects he and his fellow miners are supposed to be embarking on. No wonder, then, that rivers and creeks dominate the visual of the map; this is the customized representation of the area in a "structuring action" guided by Wilson's personal and embodied sense of places, distances, and directions. What he saw is completely subject to the pursuit, to life on the stretch: Here is a landscape wholly reduced to its service in the mapmaker's search for gold.

And like most '49-ers Wilson was looking for placer gold, gold that has been deposited in water and can be extracted by sifting through the sand and gravel on the banks of creeks and rivers. His mapping of the area consequently takes no notice of other features than what serves that very purpose; what we see is what this one perspective wants us to see, a landscape reduced to a receptacle. The map consequently works as an eerie analogy for all that is rendered invisible and overshadowed by conceptions of progress in this history of the West: Native Americans first and foremost, then Mexicans and Chinese, forests, the sequoias, the mountains, the spectacular flora and fauna; none exist in the flattened space that stretches out before the golden dream. When Wilson does mention or tell about any of this, it is predominantly in relation to

their role as obstacles. The Native Americans are mentioned here and there, mostly in connection with conflicts and wars that are getting in the way of prospecting: "Several companies are organizing and expect to start after [the Indians]. Savage is out with 200 men reports say he has about 7000 blockaded in a valley near the head of the San Joaquin and is now in at Burns diggings after more men and provisions" (*Letters*, 6 Jan 1851). This observation could well be a reference to what became known as the Mariposa Battalion, and (James) Savage the famous major who befriended several tribes and served as mediator and employer of Native American labor before the greed for more land and "diggins" subsumed all prior Native rights and claims to land. It is furthermore quite possible that the "valley" is Yosemite Valley, which Savage is credited with "discovering." None of the political and social complexity of the goings on around Wilson is part of the letters, however, which again turns the filling in on part of the reader into such a particular performance on the site the letters present to us.

They bring to partial light fragments of the history of the rush for gold, and we see as Wilson sees, and only partly lit as a historical subject. In an unpublished draft, Chiara Brambilla and Holger Pötzsch have suggested that, if "visuality can be thought of as a social fact with its historical techniques and discursive determinations, as a set of scopic regimes," then "invisuality refers to what is unworthy of being seen, not recognized" (Brambilla and Pötzsch 2012, 6). The term invisual can thus be understood, as Pötzsch suggests elsewhere, "as a cultural frame that hides certain subjectivities and/or lives" (2017). In relation to the landscape on the map we here have before us, it is precisely such hiding that comes to administer value: from within Wilson's regime of recognition, all but the profit of pursuit can be dropped. The "scene's" relation to the figuration of the invisible consequently takes on a more pressing, analogical function, for its motif as well as motivation cannot be disentangled from a scopic regime that by its insistence on inherent alterity erases all that does not fall within the fold of its particular purview.

The figure of the invisible in the narrative flash that the letter series presents to us is consequently marked negatively, a trace absolutely defining of Wilson's being in history. If the trace in Casey's understanding and which we considered in relation to Chinese Camp "consists in a self-surpassing operation whereby its meaning or value *lies elsewhere*" (Casey 1988, 241), this also fits well with the story we are able to extract from Wilson's letters. The fragmented record of pursuit, the gradual accumulation of absences, pauses, gaps and the withheld, all denote the deferment of its own being. Nested in the sedimentary systems of an "invisual" history, the letters sidestep their immediate claims and instead make the more visible what they do *not* tell, or what they *could* have

told. And it is precisely what is made visible and present to us in that flash that makes what is not the more pressing. We are here reminded of another observation Sobchack's makes, namely that, "the invisible provides the grounds for the visible and is not only a condition but also a content of the act of seeing" (Sobchack 1992, 86). The promise of the letters is consequently their beckoning to the potentially otherwise; however, its materialization only amounts to that, a promise deferred.

When I look at Wilson's map, I am looking at a worldview distilled, a draft that carries its own, bared realism. It is also a trace in a different understanding than Casey's formulation of self-suspension. Unlike the photograph, which, as Pearson and Shanks note, "provides certainty about that instant, details and texture" (Pearson and Shanks 2001, 43), the hand-drawn map expresses the presencing of a different temporality altogether, the uncertainty and doubt of the hand's memorization of the site, the corrections that accompany the line in the moment of its making. Like the archeological find, the hand-drawn map needs "flashbacks, long-term backgrounds, reflexive interpretations of past events" (ibid.) to make sense of it, and not entirely unlike archeology, both letters and map surface from underneath the sedimentations of time. The present reading of the map (and letters) may thus resemble what Pearson and Shanks call an "archeological poetics," which can be described in terms of the temporality of the trace, "a condition of an archeological method of assemblage, a rigorous attention to things, to the empirical in making connections, following the traces" (Pearson and Shanks 2001, 43). Thus, as with other kinds of traces, including the self-surpassing ones, we may well ask with Pearson: "In these traces, can we discern the movements, moments and encounters involved in their making, a forensics of the everyday: maps of practices and behaviours?" (Pearson 2006, 41). I think we can.

The reader may think I allow Wilson's crude map too much significance, but there is a point here, and to deepen that just a little further I want to return to Sofer's idea of "spectral reading," briefly touched on also in relation to Chinese Camp. Spectral reading, Sofer says, "traces the effects of those invisible forces at work in the world of the performance or play, such as characters who never appear, events that take place offstage, noises off, the narrated past, onstage hallucination, or any related phenomena" (Sofer 2013, 5). His interest lies with theatrical performance and the power and pull of what lies off stage, but can we not see this map, too, as a similar kind of performance? It certainly stages, as I indicated above, a kind of worldview, seeking to demonstrate for its "audience" a specific projection of this one place in a certain time period. The kind of spectrality on stage that Sofer discusses can thus be meaningfully transposed onto our present context in order to see more clearly what surfaces

in the linking and meeting between narrative, symbolism and concrete place. The connection loops around to the close relation between performance and archeology, and in turn to the very similar relation that exists between site-specificity and cultural history. All of this is equally meaningful to our appreciation of Wilson's letters generally and the image of the map specifically. The map, as both a "find" and a trace, performs for us a dramatization of historical background and cultural presence, and in this particular performance what is offstage – spectral, what is invisible, is key to Wilson's "presencing" of creeks and dwellings in the service of pursuit and progress. The map's spatialization of presence does not make sense without the awareness of what it leaves out; what is visible cannot be grasped beyond the "dark matter" whose "effects are felt everywhere in performance" (Sofer 2013, 3). The invisuality of the unseen, natural world, is consequently what occasions the possibility of Wilson's over-writing index, the reading and interpretation of which bring us back to Richter: "[...] all we can represent is an analogy, which stands for the invisible but is it not." In its cartographical seeing, the figure of the invisible develops on the map as the very thing which, like dark matter itself, holds it together. Faded and brittle, the letters illustrate this particular function of figuration in several ways, and always circling the *otherness* of the invisible as premised on a "potentially there." For, like otherness, invisibility cannot be absolute; if it is, as Derek Attridge says about otherness, it cannot be apprehended at all – "there is, effectively, no such thing" (Attridge 2004, 30). Otherness relies on relationality, other than or other to, trailing the potential for recognition. What is invisible is similarly predicated on relationality: it insists on its presence through its suspended being, what Sobchack above calls the availability "for seeing presently."

This aspect of site-specificity, the insertion into the performance of otherness, can interestingly be delineated along the lines of something Pearson says when he describes chorography in William Cambden's foundational work *Britannia*, originally published in 1588. He observes that,

> [Chorographies] 'collected and arranged natural, historical and antiquarian information topographically' [Mayhew 2000: 240] in region place by place, village by village, without necessarily relating it to larger spatial frames. [...] [the chorography] serves to identify and differentiate sites of significance as places to visit. In so doing it disattends, ignores or chooses not to recognize other places that fall outside its sphere of interest.
>
> PEARSON 2006, 9

Wilson, neither geographer nor writer, of course did not systematically set out to undertake anything like what Cambden did. But they nevertheless share

in common what Pearson here describes as the selective gaze intrinsic to the project of writing place. Wilson's letters carry a predisposition that is a mix of subjectively and collectively accumulated mechanisms, and the oscillation between the disattending to and choice of focus trail both. His spatialization of the region is consequently not unlike Nicoloni's cataloguing and curating of Chinese Camp; both are steered by scopic invisuality.

The map moreover combines into its site-seeing the concrete depiction of what to the letter writer is the most pressing concerns, namely waterways, but if the reader-audience takes an aesthetic attitude towards them we see them as more than that. They come to resonate with Fluck's comment that: "[T]the new perspective on the object can only be experienced in its various possibilities of revelation, criticism, intensification of experience or pleasure as long as the reference is kept in view" (Fluck 2005, 29). The observation is every bit as significant when we now turn to another aspect of the letters that in terms of aesthetic attitude and function assume a perhaps even more weighty impact on our reading and seeing. To introduce this second approach, also a visualization of what Mukarovsky calls "wrong movements," I would like to quote from one of the more detailed accounts Wilson gives of the energy prospecting and speculation produces around him. Throughout are references to the masses that descend on the region, and if in the beginning, as we saw, Wilson is confident that it can accommodate thousands more, it becomes clear already a year after his arrival that the land and the region are being overrun, the mines depleted.[2] A disposition instead toward the next, the better, the richer comes through in a detailed description of the emergence of towns in a letter Wilson writes from Curtisville in June of 1854. I quote it at some length because the "sketch of Algerine [that will give the mother] an idea of how things are done out here" reveals in no uncertain terms the energy that brought to California the many places that would soon after be abandoned:

> the first of April 53 a few holes were sunk on a flat which paid well coarse gold one piece weighing over five lbs which created great excitement the minders rushed in and found a large tract of country scarcely prospected and but little water though a ditch nearly finished to the place to be [illegible] from the Tuolumne they all concluded that it was going to pay rich and staked off their claims and concluded to wait for water which was expected in a few weeks but did not get in till fall by which time we had a

2 In this context it is interesting that one reason why Chinese Camp could stay Chinese in the same period Wilson was trekking the area was that scarcity of water discouraged most of the American miners.

THE TIME OF HOPE: LETTERS FROM A 49ER EVERYMAN 91

> town of a hundred or more house mostly good frames with planed fronts and neatly finished inside we had Gambling Saloons, Hotels, Boarding-houses, Ballrooms, Billiard Rooms, [illegible] Alleys. Barbershops, Fandangoes, Bakeries, Blacksmiths, Carpenters shops, groceries, [illegible], Restaurants, Butchers, Livery Stables and a stage twice a day from Sonora Jamestown and other places but in a month after the water got in the town was going down the miners and merchants leaving and now the place is almost deserted [...] Algerine is one of the has beens and nothing else.
>
> *Letters*, 22 June 1854

The description is of a will to prosper and develop that tears out of nowhere and nothing an entire town, only to leave it behind just as quickly. It thus analogizes similar stories across the region, and also rings with the underpinnings of an economy built mostly on expectations and little else. It is at the same time fueled by an imaginary of the possible and the potentially there that seeks to institute itself from what is purely imagined to something more than that. Today Algerine exists in the name of a road, and its brief existence illustrates Stegner's point about the West and its (lack of) places, how "many western towns never lasted a single human lifetime" (Stegner 1986, 5). Wilson's vivid description of the rise and fall of Algerine tells of a span much, much less than a lifetime, and Stegner's further point that "cumulative association" is missing from the "raw, migrant West" is well taken. And yet, and yet. Wilson's letters as they speak of this rawness invites a revision of our viewing of the fleeting and precarious time and place in California into an impression of elusive permanence. This is a key element of site-specific performance in general, and, I will suggest, also of the kind of excavationary, re-routing of site that Wilson's letters invite if we read and see them aesthetically. Nowhere is this more compellingly brought out than in the several crosshatched letters in the series. If erasures and blind spots are everywhere in Wilson's story, this is most acutely felt concretely and visually on the pages. This brings us back to the central role that the figure of the invisible plays. In the crosshatched letters it now comes to us, to borrow Attridge's description of otherness, "as a version of the familiar, strangely lit, self-distanced" (Attridge 2004, 76).

Crosshatching, or cross writing, was common in letter writing in Wilson's days, and the practice served a very concrete purpose. Postage was expensive, and paper often scarce. Writing vertically as well as horizontally on one page doubled the space one had and cost the same to send. People were accustomed to the exercise of reading these pages, which to most today is a challenge. When I look at Wilson's cross hatched pages, I see the words, I can make them out for

a short while, but as I follow the horizontal lines as they are being crossed and overwritten by vertical ones, the line I focus on sort of trails off into a zig-zagging web. It is frustrating. The pages vibrate intensely with the activity of writing, but to the untrained eye they amount to a very noisy withholding of full meaning. However, if I stay with the point above, that the pages can also be seen aesthetically, then the noise and perplexity that rise from these pages, as well as my lacking full comprehension, can be made sense of. Let us therefore retain the idea of the image that the cross hatching makes, as simply that, an image. If we assume an aesthetic attitude towards it, we "regard it as a form of representation that has the freedom to redefine and transform reality or even to invent it anew," and different images may now come to life (Fluck 2005, 26). From this perspective the pages' figuration deepen the symbolic impact of the map's spatialization, and, more crucially, take on the role of a powerful symbol for the time and place of their crafting. Viewed freely, the visual image of these letters *as* image resembles a kind of tapestry with intricate crisscross patterns, uneven, asymmetrical in places, broken up by irregularities, opaque in plac-es. And *as* image, the crosshatched letters now work as Richter's analogy, they stand for the invisible but is it not. This is not simply a matter of representa-tion, it is an ontological question, a backside of the lamp–question: invisibil-ity exists only in its potential for visibility, and the crosshatched and partly illegible pages represent the materiality of the invisible *because* they hover on the border of legibility with the potential for clarity; for, as Sobchack puts it, "seeing presently."

And so, as image, these jumbled pages can be seen to visualize history's oversights, the unattended to, moments of possibilities and impossibilities, the irretrievable and unaccounted for, the what if's. The hasty scuttle across the frail, yellowed sheets of paper, the words going hither and thither on the page; is this not just a visual emulation and enactment of the rush Wilson and thousands of others like him were part of, a race that he may or may not have completed? Could it not in fact be made to speak to that bold pronouncement Marx and Engels made about California at the very same time, a continent and an ocean away, that it was "visibly transformed into a rich, civilized land thickly populated by men of all races, from the Yankee to the Chinese, from the Negro to the Indian and Malay, from the Creole and Mestizo to the European?" (Marx and Engels 1850). The words energizing their further description – "thickly," "spur," "activity," "plunged," "created," – are all descriptions of energy, drive and purpose. The two, as mentioned in earlier pages, were quick to detect the sig-nificance of the Gold Rush and the role California would come to play globally, even if the full extent of their judgement would elude most people for many years to come. They also recognized, implicitly, the frenzy that followed from

the discovery of gold, leaving in its wake a cruelly tangled maze of hopes and disappointments, transgressions and loss. There is a slightly odd, optimistic certainty in their prediction about the future of California, which also applies to Wilson's letter series as a whole. In his vision this is, however, countered by an observation he makes in a letter from June of 1954, where he describes dire diggings and wondering if he, like many others around him, should perhaps also leave "Old Cal" and go to Australia or the Charlotte Islands, where "the diggings are reported richer" (*Letters*, 8 June 1954). That California already in 1854 has taken on the hue of "Old" speaks volumes of the drive for immediate success and the impatience that energizes the quest. This is also the character of Wilson's own excitement, all brought into the visualizing space of the letter pages.

The crosshatching thus captures an imaginary informed by an all-consuming futurity of perpetual progress but one that complexly only rests on the potentially there. Uneasily nested between recognition and erasure in the crossing lines on the page, what we see is really only what is evoked – the rest is speculation. In this sense the pages come to symbolize the time and place of its own writing, a space only rarely moving beyond the speculative, and only in a few cases giving rise to the figures that anticipate poor Willy Loman's successful brother Ben: "When I was seventeen I walked into the jungle. When I was twenty-one I walked out. And by God, I was rich!" (Miller 1983 [1949], 41). As far as we can tell from his letters, Wilson was not one of these figures, and in one of the very last entries, having watched an Englishman strike a lead, he adds the following phrase, underlined for emphasis: "my turn next maybe" (*Letters*, 12 April 1855). Within the span of the letters there is, however, no reason to think his turn came, and the story they tell comes to an end on a note of the promise to come home soon.

It is quite possible that everything went very well, that he struck a rich vein, that he set up a business that succeeded, that he did return to his mother and the farm; this, however, is not the point of the particular site-seeing we are here engaged in. The focus here is on the letters and their narrative as a site in a performative understanding. It bears reminding before I continue to the final aspect of the letters' performance on site, that aesthetic function opens for "the capacity of any system of signification to draw attention to itself as a form of expression and to refer to itself as a sign, thus foregrounding the organizing and patterning principles by which the object is constituted" (Fluck 2005, 29). This last phrase resonates powerfully with the larger context for what can be said to hold the letter series in place, namely the very genre itself of letters, and at the core of this, the fact of the unseen, but not unheard interlocutor.

94 CHAPTER 3

The first line in several of Wilson's letters to his mother reads, "Excuse me for not having written sooner" (For instance, *Letters,* 2 October 1851; 13 January 1852; 8 June 1852). Hers is a haunting presence, and even as Wilson in the penultimate letter states that he "will not mention time again, but will come as soon as can make arrangements" (*Letters,* 12 April 1855), he just cannot seem to stop himself from promising to return again in the final one. Rachel is a character offstage, invisible, but she "bends" (Sofer 2013, 5) her son's discourse to intensify the dialogization of his word and becomes in the course of the series a familiar, if unseen presence. This reaches however further than a discursive pattern of indexical signs, of action and reaction between addresser and addressee; like dark matter, Rachel's is a presence woven "into the fabric of theatrical representation itself" (ibid.) to materialize on stage as a muted tenor absolutely determining for the letters' content and structure. It surfaces from the obscurity of what lies beyond the letters themselves and demand a presence in descriptions always one step removed, an analogous potentially there. As we read on, however, their contours become more intensely felt, illustrating what Sofer calls the paradox of dark matter, "that something hidden is disclosed even as it eludes our sight" (Sofer 2013, 145). Rachel's off-stage presence consequently comes to resemble what he in relation to theatre performance and staging calls the "'not there' yet 'not not there'" (Sofer 2013, 4), and it is that very ambiguity of manifestation that transpires in her son's words as figurations now of deferral.

Like in all letter writing, of course, there is, and there must be a dialogization of the word whereby the response we hear comes inflected by the very fact of the addressee. Rachel's word "bends" Wilson's word, and in his discourse about himself and his world his own word directs itself toward her presence. If the figure that has dominated Wilson's chorography and our seeing of the site he presents to us has been cloaked in the figure of the invisible, there is another figure that surfaces in the dialogue with the addressee which is of a different kind. Rachel's worries and hopes travel across the continent and surge like waves in the son's repeated: "Will be home as soon as I can." We do not know much about her, except that she suffers from bad health in 1850–51, that she may have to sell or lease out parts of the farm back in Maryland, that she ceaselessly hopes for her son's return, and that as ceaselessly she sees those hopes let down. Already in 1852 we begin to detect an intensifying in the son's promise, and correspondingly so in its abandon: "Excuse me for not writing sooner but as I was obliged to stay over the time I promised to be home and was uncertain when I could leave did not write and now will not make any more promises about coming home but will do as soon as *I possibly can*" (*Letters,* 13 Jan 1852). Then there is a pause of about a year in the exchange and

THE TIME OF HOPE: LETTERS FROM A 49ER EVERYMAN 95

the next letter is written only in March 1954, when Wilson writes that "Mother I never expected to stay away so long." The letter that follows this looks back at a promise of return:

> About a year ago last Jan I left the mines with the intention of going home or possibly to Australia arrived safely in San Francisco but unfortunately met an old Compenero who was just going into a speculation and wished me to join him as he had not quite capital enough to carry it on as he wished and as I felt certain it would pay and that would not keep me but a few months longer consented to join him but as usual in a short time found we had made a slight mistake in our calculations that all our capital was gone and we in debt so I vamoosed to the mines again with the intention of making a few hun dols and coming home.
>
> *Letters,* 25 April 1954

The incident Wilson here reports of fits into a pattern, as I touched on above, of bad luck and bad decisions, and accounts for the not infrequent remarks we find in the letters of how he will never be able to make it, and of his low spirits. In September this sentiment finds expression in the exasperated line: "Well dear Mother about coming home I am really tired of this life and if I can possibly make arrangements to, will come next spring" (*Letters,* 20 September 1854). He does not, because the dry weather brings about little diggings – "it is impossible to make anything without water" (*Letters,* 7 December 1854). I will not include here all the references in the letters that speak to the same sentiment; suffice it to say that the oscillation between intention and its frustrations is pervasive throughout. When the final letter concludes with, "will be home as soon as I possibly can," the figure of deferral leaves the performance of the letter series in a state of pause.

The effect of this figure is first and foremost, and concretely on the pages manifest in relation to a mother's longing, a beckoning to a son who appears lost in a quest that increasingly seems to lead nowhere. The relation and exchange between home and away, between old and young, old and new, is thus not unique, and finds its place among countless others just like it. Wilson consistently refers to people he meets as foreigners, and does not seem to significantly differentiate between for instance "Chillyans" and "Yankees" (e.g. *Letters,* 19 June 1849); they are equally foreign and removed. He is indeed in a "distant land" and his encounter with the unfamiliar surroundings brings out a discourse on par with any immigrant to a foreign country in a figuration that spatializes distances in real as well as perceived ways. The act of writing itself, as Pearson reflects, can also function as an itinerary in and of itself, and the

96 CHAPTER 3

description below may help see the underlying dynamic that produces figuration in Wilson's letters:

> as we write, a text forms and is frozen. Inevitably with nothing to guide us, it travels horizontally from left to right (though not perhaps if we are Japanese or Iranian or …), top to bottom, obliging the reader to follow our tracks in the same way we made them. First nothing, then a few signs which orientate us, and those who follow us, a rudimentary map. So writing plots a journey. But it is discontinuous, riddled with blanks, pauses, spaces over which we jump because we know the direction.
>
> PEARSON 2001, 132

Pearson's comment poignantly fits the spatial site Wilson letters creates. Our journeying with him through the region and its landscapes comes trailing all of the above, and the spatialization that his chorography charts becomes our way of seeing and perceiving.

The historical, aesthetic, and epistemic invisibilities in the letter series are so pervasive as to at times threaten to overtake what in fact *is* visible. The patchy history cloaked in the letter writer's defeat and disappointment, the spatial orientation according to places that are no more, the noisy crosshatchings whose meanings are muted, the absent interlocutor, they all impress on the reader a suspended presence. What we have before us therefore can now be more finely conceived as a "there-ness" flickering in strange lights. Assuming an aesthetic attitude toward their performance on site, and as a site in and of themselves, perhaps also enable us to understand better what that "there-ness" carries. Aestheticization more specifically returns us again to what Pearson calls "archeological poetics" (Pearson 2001, 43), and central to *its* work is the temporality of the trace. In relation to the particular figurations that imprint on the letter series, temporality here assumes a poignant quality of the kind of neglection and oversight that our histories abound with. When Fluck talks about "the organizing and patterning principles by which the object is constituted," this can now be revisited more meaningfully and concretely in relation to figuration in Wilson's letters. Invisibility and deferral are precisely what constitute them as aesthetic object, and they become available to our appreciation through an approach that treats the series as chorography and site seeing. It is worthwhile to bring the epigraph back in this context, where Genette offers a description of the figure: "between what the poet has *written* and what he *thought*, there is a gap, a space, and like all space, it possesses a form. This form is called *figure*" (Genette 1982, 47). One does not have to be a poet for figuration to transpire; any discourse can produce what we perceive as the gap that Genette here talks

about. It is a space that gives away the indeterminate, the distance between intention and volition, between the present-ness of being and its delay.

The figuration of invisibility and deferral furthermore speaks to how we generally understand the world around us, one that invariably goes through precisely figuration, or tropology. This is what Hayden White refers to when he speaks of

> rendering the unfamiliar, or the 'uncanny' in Freud's sense of that term, familiar; of removing it from the domain of things felt to be 'exotic' and unclassified into one or another domain of experience encoded adequately enough to be felt to be humanly useful, non-threatening, or simply known by association. This process of understanding can only be tropological in nature, for what is involved in the rendering of the unfamiliar is a troping that is generally figurative.
>
> WHITE 1978, 5

This is not to say that what White here calls troping is a conscious act of representation, far from it. Figures transpire in the between, in the spaces that open up between referentiality and the imaginary that it invokes and is at the same time a part of. Wilson's address to Rachel, cloaked in figurations of invisibility and deferral is therefore a way to apprehend the larger context that the letters are but a small part of. Against the more classical descriptions of the promise of the future associated with California generally and the Gold Rush specifically, here is a version that perhaps more earnestly speaks of the uncertainties of that very promise. In order to convey and stay true to what it sees on the site it traverses, the rendering of the unfamiliar the letter series engages in thus adopts a tropology in kind. They can be seen as entering into a larger conversation, as a comment on the aesthetics of chance and historical happenstance. We grasp the story of the site, not in a factually oriented historical trajectory, but in a recognition and embrace of what does not get told. History swarms with invisibilities and deferrals, but they are rarely absent and forever inconclusive. "Every meaning shall have its homecoming festival," Bakhtin says (Bakhtin 1986, 170), and while Wilson's story will not be brought to any conclusive end in my exploration of it here, this is only in line with the capacity of site-specific performance for transforming space and allowing stories their repeatability in variance. The letters finally in and of themselves alert us to the concreteness in time and place of embodied experience and perception, of perspectives which, however fleetingly, can tell us something about the space they speak to and from. And, perhaps precisely because the stories in Wilson's letters are not the triumphant tales of success and conquest, they also resonate across time more recognizably, and genuinely.

CHAPTER 4

The Time of Desire: The Winchester House

> In these traces, can we discern the movements, moments, and encounters involved in their making, a forensic of the everyday; maps of practices and behaviors?
>
> MIKE PEARSON 2006, 41

∴

None of the primary sites in the chapters so far can be considered typical tourist destinations and points of sight-seeing. Granted, Chinese Camp gets the odd visitors interested in its semi-ghostliness, and Dodger Stadium of course has many a visitor who also sees it as an aesthetic object, not only a ballpark with all the accompanying functions. Those locations have in common that they activate their audience into an interpretation of the stories they tell and the performances they show us on the sites they inhabit. In doing so, they also have, and we see this in all the chapters, the potential to change our conceptions of the histories they emerge out from. They remind us that, as Dean Mac-Cannell points out, "[a]s city and country transform themselves into 'destinations,' we should not forget they once were the bedrock of social theory, not as destinations but as localities – places where different human types lived and worked" (MacCannell 2011, 83). As can generally be said of any region, such materialization of place in the region of California, too, is difficult to disentangle from patterns of difference and variation. Confrontations with otherness and the complex of convergence and divergence we looked at in the Introduction is worth bringing back just briefly here. As we recall, Doreen Massey posits place and space in a relation where the former describes "the sphere of the everyday, or real and valued practices," or as "closed, coherent, integrated as authentic, as 'home', a secure retreat" (Massey 2005, 5–6). Her conception of space is at the other end of this spectrum, namely as "the product of interrelations; as constituted through interactions" (ibid., 10). As mentioned, too, Massey and Casey are close in their take on the relation between space and place, but for Casey "a place without relation to any other place, without imbrication in a region" (Casey 2001, 690) is practically an impossible notion. Region thus provides the coordinates for how the spatial as the name for inter-relations directs place

© KONINKLIJKE BRILL NV, LEIDEN, 2021 | DOI:10.1163/9789004438002_006

THE TIME OF DESIRE: THE WINCHESTER HOUSE 99

into position and manifesting into clearly bounded sited-ness. Such actualization of place as site is consequently inseparable from its citation, the site always *cites*. Its arrangement, or posture is activated by, as the etymon *citāre* suggests, a summoning, the setting in motion and exciting (*OED*), and thus site receives its import from the energies that prompt or trigger it into existence as such. This conception of the emergence of place moreover fits quite well with the history of California following the time of the Gold Rush. As Kevin Starr puts it, "If there is such a thing as DNA codes for states – and there may very well be! – then crucial to the sociogenetic heritage of California would be ethnic diversity" (Starr 2005, 305). He also goes on to emphasize that this diversity is far from peaceful, and like Spanish California, "American California [was] founded on racial distinctions and repressions [...]" (ibid., 306). We shall not here repeat the long list of violence and aggressions that trail the coming into being of the region, but it would not be unreasonable to say that the fragmentation of a sense of cultural cohesion remains a problem for the promise of the golden dream.

The state's transformation into a hub for the world markets that Marx and Engels prophesized in 1850 called out to dreamers and entrepreneurs of all kinds and from every corner, even if only some were allowed to participate fully in its potential. Of these, the majority would probably have a similar story to show for themselves as the one Wilson's letters tell, tales that do not make for memorials and statues, names that do not get remembered in street names, towns, or buildings. The hastily built camps and towns that parade before us in Wilson's letters, many of them since long gone, resting on the bottom of reservoirs or whispering as vague echoes in the name of a road, all fit the haste with which thousands and thousands sought to build their fortunes. However, some succeeded phenomenally, and in stark contrast to the ruins and remnants of camps and small towns are the edifices that some of the more triumphant adventurers left behind. There are not a few such structures throughout the state, and we need mention here only the Hearst Castle in San Simeon, the Carson Mansion in Eureka, the Bidwell mansion in Chico, Jack London's Wolf House in Sonoma (even if London's is another kind of story altogether). Their grounds, styles, decors and so on are different, but the structures, like most monumental constructions, share in common that they materialized as the result of their owners' dreams and visions.

They are also motivated by various impulses, sometimes opaque in their representations of momentum, and sometimes construed to provide a retreat and shelter from the very life and region they had become part of. Carson had his hyper-Victorian mansion built, not only as testimony to his own work and stature, but also, it is said, to employ and protect his workers during a bad

slump in the lumber industry. Hearst built his castle as a retreat for himself and the countless guests vying to be invited, forever mythologized in Orson Well's *Citizen Kane*. With health issues, money and career problems, London built his stone structure in an effort to, as Starr puts it, "stave off chaos" and "rebuild himself and his career" (Starr 2005, 210). Regardless of their genesis and purpose, the edifices have become emblematic of the landscapes and regions they belong to and stand before us as monuments as well as the dwellings they once were designed as. They also poignantly illustrate the creation of place that Massey discusses as "a locus of denial" (5): Closed off from their surroundings in a motion of retreat they gestalt in their very arrangement the sense of a core into which energy flows, an inward flux that strives for stability and fixation.

All of the above mansions and edifices are classic sight-seeing locations, attracting visitors by busloads and announcing each in their own way the kind of performance the audience can expect, hovering uncertainly on the edges between original purpose and subsequent connotations and use. In *The Participatory Monument: Remembrance and Forgetting as Art Practice in Public Space* visual artist and public art scholar Merete Røstad says something about the relationship between permanent and temporary artworks that bears directly on this relation between the seeing of site and sight-seeing: In her discussion of participatory monuments she says that: "Permanent and temporary artworks have one thing in common: they both reveal something about the specific location, the environment in which they are placed, as well as about the time period and reason they were originally placed there" (Røstad 2018, 53). The Hearst Castle, the Carson Mansion, the Bidwell and the Wolf House Houses can all be likened to permanent artworks in this understanding. In each case the creations emerge out of very specific circumstances, framed by the particularities of their time and place, and their owners' idiosyncratic aspirations. Røstad's comment on how such monuments reveal something about their space of origin is particularly well taken in relation to architectural constructions, always bearers, quite literally so, of contemporary ideologies of aesthetics and functional purposes. They can, however, also be conceived as monumental in a more intricate sense.

In the introductory presentation of a conference dedicated to "Monuments" in Norway in 2019, the organizers write the following:

> the word "monument" bears within it the Latin mon, from *monēre*, which means "to remind," but also means "to warn." In its descriptive form "monumental" connotes something massive or imposing, something great in importance, but also expresses a sense of excess, of being overwhelmed.

The word itself thus invites a chain of questions: What do monuments call to memory? What might they warn us against? What versions of events do they impose in presenting greatness? Who and what deserves recognition? How can monuments commemorate different or competing pasts? What should be done with monuments that uplift violent pasts?

"Monuments" 2019

As we see in the recurring and heated debates about for instance confederate monuments in the US, these are all questions of considerable urgency, and ones that I shall return to in detail in the Conclusion of this book. For now, and in the present context, I will focus on *monument's* etymology, on that Janus-faced tension of reminding and warning, and the problem of excess that this very knotted relation invites. Because the two senses encapsulate a double movement of beckoning to their audience and viewers, monuments often transcend their own moments to mean differently across temporal expanses. It is one thing to consider the mansion-monuments I just listed as examples of their own moments, to focus on the particularities of each construct, its genesis as well as purpose, and intimately connected to their owners' unique situatedness in the world of their time and place (already a webbed placeness). They remain on site as reminders of the grandeur and often narcissistic impulse their architects sought expressions for, and which continues to attract us as visitors. But, similarly to Bodie in Chapter 2, the possibility for a figure emerging from that tension between reminding and warning also carries in it the potential for an excess of signification that traverses the time between its inception and subsequent reception. In this manner and as an interpretive space of possibility it addresses the audience and invites participation. Again, and as with Bodie, we thus co-create the work that results in viewing: the concrete physical excessiveness that characterizes the structures in their encounter with their audience reach toward further excess, into which our unique perspectives may enter into new figurative speculation.

The Hearst Castle, the Carson and Bidwell Mansions are, however, not the sites we visit in this chapter, and the question of excess will be directed instead at a different mansion-monument, namely the Winchester House, or the Winchester *Mystery* House in San Jose. It is not quite as well-known as the other mansions, but every bit as extraordinary, and excessive. Once the residence of Sarah Winchester, this bizarre construction would inscribe itself into the region it inhabits just as notoriously and permanently as have the others in their surroundings. The Winchester House is announced on billboards on the interstate from miles and miles away, promising to prospective visitors, not the work of magnificence and fame as much as the ghostly and inexplicable. The

first time I visited the Winchester House and did the guided tour, I thought it was mostly just entertaining, an architectural wonder and host to a peculiar story, but little more. Like my fellow visitors, I listened to the guide go through the story of the remarkable woman and her mansion, accepting the "script" as it has been performed regularly since the House opened to the public in 1923. By now that performance has ossified into a more or less permanent form, and was up until recently advertised on the House's webpage as follows:

> Since 1923 the story of Sarah Winchester and her incredibly peculiar house has fascinated more than 12 million people from around the world who have toured its lonely hallways, dark passages and ornate rooms. Come and be intrigued by this truly American tale with its combination of the beautiful and the bizarre, its narrative of heartbreak, tenacity and invention and its flourishes of the paranormal and spirits. ("Winchester House")[1]

In its revised version on the new webpage the wording is not significantly different, but adds now to its appeal the direct address to the potential visitor: "Will you be able to unlock the mystery?" The emphasis on the spiritual and ghostly has in other words been enforced, and tourists continue to visit the 160 rooms labyrinthine structure. We enter to marvel at the curiosities of Sarah's architectural tastes, the "madness" of her creation, her eccentricity and mystery, the astonishing artistic details of her creation. While the marketing of the house leans toward the enigmatic and spectral as far as exterior, interior and history goes, its significance as monument and site may, however, have interpretations that go beyond the more sensationalist aspect. And so, if the buried history of Chavez Ravine is projected palimpsestuously onto Dodger Stadium on Ry Cooder's musical and excavationary sojourn; if the site-specificity of Chinese Camp is curated onto stage in a ghostly performance of figured suspension; if the site of Wilson's letters and their chorographics of the region they traverse is bound by patterns of invisibility and deferral; then the Winchester House has a more immediate relation to both site-specific performance and sightseeing. I want to suggest that its "show" is not so much that of the ghostly and paranormal as the current orchestration insists on staging, but rather a performance that stays very close to the many and troubling meanings

1 The Winchester Mystery House website has changed since 2016, and can now be found here: https://winchestermysteryhouse.com/a-moving-day/ The site as a whole is definitely fronting the element of mystery, and now also links itself to the movie *Winchester: House of Ghosts* from 2018.

THE TIME OF DESIRE: THE WINCHESTER HOUSE 103

of the monumental as reminder, warning, and excess. First, however, here is the story of Sarah Winchester:

She was born Sarah Lockwood Pardee in New Haven in 1839 into a family of some stature. Sarah became known as the Belle of New Haven, and on the one picture of her as a young woman that exists, we can easily see why. At the age of twenty-three she married William Winchester, the son of Oliver Winchester, owner of the Winchester Repeating Arms Company. In 1866 Sarah and William had a daughter, Annie, but the child tragically died from a rare decease only forty days after her birth. Many years later, in 1881, the year after Oliver Winchester had passed, William, too, died. Sarah was devastated, and it is after this that her story enters the sphere of mythology.

The popular and common version of what then happened, and which the guides in the Winchester House will tell you, goes something like this: Convinced that her little family's misfortunes were the punishment for the sins of the Winchester gun, Sarah, in her great sorrow, went to see a spiritual medium in Boston. The medium told her that, in order to make amends for what the rifle that her family's company had caused of suffering, she must move out west, begin construction on a new house, and never stop building. This would be the only way to deter the ghosts of the countless people who fell to the Winchester. And, so began a building process that only stopped when Sarah died – in 1922. The original 8-room farm that she bought in the rural Santa Clara valley gradually expanded to eventually consist of 160 rooms, among them 40 bedrooms and 2 ballrooms, 13 bathrooms, 6 kitchens, an indoor greenhouse. The house had more than 2,000 doors, about 10,000 windows, 47 stairways, and 47 fireplaces linked to 17 chimneys. In addition to this came stairs, hallways, secret passages, windows and doors leading nowhere, elaborate ornamentations and unique aesthetic details. According to the mythology that surrounds the house, construction was ongoing every single day and night for the entire year, and the result was six floors of labyrinths. The work stopped only when Sarah died. Again, according to mythology. This particular part of the story has, however, been rejected and proven incorrect by Mary Jo Ignoffo, who in her 2012 biography *Captive of the Labyrinth: Sarah L. Winchester, Heiress to the Rifle Fortune* cites from a letter Sarah wrote back to New Haven about the many troubles she was experiencing with the additions she wanted made on the house. Sarah here writes that with all the waiting for the right weather and all sorts of other things, she "dismissed all the workmen to take such rest as I might through the winter. This spring I recalled the carpenters, hoping to get my hall finished up" (Ignoffo 111). Ignoffo notes that this and other references to Sarah's routinely letting the workers go on longer breaks "flies in the face of claims by today's Mystery House proprietors that work at the ranch was ceaseless for thirty-eight

years" (ibid., 112). It bears mentioning here, too, that in what sources we have access to concerning the life of Sarah Winchester, she is presented as a pragmatically oriented person, and the decision Ignoffo describes her taking consequently makes sense.

That does not detract from the extraordinary nature of the construction project; far from it, and during the 38 years construction went on, as well as in the years following her death, the mythology surrounding Sarah Winchester and her strange house would come to flourish. Eventually myth and the fact of the eccentric architecture would merge into the added adjective in the name given to Sarah's mansion, "The Winchester *Mystery* House," a California Historical Landmark since 1974. In connection with the making and release of the movie *Winchester* (2018), where Helen Mirren stars as Sarah, historian Janan Boehme was asked about the curious story behind the person and the house: "'There are all sorts of explanations,' says Boehme. 'Like she was trying to disconcert bad spirits she didn't want to have in her house, or she was just a really bad architect.' Gossip ran rampant. 'People were curious about her [...] She was extraordinarily wealthy, she bore a very famous name, but she was also a very private person, and since people didn't really know, they made up their own stories'" (Warner, 2018). The movie, which generally got poor reviews, falls into the company of other fictionalizations of Sarah's story, all privileging myth and eccentricity, the ghostly and the inexplicable.

In one of the few works that takes a serious and academic approach to the Winchester House, Christine R. Junker comments on how the mythology that arose with so little base in any reality has been remarkably stubborn. She notes that:

> In many ways, the Winchester mythology is even more interesting given the absolute lack of supporting historical evidence because it demonstrates the cultural desire for a particular kind of narrative about houses and their relationship to their inhabitants: in this case, the continued fascination with the Winchester mythology capitalizes on America's complicated relationship with class, the conflation of the white female body with her domestic space, and a cultural desire to acknowledge the wrongdoings of westward expansion without sharing in the cultural guilt associated with it.
>
> JUNKER 2015, 332–33

Although I am not sure that Sarah Winchester can quite as easily as this be placed in the context of expectations to and anxieties about gender and class, Junker's discussion sheds interesting light on the House and its story. I agree

that spending time on the tales surrounding the mansion is not helpful; indeed, this kind of mythologizing also completely obscures from sight alternative performances that may inform our interpretation of the monument in more interesting and perhaps even meaningful ways. I also agree that the interpretations that dominate in the public reception of the House have everything to do with a cultural desire for specific stories, in this case related to gender and westward expansion. I am, however,not quite as convinced that too much attention should be paid to Sarah's figure in relation to gender and womanhood. Junker argues that she can be seen as "an ideal figure of Victorian womanhood who observes the doctrine of separate spheres, in so far as she is depicted as rarely leaving her house, adhering to its bounds to the point of unsociability" (Junker 335). This may be so, but I think Sara Winchester and the monument she built are much more than this, and that the unlocking of other kinds of stories and symbolisms can be accessed in the performative aesthetics of the site itself. I will in the following suggest one possible path into such revision.

For, not essentially different from how we become accustomed to interpreting and seeing a certain play, reading a certain text, watching a certain movie, our seeing, reading, and watching is always a matter of perspective. We see and read and watch differently, a new, if we are given a lens through which other kinds of vistas transpire, that yank us out of accustomed and ossified habits of perceptions. Seeing site, too, depends on perspective, and in relation to an alternate seeing of the Winchester House site, two, and at first glance seemingly unrelated sources inform the present lens for seeing otherwise. Two things happened not long after my first visit to the House: One was the discovery of an abandoned Winchester Rifle out in the Nevada desert, the other was the celebration of Leo Marx's *The Machine in the Garden's* 50th anniversary in 2014. The two may seem irrelevant to each other and of no consequence to a reading of the Winchester House as site, but in the context of permanent artworks and the monumental, as I suggest the House can be conceived, and in relation to the capacity of such structure for serving as site in a site-specific performance, they are occasions that are absolutely relevant to the being itself of the house. Let me explain more fully to appreciate these connections and that between seeing and the site-specificity that inheres in Sarah Winchester's house.

On the 14th of January 2015, The Great Basin National Park in eastern Nevada sent out a press release saying that, "on November 6, 2014, Cultural Resource Program Manager, Eva Jensen, working with the park archaeology team, noticed an object beneath a Juniper tree. Getting a closer look, she discovered that it was a rifle" (National Park Service 2015). And it was not just any rifle, but the infamous Winchester Model 1873, left behind in what is definitely one of the more inhospitable parts of the West. Its sudden appearance gives rise to

endless speculations, for the gun, as former curator at the Buffalo Bill Center of the West, Herbert Houze says, was extremely valuable at the time: "You just don't leave a gun like that there" (*AP* 28 May 2019). We will never know why the Winchester came to be stood, unloaded, against a tree in eastern Nevada, but we know a lot about what that precise gun came to mean in American cultural history. The Winchester repeating rifle, known as the "the gun that won the west," was heir to the Henry rifle, the gun confederate soldiers called "that damned Yankee rifle that they load on Sunday and shoot all week!" In 1873 Oliver Winchester perfected the Henry lever action, and over the next five decades about 720 000 rifles were produced (Russell 2013).

Roughly around the same time as the Winchester rifle was found out in the desert, I was preparing a paper for a conference in honor of the 50th anniversary for Leo Marx's *The Machine in the Garden*. The unlikely discovery in the desert brought to mind something he writes in the opening pages. Marx begins his book with reflections on some journal entries Nathaniel Hawthorne made in 1844, as he awaited (as Hawthorne himself put it) "such little events as may happen" (Marx 1967, 11). Hawthorne had sat down to record through the senses his natural surroundings in a place known as Sleepy Hollow. The journal notes echo Thoreau's emplaced writing, a kind of deep mapping and in some ways a chorography itself, where, as William Bossing puts it, "language and landscape" flow together (Bossing 2000, 5). Hawthorne's notes are of a similar chorographic tenor, and Marx reads into them a pattern that emanates from a very particular event, and one that interrupts the harmonious confluence of sound and sight. For suddenly, Hawthorne writes, "there is the whistle of the locomotive – the long shriek, harsh, above all harshness, for the space of a mile cannot mollify it into harmony [...] it brings the noisy world into the midst of our slumberous place" (Marx 1967, 13). Marx for his part fastens on to "the decisive part played by the machine image;" the way, suddenly again, "tension replaces repose," the noise arousing a "sense of dislocation, conflict and anxiety." He concludes his reading of Hawthorne's notes saying that in the context of the time and place of their writing, the "elemental, irreducible dissonance contains the whole in small" (ibid., 16–17).

On first inspection, that "whole" is the unleashing of industrialization in America, because the locomotive, Marx says a little later, "associated with fire, smoke, speed, iron, and noise is the leading symbol of the new industrial power" and it "appears in the woods [...] like a presentiment of history bearing down on the American asylum" (ibid., 27). These words could however also describe the advent of the Winchester rifle into the struggle over the dominance of the West, and in this scenario rifle and locomotive travel together: The "fire and smoke" brought by the rifle is difficult to imagine without the "speed and

THE TIME OF DESIRE: THE WINCHESTER HOUSE

iron" that carried it on tracks to places hitherto remote and unreachable. Fifty years after Marx wrote *The Machine in the Garden,* the Winchester rifle in the Nevada desert (itself a machine in a garden) is in itself a little event, and one that also contains the whole in the small. It reminds us of an entire history of unceasing movement and unstoppable will to conquer. Its modest address in the remote area can indeed be read as a sequel to the original "little event" in Hawthorne's journal, ringing with "dislocation, conflict and anxiety" in its own right.

The figure that transpires from all of the above is that of displacement. For now, let us stay with the word's most obvious meaning, naming that which is out of its place, what has been (re)moved and shifted. The locomotive in Hawthorne's notes as well as the rifle in the Nevada desert are both displaced; one as the ill-timed sound of the machine in the quiet of the forest, the other as a concrete slice of the past materializing in the present, both unexpected and out-of-place visitations. Each also contains "the whole in the small:" they are manifestations in concrete form of energies thrusting westward and wanting, willing. And it is this commonality between the two otherwise unrelated phenomena that forms a perspective, a lens through which we may now see the Winchester House again. It, too, is a little event. It, too, as we shall come back to, holds in it the whole. The discovery of the rifle and Marx's reading of Hawthorne's "little event" can consequently be combined to shed their light on the House as monument, as permanent artwork, and as a host to performances that liberate it from the one story only that it has been relegated to tell. They make it possible now to see and read the site of Sarah Winchester's strange house and the area it sits in as something more than the eccentric production of an eccentric mind, and instead consider it along a trace strangely similar to that of David Wilson's quest. If the site-specific work invariably cites the ghostly presences that inhabit the host onto which it projects its staging, then I will suggest that the site can also, as we will see in the case of the Winchester House, reach toward the future. The figuration of displacement that transpires from Hawthorne's little event and the rifle in the Nevada desert motivates this monument in the double movement of warning and reminder that we will now look at in more detail as we "tour" Sarah's house.

1 "this little world"

It does not really matter so much which story we choose to go with. Whether Sarah was caught up in an attempt to escape the ghosts fallen to her family's deadly machine, or, more plausibly, that she was more than commonly

interested in architecture, insisting on supervising and directing the building herself, the house sits there, a testimony to her visions and hopes and dreams. Sprouting up in what was back in her day more or less empty farmland, was a structure well ahead of its time with the implementation of technological contraptions such as drainage techniques and indoor plumbing systems barely heard of, an indoor greenhouse that cleverly recycled water, a heating system not seen before. As Philip Monk reflects in another of the few more serious publications on the House that exists, "Sarah Winchester's folly was not merely a haunted house but a machine, like so many other inventions of the nineteenth century that demonstrate American technical ingenuity" (Monk 2006, 15). Yes, the house most certainly was a "little event," and as mentioned, it quite possibly also contains "the whole in the small." It is, however, too easy to say that the Winchester House is just a machine, or merely the eccentric production of an eccentric mind; when it was being built it was also a *garden* in its own right, an enclosed retreat into which few, if any, were allowed entrance. It is said that when Teddy Roosevelt in 1903 came to the Santa Clara Valley, the San Jose Chamber of Commerce asked Sarah if he could visit her, seeing as how he was a big fan of the Winchester rifle. The request had received but a sharp "No," and the President had to content himself with merely driving by Sarah's house. Annalee Newitz, who has done some research on this suggests, however, and quite plausibly so, that Sarah's refusal to meet with the President had to do with his enthusiastic complicity in advocating the Winchester rifle, and that she wanted nothing to do with it (Newitz 2012).

But this now digresses into mythology again; indeed, it is fascinating how easily it happens. That very point leads logically over into my next one: The Winchester House can be "read" as a site-specific work because it comes across precisely as something that is being acted out in a very particular setting in a particular part of California, continually being watched and appreciated by an audience. The triangularity of place – act – audience which characterizes site-specificity echoes McLucas's description of site-specific performance as "the ones where we create a piece of work which is a hybrid of the place, the public, and the performance" (McLucas in Kaye 2000, 55). The Winchester House can be read as a production that allows us to see its performance as more than what the tourist pamphlets and guided tours let on. For as others have pointed out, too, the House's emplacement in the hub of Silicon Valley strikes several interesting chords of comparison and reflection that go straight back to the region's early transformation into financial center as well as to its persistently seductive charm to new waves of dreamers and entrepreneurs. Marx and Engels also commented that, "[the great mass of gold] has already taken control of the main trade with California and in general performs the same function

THE TIME OF DESIRE: THE WINCHESTER HOUSE 109

for the whole of America as London does for Europe" (1850). The excess that defines Sarah's mansion-monument is thus in many ways but the concretization of the kind of surplus of energy that pushed the region into the state and State we now know it as. And as a monument, what Røstad calls permanent artwork, the house should perhaps be seen as both a warning and a reminder of precisely the kind of forces that define it, then as well as now.

The immediate quality of the House's performance in relation to this aspect is nested in the nature of the trace that the house vibrates with and as. Referring to trauma vis a vis its memory as illustration, Casey observes that, "traces exceed their own origins" and further adds that they are "more than depository and repository in function" (Casey 1988, 242- 243). The origin that the Winchester House as a trace speaks of and "exceeds" is mysterious, but not because we know so little about the House's owner and her history, or the alleged visitations at night of ghosts and spirits. Mystery here does its work in a much deeper and timeless sense and evokes a different kind of idea of the mystic. It so happens that only a couple of years before Sarah died, novelist and historian Waldo David Frank published his *Our America*. In the introduction to his essays of cultural history and criticism Frank notes: "In this infancy of our adventure, America is a mystic Word. We go forth all to seek America. And in the seeking we create her. In the quality of our search shall be the nature of the America that we create" (Frank 1919, 10). Frank was addressing the American project in general, its exceptional nature as somehow excused from the wear and tear of time and tradition, as simultaneously inclusive and exclusive, and he did so with great faith in its continued destiny. I am not suggesting that there is a direct relationship between Frank's "mystic word" and Sarah's mystic house; I am, however, proposing that the house she built and its presentation before us today can be viewed as a very site-specific performance of a similar kind of seeking and creation that Frank so poetically described in relation to the nation itself. While Sarah's search must necessarily have been more modest than the projects depicted and explored in *Our America*, her seeking and creation in the end comes to stand in a synecdochal relation to the more wideranging project Frank had in mind.

A hint of this goes via the inscriptions from Shakespeare on the window in the mansion's Grand Ballroom, an exquisetly decorated space to awe any visitor. Its décor is stunningly beautiful: "Mrs. Winchester's elegant Grand Ballroom is built almost entirely without nails. It cost over $9,000 to complete at a time when an entire house could be built for less than $1,000! The silver chandelier is from Germany, and the walls and parquet floor are made of six hardwoods – mahogany, teak, maple, rosewood, oak, and white ash" (Winchester House 2018). We can consider the Grand Ballroom, a synecdoche in itself, as

one piece of the larger site-specific work that the Winchester House is, and try to see its site-ness in relation to the larger cultural context in which it after all was constructed, as well as to the contemporary scene on which it sits and to which it continues to speak in performance. It bears repeating that, as Nicola Shaugnessy puts it with reference to Tim Cresswell, place should be conceived of in "terms of fluidity, a constant process of making and being: 'places are constructed by people doing things and in this sense are never 'finished' but are constantly being performed'" (Shaughnessy 2012, 104). As we enter the Grand Ballroom, the making of the space that Sarah created is in every way adhering to this template, we co-create the work and add to it as host our ghostly visitations in yet more interpretations.

If we are to believe the stories, in whichever version we go with, Sarah rejected even the President; she also, however, refused everybody else entrance into her home. The two grand ballrooms, in all their fantastically rich furnishings and ornamentations were never used; there were never guests, and this despite the artistic effort that went into their making. In the commonly told presentation on the tour through the house this is also where the story ends, with the guide pointing to two beautiful, stained windows where are inscribed lines from two Shakespeare plays. The one on the left is from *Troilus and Cressida*: "Wide unclasp the tables of their thoughts," the one on the right from *Richard II,* "These same thoughts people this little world." We are told, as also the Winchester House's official website says, that in the first case, "The lines are spoken by Ulysses, and refer to Cressida's sometimes flirting nature." This description is however somewhat misleading, for the context that the line is taken from is, granted, a speech Ulysses makes, but it is spoken, as Shakespeare scholar Stuart Sillars points out, "after Cressida has been passed around the Greeks in a kind of kissing game" (Sillars, conversation with author, 20 February 2016). The background for the line is consequently a very specific one. About the line "These same thoughts people this little world" we are told in the common interpretation of the house that, "[t]he imprisoned Richard means that his thoughts people the small world of his confinement" (Winchester House, 2016). If we look more closely at the original monologue the line is taken from, we realize the tremendous depths it speaks of and to:

> I have been studying how I may compare
> This prison where I live unto the world:
> And for because the world is populous
> And here is not a creature but myself,
> I cannot do it; yet I'll hammer it out.
> My brain I'll prove the female to my soul,

My soul the father; and these two beget
A generation of still-breeding thoughts,
And these same thoughts people this little world,
In humours like the people of this world,

> For no thought is contented. (*Richard II*, 5.5, emphasis added)

The sentiment in these lines may address confinement, but they do so in a very different sense than what immediately transpires as we read the one line in isolation. In its original setting, the mirroring of the outside, real world and that on the inside of the walls surrounding Richard provides a momentous comment on the life of the mind, broadly speaking. As Charles and Mary Cowden Clarke note in *Cassel's Illustrated Shakespeare*,

> "*This little world.*" Meaning himself, his own person: and since he peoples himself with many persons, or represents in his own person many people, he renders the prison populous like the world [...] By proving his own inner world to be peopled by thoughts, he proves the prison that contains himself to be like the populous outer world. Shakespeare elsewhere uses the expression "this little world" for human identity, individual self.
>
> COWDEN CLARKE 2007, 106

This comment provides us with some context for the line, and we can perhaps now see the windows in the unused ballroom perform in a slightly different light. While the Winchester House guide will say something like, "Nobody knows for certain what these lines meant to Mrs. Winchester," I will suggest that a fuller reading can be teased out from the stained windows if we see them as a kind of site-specific installation, a part of the artwork and performance that this monumental construction stages. If site-specific works can generally be described as being "designed for a specific location, and if removed from that location it loses all or a substantial part of its meaning" (*Tate Glossary of Art Terms*), then site-specific installations are more concretely bound by the audience's experiencing of its placement. I quote Tate's definition at some length:

> Installation artworks [...] often occupy an entire room or gallery space that the spectator has to walk through in order to engage fully with the work of art. Some installations, however, are designed simply to be walked around and contemplated, or are so fragile that they can only be viewed from a doorway, or one end of a room. What makes installation art different from sculpture or other traditional art forms is that it is a

complete unified experience, rather than a display of separate, individual artworks.

Tate Glossary of Art Terms, 2020

The two windows and their inscriptions constitute the central piece in the room, and the audience have no choice but to contemplate and wonder about the meaning of their words, allowing some time to reflect on their role in the room's generally spectacular yet also sadly abandoned presentation. This is why we can also consider the windows as a site-specific installation and component of a larger piece – the Grand Ballroom itself, which in turn is a part of the much larger performance that the House in its totality is. As elements of a site-specific work, the Shakespeare quotes and their placement were and are meaningful *only* in the particular location of the Grand Ballroom, and to appreciate this element will allow us to "see" the performance as a whole in a different light than what the script that typically frames it invites.

For interestingly, when I showed images of the two windows to Sillars, his initial reaction was that they are rather "unlikely things for quotation" (Sillars, conversation with author, 20 February 2016). So unlikely, in fact, that, rather than speculate about her knowledge of Shakespearean scholarship at the time, it is quite possible that Sarah simply found the two lines in one of the several dictionaries of Shakespeare quotes that were circulating on both sides of the Atlantic already from the mid-19th century. She might, for instance, have searched for a poignant declaration on the word "thought," and up would have come, among many others, certainly the *Richard II* example. In for instance Aaron Augustus Morgan's *The Mind of Shakespeare as Exhibited in his Works* (1876) the word *thoughts* yields 37 hits, two of them from the lines on the windows. Sarah may in other words not have been overly concerned with exactly where the quotes were taken from, and hence ignored the bleakness and obscurity of the first play, and the intricate context the lines from *Richard II* are lifted from. Perhaps she was instead drawn to a particular sentiment expressed in isolation in these two lines, resonating, for whatever reason, with her own thoughts and feelings on the matter of, well, thoughts.

It is difficult in this context to not bring in another, and much more famous American recluse, namely Emily Dickinson. In one of her many letters she famously wrote that, "To live is so startling it leaves little time for anything else," and the tenor of this brief but all-encompassing line arranges itself perfectly with the two quotes Sarah chose to express herself with. For, taken together, the two inscriptions make a powerful statement on the relation of the outer world to the inner life of the mind: unlock and open the tablets on which are inscribed the thoughts of the world, and you find the same thoughts there

occupying *this* little world – that of the "individual self" (Cowden Clarke 2007, 106). Effectively then, thoughts, or ideas, pertaining to the world outside are collapsed onto those that occupy the mind of the architect, an uncanny echo of Dickinson's stance in one of her lesser read poems: "One need not be a chamber to be/haunted,/One need not be a house;/The brain has corridors surpassing/Material place" (Dickinson, "Poem 69"). The lines rehearse the interpretation of the line from *Richard II* as rendering what Cowden Clarke calls the prison populous like the world, and hints that the Winchester House, rather than being a prison, maybe in fact served Sarah in a way similar to Dickinson's idea of the brain's superiority as material place. And, let us not forget that the surface the quotes are placed on is but a transparent filter between spheres, literally connecting the outside with the inside.

It is a curious realization that, when we read the two windows in the concrete setting they occur in, namely a ballroom that only *pretends* to serve its function, this notion of sameness between outer and inner worlds comes to carry a timeless message. This brings me back to the ballroom as a site-specific installation. For it is almost as if Sarah knew there would be audiences coming through, more guests flowing through her rooms than she could ever imagine, or maybe that is exactly what she imagined. The "note" she left behind on the two windows may have meant something very particular to her personally at the time, but it also travels with remarkable potency across time to speak to its audiences today. For the sense of simultaneous inclusion and seclusion on the windows in the Grand Ballroom reverberates on several levels. The "mystic word" that in Frank's work summarizes the American project as a creation of a collective seeking, becomes in the Winchester House a creation resting on a seeking that looks indefinitely into the future. The transparency between external and internal space provided by the stained windows anticipates in metaphor the creation and activity that a hundred years later would dominate the area the House inhabits. The tech industry centered in Silicon Valley and which has turned out to be a kind of second Gold Rush does not *actually* bring worlds concretely together; instead technology designs "windows" between worlds, platforms that at the same time as they "wide unclasp the tables" of the world also allow, perhaps even encourage, the seclusion of "these same thoughts." We will return to the relationship between the performance of the House and its contemporary surroundings toward the end of the visit.

The site-related detail of the two windows is only a small part of what Sarah's work performs, for the windows rehearse the House as the little event we discussed earlier. Its genesis and purpose in significant ways contain Hawthorne's "whole in the small." It holds in itself the world in miniature format, as we see already with the windows and their powerful symbolism. The

house also channels into its edifice a simultaneity of impulses and energies of the time of its genesis that extends to what I will suggest is the "origin" of the trace it makes, and, in Casey's formulation, what the trace "exceeds." It is helpful here to repeat his words: The trace, he says, "consist in a self-surpassing operation whereby its meaning of value *lies elsewhere* – namely, in that *of which* it is the trace, that which the trace signifies by a self-suspension of its own being or happening" (Casey 1988, 241). Now, if we see the House as a trace, and a trace that continues its work as such in its site-specific performativity to the world, then in what does its self-suspension consist? As a "little event" emerging in the landscape and expanded on in partly inexplicable ways and without pause, the House comes fraught with a similar kind of tension and dissonance that Marx diagnosed in relation to the little event in Hawthorne. I would in fact suggest that, from the very first moment of its creation, and in an impulse of simultaneous retreat and expansion, it is precisely contradictions and discords that propel the Winchester House into existence. The tension is echoed, not just in the ballroom (which stands in a similar synecdochal relation to the entire house as the house did and does to its larger cultural contexts), but also in the House's ambiguous quality as garden *and* machine, escape *and* entrapment, idealism *and* realism, spirituality *and* worldliness. As Monk describes its origin, "it was something that was real and fantastic at the same time" (Monk 2006, 97). So, let us forget about the speculations about secret, nightly séances; the idea that Sarah was engaged in a life-long battle to expiate the sins of the fathers. Let us leave behind the theory that the house is in effect a crypt, protecting the loss of Sarah's husband and child, and instead stay with the much more likely motivation, that the house was conceived to mark a new beginning, an all-consuming project allowed by the kind of time and money Sarah as heiress to the Winchester fortune had at her disposal. The properties of its "little event," and the sentiments captured in the two tablets, the mirroring of the outside world in that of the inner, all signal impulses that impel into existence a monument of great complexity. And yet the fact remains that the story is still one of displacement. And loss. And desire.

The only picture that exists of Sarah from her time in San Jose shows her as an elderly woman. She is sitting in her horse drawn carriage; the driver on his seat in front of her has a firm grip on the reins and seems ready to let the two horses start. In the picture the carriage is positioned to the left, with the figure of the horses extending across the photo almost all the way to the right. Behind the horses we see the corner of a house, not the mansion itself, and parts of the garden. The driver is looking straight ahead, but Sarah is looking directly at the camera, whose lens captures her from the other side of the

THE TIME OF DESIRE: THE WINCHESTER HOUSE 115

driveway where the horse and carriage are standing. It is said that the photo
was taken unbeknownst to her by a gardener, but the direction of her gaze
suggests differently.

The raised collar on Sarah's fur coat and the blanket over her lap indicate
that it must be a cold fall day, even a winter day. The driver also has a blanket.
We don't know why they are standing there, since they would already be on
their way out from the carriage house that is directly in the rear of the wagon
and not visible on the photo. Sarah was very small, and had a staircase specially
built for her in that house to get more easily in and out of the carriage. One
wonders: when she noticed the camera, did she stop to lecture the garden-
er? The fact that only two pictures of her exist (the other is of her as a young
woman when she was still a Pardee) tells us that she did not particularly care
to be photographed. She doesn't look mad, though, but rather expressionless,
thoughtful at best. It is hard to tell since a certain photographic blur inter-
venes in this one image that we have. The result is that Sarah's facial features
as well as those of the driver are somewhat clouded, and an optical illusion of
transparency comes to shroud their figures. This creates an eery contrast to the
sharp outlines of the building in the background, the horses, the wagon itself.
The effect of this unevenness, presumably not intended, is a displacement of
Sarah's figure that stirringly resonates with the misty details of her life. If we on
the other hand see the picture as illustration to the site-specific performance
of the House itself, it oddly makes sense.

We must here bring back the idea of displacement, now not in the sense
of what is out of its place, what has been removed and shifted like the rifle
in the desert or the train in the forest we began with. I have in mind rather
displacement in the sense of taking something or someone's place – a replace-
ment fueled by the energy of desire. Jacques Lacan describes his diagnosis of
desire as follows: "The enigmas of desire amount to no other derangement of
instinct than that of being caught in the rails – eternally stretching forth to-
wards the desire for something else – of metonymy" (Lacan 2003, 184). This
kind of displacement more complexly refers to "the substitution of one idea
or impulse for another, as in dreams, obsessions, etc.; the unconscious transfer
of intense feelings or emotions to something of greater or less consequence"
(*OED*), to Freud's tackling of the repressed that returns elsewhere. The desire
for something else, something new reaches forth, but within the limitations
of the imagination – a bounded-ness that holds it to the origin that invari-
ably precedes it. Conceived of in terms of figuration, we are no longer relating
to synecdoche, part for whole, but the more complicated trope of metonymy,
where a word is used that describes what is associated with an object, although
not actually a part of it.

We saw how metonymy as orchestration for Bodie's performance created a space for multiple views rooted in a tropology of connotation, adding to its site-ness a kind of sideways cumulation of associations. In the case of the photo of Sarah and what it refracts, the dynamic is not entirely different. For metonymy and the metonymic mode of figuration, just like desire itself, is a bit like the king in chess: Whereas the queen moves in all directions and as far as the board allows, the king's movements are limited to the checkers immediately next to where he stands. So, too, in tropology. We could say that metonymy moves according to significations and associations that touch and border on the "original," in contiguity, and this is also true of desire, bounded as it is by the "rails" of what its longing originates in. Like the trace, then, desire can be located to a core, a kernel, an origin that sets off a process of selection along contiguous associations, aspirations, and projections, but like the trace, desire can also take on an excessive quality that surpasses its origin. In either case, we are relating to a performance on site that cites and cumulates in its citation.

In both of the above understandings, displacement resonates with the Winchester House. In any version of Sarah's story, her displacement *from* old life in New Haven *to* a new life in San Jose, her replacement *of* old *with* new in the end amounts to a mere shift, a *Verschiebung* of an impulse that does not significantly travel. In the end it is a fantasy, Lacan's "derangement of instinct," for the move, or shift does not lead to a breach with the past. The house in its performativity comes instead to stand in close relation to Frank's seeking of America as the "mystic word," and as a small part of *its* whole, Sarah Winchester's creation, labyrinth and all, even as it strives and desires toward that very breach and crossing, dramatizes instead before us the impossibility of such breach and complete crossing. We can see the unceasing construction as a signal of the compulsion to keep searching, yet one that remains trapped in what instigates the search itself. This is only another way of saying that the trace exceeds its origin: the house is a fantasy that merely secures perpetual seeking and creation. Sarah and her project, whichever it was, are indeed caught in Lacan's rails, and "eternally stretching forth towards the desire for something else." To desire is to exist in the fantasy and to keep the will alive, and perhaps this is the essence of the Winchester House as a site-specific work and performance. Differently from the architectural relatives we started this chapter with, Sarah's invites endless viewings and interpretations, and in this abides also the power of her monument.

Pearson observes that, "[a]lthough the stage is a site of imagination and site is always inescapably itself, site may be transformed by the disruptive presence of performance seeking a relationship other than that of a ready-made scenic backdrop against which to place its figures" (quoted in Shaughnessy 2012, 104).

THE TIME OF DESIRE: THE WINCHESTER HOUSE 117

This perspective on site and performance opens up a view on the capacity for place and site to come alive in the act of viewing and creating space that invariably falls on the audience. I think it applies well to the Winchester House as a whole as well as to its constituent parts, especially as we consider what Pearson also notes about the function of synecdoche: "If the stage is essentially synecdochic [...] site is frequently a plenitude, its inherent characteristics, manifold effects and unruly elements always liable to leak, spill and diffuse into performance [...]" (ibid.). It is exactly this sense of spilling that takes place when we, as I have done here, open up for alternative ghostly presences on the stage: To frame the Winchester House as monument of warning and reminder, and as a gesture toward excess invites an interpretation of it as a work that meaningfully positions it in relation to its contemporary place and time. I come back to this element shortly.

There are of course other aspects in this performance that could be commented on, for instance the labyrinthine nature of the entire structure (it takes the guides quite a while to learn it and to not get lost, and one is warned to keep children close and not let them wander off), or the quirky windows and stairs leading nowhere (another installation of the rails of desire and their entrapment). I want instead to shift the focus a little and return to the house and site as a "little event" in all the specifics of its location. I began the chapter by briefly listing some of the other mansions and structures that are scattered throughout California. In their own ways each manifests their owners' and creators' hopes and wishes, and what we as audience see when we go to the sites are the traces of these aspirations, ideas, and, fantasies. There is, however, a different quality of the trace worth keeping in mind. In Casey's words that quality, as we have mentioned before, "consist in a self-surpassing operation whereby its meaning of value *lies elsewhere* – namely, in that *of which* it is the trace" (Casey 1988, 241). In a reformulation of this he adds that the trace has "a status, function, and value of their own that exceeds their materiality just as it surpasses their facilitating effect" (ibid., 243). The trace, in other words, attains to a being of its very own, which both is and is not traceable to its origin, yet also more than this. I will not here go into Casey's discussion of Levinas and the trace of the other here; suffice it to note that the trace in this reasoning can be seen as primary, not secondary. The perspective bears meaningfully on the Winchester House, and specifically in relation to its performance of desire. Desire, like the trace, must necessarily reside *elsewhere*; like the trace, it is not it itself, but neither is it secondary. This brings us once more back to Frank's "mystic word."

While there is no direct connection between the Winchester House and Frank's work, the two coexist in a kind of culturally synecdochal relation and

circulation of meaning pertaining to their contemporary moment and imaginary. The mystery, the seeking, and the creation Frank speaks of resonate with a faith in the exceptional nature of a future-oriented project that nevertheless also complexly insists on its traces. Within this framework the site of the Winchester House as a "little event" and site-specific performance plays its part, and it chooses the West and California as its logical but precarious destination and stage. Whether or not it is true that Sarah was told to go out west to begin her perpetual project of construction to atone for the sins of the rifle that made her fortune, it is no coincidence that the site for new beginnings would be the Golden State. Can we imagine Sarah's story ending in Ohio? Alabama? Maine? Somehow that does not sound right; a project like this, in pursuit of and in desire, needs spatial coordinates anchored in an imaginary where desire can be sustained endlessly, at least hypothetically. This is in part also what drives Wilson's letters, the promise of success fueling his search, and that of thousands and thousands of others who have since heard the beckoning call of possibility. While it would have been part of the attraction for Sarah, too, we must not forget that hers was also motivated by a more practical motivation. Ignoffo in her *Captive of the Labyrinth* reports that when Sarah was only forty years old, she had rheumatoid arthritis, and she was already starting to suffer from the illness (Ignoffo 2012, 84–85). Her doctor had recommended relocating to a drier and warmer climate for some relief, and this, combined with the possibility of leaving behind an Old World holding but painful memories would be plenty of reason good enough to go West. It does, however, not detract from the project of the future that the House also stands for, and no matter how much its proprietors insist on the ghostly and spectral of its performance, I suggest it is ultimately the aspect of aspiration in these various redactions that keep us interested.

Again, Whitman sung it in his "California Song" in 1874, proclaiming that, "At last the New arriving, assuming, taking possession/A swarming and busy race settling and organizing everywhere," seeing in California the greatest promise of America's larger promise ("Song of the Redwood Tree"). In characteristic exultation the poet celebrated the prospects Marx and Engels had already pointed to; as we saw, the same ones that compelled David Wilson in the previous chapter "to seek his fortune in that distant land." And, while one should not make too much of Whitman's cultural impact, its articulation of the promise of the future is closely aligned with Frank's search, and by extension, resonating in Sarah's incessant world building. Does this change the house and its site-specific performance? It does not, and Whitman's "deferr'd Promise" to be fulfilled remains carried in the figure of displacement and desire, and it still dominates the site. That figuration moves us also out of the House itself, and into its surroundings.

THE TIME OF DESIRE: THE WINCHESTER HOUSE 119

For we cannot ignore the larger site the Winchester House's performs on. Nothing is left, of course, of the Santa Clara valley farmland the originally small structure once sat on; today Sarah's mansion lies on the edge of San Jose's Santana Row, an upscale outdoor shopping mall that in a nod to the capital of dreams further south calls itself the Rodeo Drive of Silicon Valley. The eccentric figure of the house, with its pointed silhouette and countless gables and towers in all sizes and shapes forms a strange contrast to the sleek brick and glass buildings hosting restaurants, shops and offices across the street. Maybe even more perplexing is the company of the futuristic looking domes of the Century 23 movie theatre that sits next to it on the same side of the street, a kind of kinship in reverie. Because, for all their differences, many of the various structures that have sprouted up in Sarah's neighborhood *do* mirror each other in a rather spectacular and paradoxical way. I said before that hers is a construction feeding on the impulse of simultaneous retreat and expansion, orchestrated by the figure of displacement, Whitman's deferred promise. Maybe we can bring this back now, to include also the larger setting.

For the edifices on the other side of Winchester Boulevard (named after Sarah and her mansion) are in a sense also simultaneously fantastic and real; they, too, reflect Frank's mystic word to accommodate the seeking, and facilitate creation. They cater to the ones who make fortunes off of ideas – a never-ending search for and striving toward the near impossible, the barely thinkable. And they, too, never stop building, or working: In the gym you see the participants on step-masters conducting their business, scheduling appointments and arranging their lives on their phones. Since 2014, when Apple and Facebook were first to offer female employees the "perk" of having their eggs frozen so as not to have to interrupt their careers to have babies, several other companies have followed suit. In fact, employees with the tech giants never really have to leave their workplace at all; there are sleeping pods, medical centers, styling salons, restaurants, dentists and so on to take care of all needs on site. Is this really so different from the home Sarah rarely needed to leave, where she lived her life enclosed, the structure a self-sufficient manifestation of her dreams and visions?

Perhaps we now also can appreciate another, more ephemeral element of the Winchester House's site-specific performance, one where we experience being concretely on site yet at the same time partaking in what Bertie Ferdman calls "off-time" (Ferdman 2018, 84). Ferdman refers to her own visit to Dealey Plaza in Dallas, walking around the site of Kennedy's murder with headphones that "curate" the visit for her, not entirely differently from how Nicolini's "catalogue" of Chinese Camp guided us through that site. Ferdman is interested, she says, in "how activating space (on-location space, specifically) through

the manipulation of bodies in performance (both performer and spectator bodies), dislocates time and renders a non-linear 'off-time' temporality in the now, *on-site*" (ibid.). While there is no embodied performer as such involved in the Winchester House's performance, I think we can regard the interplay of site, audience and story as it is told by guides as coming very close to the kind of activation of space Ferdman is here talking about. I will also suggest that, while that activation takes place on-site (as does Dealey Plaza for Ferdman), the dislocation of time in the case of the Winchester House is even more complex, and rich. It does not only insert itself on-site as being of a temporality long past, it also bizarrely reaches into the present. The larger context for its concrete placement and enactment has everything to do with the figure of displacement, also caught in the rails of desire, eternally stretching forth.

The significance that inheres in this on-site/off-time work can furthermore be related directly back to Frank and his mystic word, to Marx's "little event" in Hawthorne that holds the big in the small, and to the monumental that inheres in the Winchester House. In its gazing over to the center for Silicon Valley's dreamers and seekers, it is both a reminder and a warning of the region's promises and pitfalls, and appropriately so in the context of the most recent tech boom, the last wave of dreamers that now fill the Valley. This explosion of seeking and creating is taking desire and the figure of displacement to a level that most certainly exceeds the origin of which it, like the Winchester House, is a trace. In relation to "the (off) time of desire" that the Winchester House as reminder and warning performs, this, other trace takes on an excessive quality that absolutely surpasses its origin: A curiously apt addition to the monuments that simultaneously commemorate and enact this is Apple Park, nicknamed the "Spaceship" for its distinctive shape. It is gigantic, and just like the Winchester House in its day, a self-sufficient entity with room for more than 12 000 employees in a structure of astonishing and innovative features. The domineering feature of its design are the curved glass walls, six kilometers of panes in total. The solar panels that cover its roof makes the building nearly self-powered, and it is considered one of the largest such structures in the world.

The location of this recent addition to the list of spectacular edifices is Cupertino, only a ten-minute drive from San Jose and Winchester Boulevard. Fittingly, it, or rather, the creek the town would grow up around (today Stevens Creek), was named after Saint Joseph of Copertino by one of the early Spanish explorers. Saint Joseph is the patron saint of air travel, pilots and the learning disabled, and was in life famed and sought after for his deep devotion and levitations during prayers. When he was canonized, seventy such levitations were listed. The place name forms a curiously suitable backdrop for the "spaceship," and for the Winchester House. In their moments of creation both aspire to

the near impossible in their architectural visions, and thus commemorate in their very structures the trope of desire that stretches forth. They are moreover not all that different. Sarah's fantastic labyrinth is forever striving towards the future to vanquish the past (if we go by the legend) and to conquer the future, and the Apple spaceship, founded on ideas of the near impossible, aspires to the same. Both are self-sufficient, and the spaceship is as inaccessible as was Sarah Winchester's House was in its day. Both take flight to reach the unattainable. Saint Joseph of Copertino consequently seems a very appropriate company for their endeavors, forging a strange continuity of performance on site, off time, and in a curiously resonant illustration of the mystic word.

CHAPTER 5

The Time of Romance: Fort Ross

See how the metaphor of the West dissolves into foam at our feet.
RICHARD RODRIGUEZ

∴

In the beginning of his *Site-Specific Art,* Nick Kaye comments that if "meanings of utterances, actions and events are affected by their 'local position,' by the situation in which they are a part, then a work of art, too, will be defined in relation to its place and position" (Kaye 2000, 1).[1] The chapters and sojourns in this book are obviously not about works of art in any traditional sense of the word (although most would agree that the architectural wonder that the Winchester House is can be seen as one). But I come back to the idea that when we assume an aesthetic attitude toward these places, events, and actions, we also perceive them as more than can be contained in and by their strictly referential quality. It is fitting to recall Mukarovsky's proposal that, "[o]nce the aesthetic function becomes dominant [...] the exercise takes on interest in itself as a performance or spectacle" (quoted in Fluck 2005, 9). Both perspectives align to illuminate what happens in the triangular co-creation of audience – site – work in all of the site-seeings so far, be that to aesthetically see Chavez Ravine as it is actuated on the site of Dodger Stadium, Chinese Camp in curation, the aesthetics of the yellowed letters and their chorographic attitude to the space they chronicle, or Sarah's House and the "little event" that it is. In all cases actual, concrete place determines the performance, and in relation to all we see site emerging from spatial practices of contesting impulses between the inward – and outward-directional, the centripetal and centrifugal, difference and sameness. The aesthetics of site-seeing thus inevitably leads us into performances in and of spaces *other than,* their representations hovering on the edges of place conceived as secured retreat, but with the threat of disruption and porosity

1 A section of this chapter appeared in a different context in "Russia's Californio Romance: The other Shores of Whitman's Pacific." 2013. *The Imaginary and Its Worlds: American Studies after the Transnational Turn*, edited by Laura Bieger, Ramon Saldivar and Johannes Voelz. Lebanon, NH: Dartmouth College Press.

© KONINKLIJKE BRILL NV, LEIDEN, 2021 | DOI:10.1163/9789004438002_007

THE TIME OF ROMANCE: FORT ROSS

already built-in. As with language, where what Bakhtin calls unitary language contains in itself the impulse toward heteroglossia, place, too, awaits its own unknotting. The last site-seeing in this California sojourn will illustrate how the oscillation inherent to the spatialization of place does its work over time, visualized in the details of the site itself as well as in its particular situatedness within a web of global reaches.

Fort Ross is a California Historic State Park located just a couple of hours' drive up the coast north of San Francisco. The name hails from California's Russian past, and the fort, established in 1812, was once the southernmost settlement of the Russian Empire and consequently part of what to many is a rather unfamiliar history. When we think of California's international relations what mostly comes to mind is the Spanish and then Mexican past, and a troubled record of relations to first Chinese immigrants, as we saw in previous chapters, later with Japanese citizens during WWII. We also think of the influx of people from all over the world in connection with the Gold Rush, and the southern border which in recent decades has assumed so much more attention than in previous times. Preceding all of these histories is that of the Native Californians, victims to first Spanish and then Anglo-American aggressions. The history of Native Americans' encounters with different colonizers in the US takes precedence in the record of violent and wrongful confrontations, and the West Coast is no exception. From an estimated 300 000, "[b]y 1860, the state's native population had been reduced to 30,000, decimated by violence, disease, poverty, the influx of gold miners, assimilation, and other historical factors. Just 40 years later, in 1900, this population had plummeted to 20,000" (*Calisphere* 2019).

In the register of different kinds of meetings there is, however, one that tends to go unnoticed, and it is one that takes place on the route running along the Pacific from North to South. While it did not leave all that many traces behind, Fort Ross is one and it holds within its stockades a fascinating story. Not unlike the Winchester Rifle found in the Nevada desert, it, too, can be seen as a little event that summarizes moments and movements of global reaches. In its current display, Fort Ross moreover and much like the Winchester House fulfils all criteria for sightseeing as we typically think of it. As a state park it is open daily and receives many visitors curious about and often surprised by its little told story. It is not only the history of Fort Ross itself that attracts, its location is also spectacular, even by the standards of the northern California coast. Overlooking the Pacific and with the redwood forests in the mountains behind it, it offers a stunning vista. The park contains among other the old and recently restored Russian cemetery, the stockades of the one-time colonists, and a historic orchard from that time period. There are also a few original buildings on

the grounds, but most have been rebuilt, including the little orthodox chapel and the warehouse. Each year the park hosts a festival where representatives from the different actors that are part of its history participate. This includes the original inhabitants of the area, the Kashaya Pomo Indians, sometimes also Alaska Natives who have their own historic relation to Fort Ross by virtue of having been brought to Fort Ross by the Russian America Company. The festival hosts contributions by the Russians, as well as elements from the variously composed community in the area, which hails from what is called the Ranch period after the Russians sold the fort in 1841. A look at the program for the 2019 Festival, for instance, reveals nevertheless a definite emphasis on the Russian past, with dances, foods, arts and crafts representing various aspects of life in Russia-away-from-Russia in the 19th century. As a kind of memorial, the park thus speaks to a diverse and messy past, and, even if not designated as a commemoration of trauma and loss, it is, by virtue of a series of overwritings and erasures, also that. Fort Ross is a reminder today of a moment where cultural imaginaries of very different composures and intentions would meet to grapple and conflict, but also to reconcile, and as we shall see later, even romance each other.

There is nothing inherently unusual about the cultural display such as the festival mentioned above; as everywhere in the world, the United States abounds with sites that turn their conglomerate histories into tourist destinations in an exercise that always runs the risk of essentialization. What is interesting about Fort Ross and its performance of its cultural memory is the nostalgia that the threat of its closing a few years ago activated: As a result of the financial crisis and numerous cutbacks in 2008 and 2009, then California Governor Arnold Schwarzenegger put Fort Ross on the list of several California state parks that would be dropped from funding programs. Word of the cutback and the effect it would have on Fort Ross reached Moscow, and the Russian government promptly sent Ambassador Sergey Kislyak to try to save the little fort. On his visit to Fort Ross Kislyak "pleaded [the governor] to spare the site," saying that it "holds significant cultural, historic and sentimental value for the Kremlin, Russians and Russian Americans" (*SF Gate* August 28, 2009). While Schwarzenegger could not at the time make any such promises of a restored funding program, a year later Victor Vekselberg, CEO of the Russian conglomerate company Renova Group, signed a three-year agreement to sponsor Fort Ross until its bicentennial in 2012. In 2019 the Renova Group is still very much a force in the running of the park and has raised significant funding for restorations and various events that the park organizes, for instance the above mentioned annual festival. So, what was it that occasioned this reaction from a nation traditionally an arch adversary, more at odds with the US than not?

THE TIME OF ROMANCE: FORT ROSS

In terms of site-specific performance, what is it now that is being staged? The relationship we have seen previously between Mike Pearson's host and ghost in relation to the staging of "works" attains to a more than complex quality in this case, for, is this not in some ways literally the return of the ghost? To find meaningful answers to the question we have to consider in more detail the actual genesis of the site, as well as the trajectories that would lead to its demise and later resurrection. Only then can we return to Fort Ross' site-specific participation in the genre of the adventure romance, and the contemporary reflectiveness of its nostalgic posture.

1 The "eventmentality" of Fort Ross

To begin with, I propose we see Fort Ross as a classic example of Casey's observation that, "[m]inimally, places gather things in their midst – where 'things' connote various animate and inanimate entities. Places also gather experiences and histories, even languages and thoughts" (Casey 1996, 24). Fort Ross is a prime example of a place that "gathers things," and also illustrates the palimpsested nature of history's deposits, the sedimentations of a succession of cultural imaginaries converging onto one and the same site. Fort Ross is therefore also an instance of Casey's "eventmental" character of place (Casey 1996, 38). He asks:

> What if time, space, and their projections and reductions as sites are non-simply located *in places*? Then place would no longer be the mere occasion for happenings positioned in an infinitely capacious space and time. Place itself would be the happening, and space and time what *it* occasions, what *it* specifies in determinate and measurable sites. (ibid., italics in original).

This reversal of causality opens for a view of spatial practices that more concretely locates place as the locus of events, a knot which holds in it the stories that shape it. As site in this sense, Fort Ross offers an unusual performance of imaginary and "real" work, and one that goes directly to the heart of Boym's restorative nostalgia, as well as to the irony of palimpsesting: Erasure paradoxically preserves. Finally, it speaks to the entirety of Bakhtin's often-quoted passage about meanings and their homecoming festivals:

> [a]t any moment in the development there are immense, boundless masses of forgotten contextual meanings, but at certain moments of the dialogue's subsequent development along the way they are recalled and

invigorated in renewed form (in a new context). Nothing is absolutely dead: every meaning will have its homecoming festival.

BAKHTIN 1986, 170

I cannot think of a better example of such homecoming festival of meanings than what happened to Fort Ross in 2010 as its layered stories were being nostalgically recalled and invigorated. In terms of its genesis and subsequent development into our own time a couple of points need to be made. Genesis, be it of place or of person, idea or thing is invariably an emplaced affair. There is no origin without temporal and spatial coordinates; there is no succeeding trajectory without some realization of a course set in motion, albeit not necessarily staked out in exact accordance with the expectations from point of origin. So many things can get in the way, and in the case of the "eventmentality" of Fort Ross, things did indeed get in the way. Its actualization on site today, including its hasty salvaging by its "original" founders, is the result-so-far of various vectors of complex global reaches that in many ways do their work today just as they did two hundred years ago. Here is a fascinating tale and the stuff of movies, combining drama, politics, romance, and tragedy. We will begin mid-story, with a correspondence that took place in the spring of 1822 between US Secretary of State John Quincy Adams and Russian Councilor of State plenipotentiary Pierre de Poletica.

This particular flurry of diplomatic letters between old and new worlds was occasioned by a claim Russia had made to the North American territory extending to the 51st degree north, and certain regulations they intended to place on non-Russian commercial vessels operating in that area. In his letters, Adams politely makes clear that the US is quite unhappy with the edict and the strictures it sets out to place on American citizens. He further questions the Russians' explanation of their grounds for the right to the claim, to which de Poletica responds with a detailed chronicle of Russia's history in the Northwest in the period between Vitus Behring's journey in 1728 and the Russian American Company's 1799 charter, where Russia claimed the territory north of latitude 55. The tenor of de Poletica's argument is reminiscent of a more moral reasoning, as the Russian claim is founded, he says, on

the three bases required by the general law of nations, and immemorial usage among nations, that is, upon the title of first discovery, upon the title of first occupancy, and in the last place, upon that which results from a peacable and uncontested possession of more than half a century, an epoch, consequently, several years anterior to that when the US took their place among independent nations

DE POLETICA, 28 February 1822

THE TIME OF ROMANCE: FORT ROSS 127

We hear a slightly overbearing note in this remark concerning the US' status, reminding the newcomer of his place. In retrospect we may marvel at the attitude, since even as late as this, 1822, it is apparent that the US is not taken quite seriously by Europe as an agent in the world, with its own trajectory and design. And as we know, that did not really significantly change even when, only a year later, President Monroe formulated the doctrine that would set the tone for how American foreign policy would be guided for all future.

On the other hand, de de Poletica's reminder to the US of its place among the more august dominions in the "new world" at least acknowledges that the US is in fact present. This marks a change from how another Russian plenipotentiary related to the young nation only sixteen years earlier. In *his* letters back to St Petersburg from the expedition that would put him as far south as San Francisco, Nikolai Petrovitch Rezanov, envoi of the Russian American Company, seems quite oblivious to the newcomer in the East. Indeed, the conversations and discussions he had with his Spanish counterparts, the Commander of the Presidio in San Francisco and the Governor of Alta California refract, as we shall see in more detail below, no real awareness of the potential and "meaning" of the new republic.

The Russian Californio adventure that would lead to the establishment of Fort Ross in 1812 begins in earnest March of 1806, when Rezanov and his crew found themselves just outside the San Francisco Bay on the ship *Juno*. It must be said, however, that under Peter the Great explorations and expeditions northward and eastward from the Siberian Pacific coast had started as early as 1725. The Czar was "determined to make his country more modern and less isolated" (Gibson 2013, 15). It was Virus Bering's second expedition that on return in 1742 could report of a "'great land' (Alaska) across the ocean to the east and, more important, samples of peltry – this time not sables but the even more lucrative 'sea beavers' (sea otters)" (ibid., 15–16). Between then and Rezanov's arrival in San Francisco, the Russians' efforts to hold on to their presence on the northwestern coast were getting increasingly more challenging, not least because Spain, England, and later the US were sending their ships into the same waters. When Rezanov sailed south from Sitka in 1806, where the Russian settlement was in great distress, it was primarily to secure supplies for these outposts, although on his mind were also the negotiation of more permanent trade agreements. Again, this came out of a concern first and foremost with enforcing the situation of the Russian colonies in Alaska, where the growing season had proved impossible. To establish the Russian presence further south on the Pacific coast would mean a certain independence, with "an agricultural colony that could provision its Alaskan settlements" (Gibson 2013, 17). A closely related objective was, however, also the

negotiation of the boundaries between the Russian and Spanish empires on the California coast.

The initial meeting between Russia and Spain in San Francisco could well have turned out a disaster. In his letter back to the Minister of Commerce Nikolay Petrovich Rumyantsev in St. Petersburg, Rezanov tells about his arrival in Alta California in detail, and the decision he felt he had to make to ignore the well-known Spanish ban on trade with foreign ships. He writes: "I deemed it pointless to make contact in order to request permission [to enter], for in case of a refusal we must perish at sea, and so, figuring that two or three cannon balls would make less difference to us than a refusal, I decided to go straight through the [Golden] gate and past the fort – such was our situation" (*Rezanov Voyage*, 2–3). The Spanish Commander, Don Luis Dário Argüello, was away at the time, but his son had been notified of the arrival and he and the missionaries who were also there welcomed the Russians in a most gracious and hospitable manner. There were some initial language problems, and naturalist and physician Georg von Langsdorff who traveled with Rezanov, notes in his journal that, "[as] neither Lieutenant Davidov nor myself understood Spanish, the conversation was carried on in Latin, between me and the Franciscan padre, this being the only medium by which either one could make himself intelligible to the other" (Langsdorff 1814, 38).

Judging by the accounts from both Langsdorff and Rezanov, the six-week stay in what was then called Yerba Buena would become a most pleasant one, starting already with the initial welcoming dinner on that first day. After having exchanged their initial introductions, Rezanov and Langsdorff, the latter now functioning as interpreter, were welcomed on shore to join the "comandante temporal" for dinner at the Presidio. About this Langsdorff writes that, "[the Argüello family's] simple, natural cordiality captivated us to such a degree that we forthwith desired to become acquainted with each individual member of the family, and to learn the name of each one, having at once formed a strong attachment for them, and becoming interested in their personal welfare" (Langsdorff 1814, 41). The next day is spent visiting the Misión San Francisco de Asís, or Mission Dolores as it is known today. Langsdorff's account of the day is very positive and filled with the naturalist's observations of flora and fauna, as well as the customs and habits of the *religiosos*. He also gives detailed descriptions of the Native American *neofitos*, their living conditions and relations to the Spaniards. His is the detached perspective of the scientist, and offers a fairly representative rendition where objects in nature and culture are treated more or less the same – precisely as objects. He concludes the account of the outing to the Mission noting that, "[a]fter we had been shown all over this Misión San Francisco de Asís, and had become acquainted with the

THE TIME OF ROMANCE: FORT ROSS 129

misioneros and the inhabitants, we made our way to the Presidio on the approach of evening, with a deep feeling of gratitude for the generous reception we had been given" (ibid., 68). Not long after this, the Commander himself, Don José Darío Argüello, arrives in San Francisco with Nueva Californio Governor Don José Joaquín Arrillaga. The Governor and Rezanov would become friendly during the latter's stay, hinted at in Rezanov's report already after their first encounter: "The unreserved manner of the gobernadora, the mutual exchange of compliments at the table, and my intimacy with the members of the Argüello family, combined, very soon created in us a sincere mutual regard" (*Rezanov Voyage*, 23).

The exchanges between the two government representatives in these outposts of each their own empire make for interesting reading, not least precisely because of where they are. Their voices speak far away from cosmopolitan and administrative centers in old as well as in new lands and meet in a kind of pocket of calm in the midst of the Napoleonic turmoil awaiting in Europe. The talks moreover refract interesting references to conceptions of global trade routes, international foreign policy, and, finally, to the future destiny of the coast. Their talks were naturally also focused on events in Europe, and Rezanov's letters abound with reports of their discussions about European relations and Bonaparte's forays. Early on in the stay, on his way to see the recently arrived Governor, Rezanov asks one of the Mission's padres who accompanies him if they have now been granted permission to buy breadstuffs from the Spaniards. The Padre, a little uneasy, tells him of ominous reports:

> I must answer you in confidence. Previous to his leaving Monterey the Gobernador received news from Mexico to the effect that if we are not at war with you now we soon shall be. "What blunder!" said I, laughingly. "Would I have come here at such a time?" "That is what we said," the Padre replied.
>
> *Rezanov Voyage* 21

But, as news of developments overseas come closer to the outposts, this joviality which generally characterizes the conversations between Rezanov and Governor Arillaga is interrupted by a growing sense that they might soon be at war. At one point the Governor tells Rezanov quite candidly that:

> I acknowledge that I wish you success with all my heart, but I cannot conceal the fact that I hourly expect a report of a total breach of concord between our governments. I do not know how to meet and consider your project, and I must tell you frankly that it would be very agreeable to me if

you would hasten your departure in a friendly manner before the arrival of the courier expected by me.

Rezanov Voyage 12

Other conversations between the two were about existing and future trade agreements, and, more immediately connected to their actual location, complaints about imperial administrations' unwillingness to bolster their peripheries, northern as well as southern ones. This latter is a recurring topic of conversation. An exasperated Arrillaga tells Rezanov that quite often when he solicits assistance from Mexico, she simply answers by cursing California as "causing nothing but problems and expenses!" (*Rezanov Voyage* 55).

While it may not have been one of the most momentous historical events in American history, Rezanov's visit in what would become San Francisco those few spring weeks of 1806 meaningfully echoes with early manifestations and feelings of what Peter Hitchcock calls "the experience of globality" (Hitchcock 2003, 7). This lesser known history of encounter and exchanges between representatives of the Spanish and Russian empires in the beginning of the 19th century is one of those seemingly immaterial accounts that turn out to encapsulate and refract in miniature version larger narratives that more obviously and crucially serve history. For, as Hitchcock points out, in the continuation of the experience of globality follows the question, "[w]hose imagination?" (ibid., 7). From a northern point of view, a sense of globality could be imagined in terms of the Northwestern Pacific and the exploration of trans-Pacific supply routes, with the northern coast of California as the easternmost boundary. This idea certainly underlies some of the assumptions we find in Rezanov's reports back to St. Petersburg. In one of the few passages where the US is mentioned, he expresses great confidence in the workings of diplomacy, and in a Russian future on the coast. In reassuring tones, he writes that,

> The US claim the right to [the northern Pacific] shore, as the headwaters of the Columbia River are in their territory, but, upon the same principle, they could extend their possessions to all the country wherein there are no European settlements. But they will, I think, discontinue making settlements there, for the Spaniards have opened to them four ports on the Eastern coast of America, and they are excluded from touching the western coasts of America by a commercial agreement.
>
> *Rezanov Voyage* 72

The optimism makes sense in the context of the already existing Russian plans of annexing what is today the North Pacific coast into a "Russian Sea." Andrei

THE TIME OF ROMANCE: FORT ROSS

V. Grinev goes through various accounts by historians as well as tsarist officials, noting that "[o]ver-secretary of the Senate I. K. Kirilov, already in 1733 stipulated the possibility of joining the American lands in California and Mexico to the possessions of the empire, and as a possible counteraction to the intrigues of the Spanish he proposed using the hatred of the local Indian tribes toward them" (Grinev 2010, 25). Grinev then concludes that Kirilov's report proves that from very early on, "a project of broad expansion in the Pacific basin existed in government circles, including even the land of California" (ibid.). Years later, Rezanov's faith in a Russian future on the California coast was consequently not unfounded; he was in fact a latecomer to the plans of extending the Russian empire. In another of his letters back to St Petersburg he even prophesizes that, "the industries of interior Russia will receive a new impulse when the number of factories will have to be increased on account of the California trade alone, and in the mean time ways will be found for trade with India by way of Siberia [...]" (*Rezanov Voyage* 42). The confidence these lines exude speaks of many things, among them the transnational, indeed trans-imperial character of California already in the early 19th century, and the multiplicity of differently originated point of views, imaginations, and imaginaries that it already played host to. A similar tenor, albeit a warning more than anything else, is found in Langsdorff's more sober style. He is skeptical to these plans, and in his *Narrative* notes that "[t]he Russian American Company's possessions are at such great distances from one another, that, with the present means of navigation, the company could hardly afford the upkeep of communication, and the lack of ships and sailors would be doubly felt if a regular intercourse with Nueva California should be attempted" (Langsdorff 1814, 87). What is remarkably missing from both Rezanov and Langsdorff's positions is any real reference to the fact of the republic to their east. In all the speculation about a Russian future in California, the US is given little attention.

We must here bear in mind that Rezanov's visit and reports took place only three years after Jefferson had secured the Louisiana Territory, and while that president harbored no explicit, immediate plans of pushing the boundaries of his new territory further west, he noted in a letter already in 1786 that, "our Confederacy must be viewed as the nest from which all America, North and South, is to be peopled" (Horsman 1981, 86). In a letter to James Monroe on the possibility of relegating territory to emancipated slaves, Jefferson had expressed more clearly a vision for the possible future of the continent: "It is impossible not to look forward to distant times, when our rapid multiplication will expand itself beyond those limits, & cover the whole northern, if not the southern continent, with a people speaking the same language, governed in similar forms, & by similar laws [...]" (Jefferson, 21 November 1801). And, of

132 CHAPTER 5

course, roughly at the same time as Rezanov was in San Francisco the Clark and Lewis expedition was in full progress, completed in the fall of that same year. While there is no good reason Rezanov should be familiar with Jefferson's letters, one wonders a little that the US is barely mentioned in his letters to St Petersburg. Granted, we hear how on a couple of occasions Arrillaga refers to his problems with the "Bostonians."[2] He confides in Rezanov that "the audacity of the Bostonians has alarmed us, but the ministers have promised to dispatch a frigate this year to watch the vessels from the American states [...]" (*Rezanov Voyage*, 56). As we know, the "Bostonians' audacity" would only forty years later be carried out on a military and ideological scale that realized the mythological quality of California into, as explorer Charles Wilkes noted in 1839, the controller "of the destinies of the Pacific" (McDougall 1997, 93). Mexico would gain independence from Spain in 1821, and in 1842 the Russians would retract to Alaska. Shortly after, the Commander of Northern California, Don Mariano Guadalupe Vallejo, would be ousted from his home in Sonoma and imprisoned at Fort Sutter in Sacramento. Two years after that Vallejo and his fellow Californios were American citizens, and then, in 1849, gold was found, assessed by Marx and Engels as "the most important thing which has happened in America." The prosperity they prophesized would sure enough come true, but not so much the co-existence of disparate peoples they also prophesized. As we considered previously in Chapter 2, the determination of Anglo American 49'ers overran that of other groups, and Marx's and Engels' inter-racial "rich, civilized" land was soon in the hands of only some.

In hindsight one can see at least in part how it was that the rapid changes in the region could come about, and also how neither a Spanish nor a Russian California had much chances of being realized. Spain and Russia were both overextended and had to expend expensive and time-consuming energies in Europe. Perhaps as importantly, their ventures in America were circumscribed by a different sense of progression than that of the young US. One could, perhaps, think of this difference in terms of a chronotopic variation, in which the ongoing adventures were guided by different time-space principles stemming from rather concrete geographical and historical features which in turn generated and were generated by different imaginaries. The US had torn loose from her past more or less entirely, eventually founding herself in the commitment to the Declaration of Independence in a steady, forward looking gaze. This would be shared and enforced by a stream of immigrants whose perspectives

2 The Russians adopted Chinook terms, who referred to American shipmasters as "Bostonians" and the English ones as "King George's men" (Gibson 27, fn. 6).

embraced the futurizing potential of their new home. In stark contrast, the presence of Russia and Spain in their "new world" operated along a principle not of breach with the past, but of continuity. This other kind of orientation would hold their gaze directed toward the past; for Spain in an abstract sense, for Russia in an abstract as well as a concrete, geographical sense. Out of these very different modes of imagining result radically different performances of relations to the past that necessarily also influence those in the present. Richard Rodriguez identifies the differences between colonial Spanish and English imaginaries in the following observation:

> The two groups had different ambitions. Spaniards dreamt of gold. Spanish settlement was also, of course, Roman Catholic and connected the United States with Mexico, and through Mexico to the court of Madrid and the Church of Rome – a continuous line uniting past with present.
> Low-church English Puritans tended to be in rebellion against English memory; everything was focused on the future.
>
> RODRIGUEZ 2008, 20

A similar link from past to present via religion and tradition in a broader understanding can be posited in Russia's case; indeed, the teaching of Orthodoxy to colonial subjects in the Kodiak islands was explicitly endorsed by among others Rezanov himself (Miller 2010, 112–113). This went hand in hand with a general emphasis on education, of Russian and Native Alaskan children alike, and Rezanov was consequently in line, as Miller puts it, with other European elites' thinking in the context of their colonizing projects: "It was imagined that in distant 'laboratories' of imperial rule local people could mimic the best traits of European subjects and hopefully abandon those behaviours less desirable" (ibid., 115). This, then, was very much behind the Russian model of interaction with the native peoples in places where they settled, such as the Kodiak Islands and Sitka. It also bears mentioning that there was a high enough rate of intermarriage between ethnic Russians and indigenous Aleuts to receive its own term, *kreoly*. It was, according to some sources, none other than Rezanov himself who was the first to use the term, if only informally (Vinkovetsky 2001, 201).

Purpose, presence, and perspective in the New World were consequently radically different in the Russian California vision from that of the future-oriented US. For both Spain and Russia, the anchoring of the New in spiritual centers and cultural traditions in the Old forged connectivities that in some ways chained the actors in the present to their pasts. Related to this temporal enactment of continuity was, in Russia's case, a spatial one, for the strained

empire had somewhat uncertain cultural edges. Its relation to the peripheries on the American west coast proceeded along principles of gradation rather than clear-cut ruptures. This was a result of the overland routes that early explorers had traversed before the circumnavigations started in 1803. Historian Ilya Vinkovetsky thus notes that,

> the Russian crossings of Siberia were greatly assisted by the indigenous Siberians who lived along the way. The diversity among [these] cultures is impressive, but what is particularly salient is that some of these cultures [...] bore striking similarities to the indigenous cultures that the Russians would find on the North American side of the Pacific. [...] In a very real sense, in the eighteenth century, for the *sibiriaki* (the Russians of Siberia) the line between the so-called Old world and New World remained blurred and fuzzy.
>
> VINKOVETSKY 2001, 196

In several ways, then, the route from St Petersburg across the ice-cold snow forests into the new territories marked not a definite breach (with the periphery as inherently and irreconcilably Other, different, and past), but a more blurred and continuous trail that may also have posited frontiers more porous. This kind of advance furthermore evokes a sense of movement guided by the principle of metonymy, an important point to keep in mind for the site-specific performance that Fort Ross would stage 200 years later, and which I come back to in detail very soon. The metonymic in this case is, however, not a modus operandi of the kind that we saw with Bodie in Chapter 2, where metonymy applies to the seeing itself of the ghost town. In that instance, the focus is on the orchestration of the gaze into a multiplicity of viewpoints, yet commanded by a mode of association, of joining together, as the word implies.

When I refer to metonymy in relation to the Russian progression southward along the North American Pacific coast, a similar point applies but on one level it has to be understood quite literally and concretely. In cognitive linguistic terms, one could say that the projection from an original, or source domain of knowledge (Russia,) is brought onto its target domain (new world) in a transfer of spatial practice where the original domain is not quite left behind. Instead, the route leading from past to present (and future) governing Russian ventures, stays closely connected to it point of origin, the home domain. Consider how different, tropologically speaking, is the American project in its intent to disconnect from so much of the Old World's habits and forms. David Lowenthal frames that difference in a comment that resonates interestingly with our line

THE TIME OF ROMANCE: FORT ROSS 135

of thought here that sees differences between empires' routes tropologically. "In severing imperial bonds," Lowenthal writes,

> Americans discarded not only the mother country but many of its traditions. Three interrelated ideas helped justify dismissal of the past: a belief that autonomy was the birthright of each successive generation; an organic analogy that assigned America to a place of youth in history; and a faith that the new nation was divinely exempt from decay and decline.
>
> LOWENTHAL 1990, 105

The passage echoes the condition of breach rather than of continuity, and points at a frame, or perhaps more accurately a filter predicated on future orientation rather than the backward-looking gaze. I will not go into this complex in too much detail here, but it stands to reason that if the route from past to future, from old to new in the Russian case can be conceptualized metonymically, then this other route, one defined by the idea of rupture and future orientation, may have its own trope. Metaphor is perhaps the appropriate one here, making its comparison by implication and not the kind of contiguity that metonymy requires. Instead, metaphor projects the familiarity of one idea or domain over into another, sometimes entirely different one, and only by loose association. There is no immediate connection between "love" and "rose," as the typical example of metaphor has it. Metaphor, in a word, has a certain plasticity to it, metonymy much less so.

Whichever the case, the contrast in direction of temporal and spatial orientation would come to matter a great deal for the unfolding of events in what is today the US generally and on the California coast specifically. Such tropological choreography relates in turn closely to the social and cultural imaginaries that embed it, and which are at the same time embedded *by* it. Imaginaries can seem deceptively easy to understand; philosopher Charles Taylor, for instance, describes social imaginaries as "the ways people imagine their social existence, how they fit together with others, how things go on between them and their fellows, the expectations that are normally met, and the deeper normative notions and images that underlie these expectations" (Taylor 2004, 23). Underpinning this straightforward explication are, however, a wealth of intricate contingencies. The imaginary, Taylor continues, is "carried in images, stories, legends," "is shared by large groups of people," and makes up "that common understanding that makes possible common practices and a widely shared sense of legitimacy" (ibid.). The next, crucial node in this reasoning is that "if the [background] understanding makes the practice possible, it is also true that it is the practice that largely carries the understanding. At any given time, we can

speak of the 'repertory' of collective actions at the disposal of a given group of society" (ibid., 25). The social imaginary can consequently be conceived of as a kind of enabling and enabled frame, or filter, through which a group, community, society sees, grasps, and performs its understanding of its own practices.

To elaborate a little further on the frame, or filter, it is useful to turn to another thinker whose calibrations of the imaginary complements the above, but who possibly also speaks more directly to the tropological underpinnings we are interested in here. Philosopher Cornelius Castoriadis does not talk about the modern social imaginary, but the more general and always present *instituted* social imaginary. This is specifically "a constitutive faculty of human collectivities, and more generally of the social-historical sphere," among whose work are institutions, "quickened by – and bearers of – significations" (Castoriadis 2007, 73). These significations, Castoriadis continues, "refer neither to reality nor to logic, which is why I call them social imaginary significations" (ibid.). The accentuation of these less tangible elements is more clearly explicated in his suggestion elsewhere that the imaginary has to "use the symbolic not only to 'express' itself (this is self-evident), but to 'exist,' to pass from the virtual to anything more than this" (Castoriadis 2005, 127). This latter observation is particularly relevant to our focus here. One could argue that it was precisely the varying instantiations and institutions of the symbolic that at least in part would determine the future of Russia's and Spain's roles on the Pacific coast. For the third actor in this New World scenario is precisely the newly constituted United Stated and its sense of legitimacy borne of breach, with understanding and practices, and a subsequent enabling and enabled frame embedded in a tropology uniquely orchestrated around the future.

I must emphasize that I do not intend to say that we can describe foreign policy relations in the early 19th century by means of tropology and a few letters, but the Russian – Spanish affair, and the Russian California enterprise do tell us something about the cultural and historical negotiations of old and new, and the potential of differently originated and "troped" imaginaries as they are lodged in place. Needless to say, the Russians would withdraw from California, and from the entire North American Pacific coast. The negotiations that took place between Rezanov and Arrillaga in San Francisco resulted, however, in a trade agreement between their respective empires, and on his stop in Sitka on the way back to St. Petersburg, Rezanov urged the Russian American Company to establish a colony on the northern frontier of Spain's Alta California to secure supplies for the Alaskan settlements. This, now, would in 1812 result in the establishment of Fort Ross as the southernmost Russian settlement in California. To the fort came Ivan Alexandrovich Kuskov, assistant in Sitka to the Russian American Company's manager Baranov, and with him he had twenty-five

THE TIME OF ROMANCE: FORT ROSS

Russians, many of them craftsmen, and eighty Aleuts (Watrous 1998). In the years Fort Ross existed as a Fort, it was never once attacked, and largely functioned as a more or less self-contained community of Russians, Aleuts, and Kashaya. Stephen Watrous describes this as follows:

> Although no one left a detailed account of daily life in the colony, the observations of both residents and visitors point to a busy if simple existence. In addition to hunting sea mammals and birds, parties fished for salmon, sea perch, and sea bass, and harvested local shellfish for the settlement's larder. Sturgeon were caught in the Russian River. Farming and ranching consumed many hours of the colonists' time, with even some of the Aleuts and Indians joining in to handle planting, cultivating, herding, logging, and construction chores.
>
> WATROUS 1998

In this way Fort Ross remained in operation until 1841, until finally Russia realized that it could not hold on to her distant colony any longer – it was too complicated, and too expensive. The Fort was offered up for sale, and the only interested buyer would be John Sutter, who bought it for 30 000 $ (sources disagree, however, as to whether he ever actually paid). And, so ended Russia's affair in California. It lasted only briefly and left nothing behind like the marks which the presences of Spain, and then Mexico did. We now circle back to where we started, and the Russian Ambassador's plea to Governor Schwarzenegger in 2009: For why is it, then, that when Fort Ross was threatened with closure in 2009, the Russian government rushed to its rescue? Surely, it is not simply that it was once a Russian holding; it would become an impossible enterprise should a nation try to look after all the fragments of its past. So, why is this site so special, and what is it that we as visitors see when we visit? This now brings us to the performance on site that Fort Ross invites to.

2 Interrupted: Nostalgia and Time Out of Time

There is as far as I know no historical record of any explicit longing or design for reclamation on Russia's part for the piece of land they once claimed. On the other hand, Fort Ross is one of very few traces left from the Russians' brief sojourn, and maybe this helps explain the rush to save it from oblivion. Nostalgia is clearly involved when the Russian ambassador said that the little fort "holds significant cultural, historic and sentimental value for the Kremlin, Russians and Russian Americans." It remains a monument to having once been present

138 CHAPTER 5

unlike other traces that we know of, which are entirely erased. The cemetery once located on Russian Hill in San Francisco is one such. Today a high-end neighborhood with no observable link to a Russian past, the hill takes its name from a cemetery for deceased Russian sailors who were not allowed to be buried elsewhere. The graves were later moved; sources have different years for this, but relocation took place sometime between the early 1850s and 1870s; the bilingual plaque where the cemetery used to be dates it to the 1860s.

Other place names are not quite as finalized. Russian River in Sonoma County, named Russian Gulch by the same Kuskov who established Fort Ross, is today host to more than one hundred vineyards. They offer dreamy hideaways to visitors from the entire world, advertising themselves as romantic retreats from modern life, like little pockets of past-ness in the flux of the present. While the Russians did not start the wine industry themselves, they had something to do with it: To my knowledge, the earliest, still operating California vineyard lies in Sonoma, a town built around the last and northernmost of the Franciscan mission, and established with the explicit objective of shoring up the Russian presence at Fort Ross. (Parkman 1996/1997, 363).[3] None of this, however, can possibly help explain why the Russians would be so keen on aiding the flailing Fort when Schwarzenegger put it on the "death list" of California's state parks.

So, what is it? As far as the sentimentality the ambassador referred to, what is the nature of the feelings Fort Ross evokes? I said before that the story of Rezanov's journey is the stuff of movies, and we have seen the parts played by imperial politics and economics. There is, however, another aspect to the story of Fort Ross, and it involves both romance and tragedy. For, quite early on in his stay in San Francisco, Rezanov had fallen in love with Commander Argüello's youngest daughter, the lovely Maria Concepción. The romance is mentioned in his reports to St. Petersburg; a little abashedly he tells the minister that he apologizes for divulging such personal affairs, but, that "associating daily with and paying his address to the beautiful Spanish senorita, I could not fail to perceive her active, venturesome disposition and character, her unlimited and overweening desire for rank and honors, which, with her age of fifteen years, made her, alone among her family, dissatisfied with the land of her birth" (*Rezanov Voyage* 37). Rezanov goes on to relate how he has told Maria Concepción of the much colder Russia, yet a country rich and bountiful, and that she would be willing to move there. Then follows a line that rings a little cynical in our ears: "[...] at length I imperceptibly created in her an impatient desire

3 See Parkman's essay "Fort and Settlement: Interpreting the Past at Fort Ross State Historic Park" for a thorough survey of Fort Ross' relation to Spain and Mexico.

THE TIME OF ROMANCE: FORT ROSS 139

to hear something more explicit from me, and when I proffered my hand, she accepted" (ibid., 37).[4]

Langsdorff, too, comments on Maria Concepción's beauty, but goes into a far more detailed exaltation when he describes her than does Rezanov. This can of course be explained by the medium the latter had to communicate through, constrained by the nature of the official business letter report. Langsdorff can more freely write in his journal that the young woman "was distinguished for her vivacity and cheerfulness, her love-inspiring and brilliant eyes and exceedingly beautiful teeth, her expressive and pleasing features, shapeliness of figure, and for a thousand other charms, besides an artless natural demeanor" (Langsdorff 1814, 42). He comes back to the young beauty in a chapter of his *Narrative* titled "Trade and Romance – Dona Concepción." The juxtaposition of the two, trade and romance, and Langsdorff's own comments on the plans of marriage, reveal that he saw it as part of Rezanov's plan to finalize trade agreements with the Spanish Commander. He writes: "Our intimate association daily with the Argüello family, the music and dancing, the sports, aroused in the mind of Rezanov some new and important speculations. These led to the formation of a plan of a very different nature from the original scheme for the establishment of commercial relations" (ibid., 85). The description that follows is, however, more ambiguous as to his perceptions of Rezanov's design, because here Langsdorff says that Dona Concepción's "bright sparkling eyes [...] had made upon [Rezanov] a deep impression, and pierced his innermost soul" (ibid.). Surely, this is not the description of strict and pragmatic business. And yet, only lines later Langsdorff adds that for the sake of future business bonds, Rezanov "had therefore decided to sacrifice himself, by wedding Dona Concepción" (ibid., 86). So, which was it, sacrifice or infatuation? It could of course be both, but this will never be known – the marriage never took place.

When Rezanov left the Presidio in the late spring of 1806 it was with the promise of a speedy return to his future wife once the Czar and the Pope had blessed the mixed marriage, and to continue working on the plans for the

4 Rezanov was not the only Russian to fall in love in Alta California. Josef Bolcoff, for instance, was one of many Russian sailors who jumped ship in California during the first decades of the 19th century. (Indeed, Rezanov himself in one of his letters complains of this, saying that several of his crew are talking about staying behind, to the extent that he "ordered their removal to a barren island, where they were held until departure." It is very likely that the island was Alcatraz, and these unruly sailors its first prisoners.) Bolcoff became a Mexican citizen in 1822 and married Candida Castro of Santa Cruz the same year. In Santa Cruz he not only ran the dairy farm that would later pass over to the Wilder family, but also engaged in smuggling on that wild Pacific coastline. More romance. Today the former Castro Ranch, now the Wilder Ranch, is, like Fort Ross, a State Park.

fringes of his empire. But it was not be: On the way back to Saint Petersburg on horseback across Siberia, he caught pneumonia and died in Krasnoyarsk in the beginning of March 1807. Various accounts tell the story from there on differently, but most sources hold that news of his death did not reach Doña Concepcion until two (or five) years later. She then joined a Dominican order and spent the rest of her life in the monastery, dedicating her life to helping others until her death in 1857.

Romance and tragedy would consequently accompany the Russian design on California, and the story of this encounter and its sad denouement would be inscribed into the broader register of California romances. The earliest and still best known is probably its immortalization in Bret Harte's long poem "Concepcion de Arguello," published in the section of his 1882 *Complete Poetical Works* which is titled "Spanish Idyls and Legends:"

> Count von Resanoff, the Russian, envoy of the mighty Czar,
> Stood beside the deep embrasures, where the brazen cannon are.
> He with grave provincial magnates long had held serene debate
> On the Treaty of Alliance and the high affairs of state;
> He from grave provincial magnates oft had turned to talk apart
> With the Commandante's daughter on the questions of the heart,
> Until points of gravest import yielded slowly one by one,
> And by Love was consummated what Diplomacy begun.
>> HARTE 1926, section II

The poem then narrates Concha's waiting for her love's return; in Harte's pen this waiting goes on for forty years with a "music in its dreary monotone." The final stanzas tell the end of the romance: The Governor of the Hudson's Bay Company, Sir George Simpson, visited Santa Barbara early in the year of 1842, and reportedly met the older Doña Concepcion there. Harte included this in his poem, and its rendering lends an extra tragic note to the conclusion of the story. At a banquet in honor of his visit Sir George relates to the guests that Rezanov "[died while speeding home to Russia, falling from a fractious horse," upon which a "deathlike silence" falls on the banquet and Doña Concepcion, now a nun, gets up, and her "trembling figure rising fixed the awestruck gaze of all:"

> "Lives she yet?" Sir George repeated. All were hushed as Concha drew
>> Closer yet her nun's attire. "Senor, pardon, she died, too!" (ibid.)

The real-life love story was later picked up also by the tremendously popular novelist and native Californian Gertrude Atherton, author of innumerable

THE TIME OF ROMANCE: FORT ROSS 141

books, and among them the 1926 *Rezanov*. This historical novel is based on many of the same sources we have consulted here, and fictionalizes on the plot lines the actual history that Rezanov's visit and journey provide. As a romance, the main focus of Atherton's novel is of course the relationship between the two unlikely partners, and the embellishment on thoughts and conversations entirely the work of fiction. This is Atherton's license, and as she follows Rezanov to his dying moment in Siberia, the novel ends: "So dies Rezanov; and with him the hope of Russians and hindrance of the Americans in the West; and the mortal happiness and earthly dross of the saintliest of California's women" (Atherton 1906, 320). The Rezanov story thus comes down to us as one of California's great love stories; indeed, the inscription in *The Rezanov Voyage to Nueva California*, published by The Private Press of Thomas C. Russell in 1926, reads as follows: "To C.O.G. Miller, Esq. of San Francisco, who, amid his multifarious business interests, is never-failing in his interest in the romantic history of California."

Interestingly, it would be about 50 years before the Rezanov story received its own and popularized version in Russia. In 1981 the rock-opera *Juno and Avos*, based on the renowned poet Andrei Voznesensky's poem "Avos" from 1970, premiered to great acclaim. It successfully survived the transition from the Soviet Union to Russia and remains popular today. That the romance carried in opera form shows no slowing down in attracting its audience is also reflected in the *San Francisco Classical Voice*'s enthusiastic review when it was expected to play in San Francisco in 2012: "When you think of monumental stories of great lovers, which ones come to mind? Romeo and Juliet, of course. And maybe Antony and Cleopatra, Lancelot and Guinevere, Tristan and Isolde, Achilles and Patroclus, and Pyramus and Thisbe, to name a few. I propose another pair: Nikolai and Conchita. Never heard of them? You're in good company" (Godavage, 2012). It is quite understandable that the review places the story in such famous grouping as it does, because it fulfils the criteria of a classic adventure romance almost to a point. The possible distinction between it and these others is that it really does not need much fictionalization to work as such; the actual history is plenty. Its consistency with the genre is consequently the more remarkable, for some of the aspects Bakhtin discusses in his introductory remarks to his "Forms of Time and the Chronotope" read like they could be made with Rezanov and Conchita in mind. The list of elements characterizing the adventure romance, and which would endure in some form or other throughout centuries of its generic life, include among other the following: We have a hero and heroine of marriageable age (both Nikolai and Conchita), they are remarkable for their exceptional beauty (Conchita), they meet unexpectedly (absolutely so in this case), they passionately fall in love (probably), their union is delayed by

various obstacles (in our case foreign policy, religion and vast expanses), they are parted (Rezanov's departure), the consent of parents or others must be obtained (his plans to get the approval of the Church), and finally, the story takes place against a "broad and varied geographical background, usually in three to five countries" (Bakhtin 1991, 88). The last criterium would in the romance between Rezanov and Concha include Russia, Spain, the US, France, and various expanses of indigenous territories; there are detailed descriptions of surroundings in the descriptions by both Langsdorff and Rezanov. There are discussions of a religious, political, scientific nature between Rezanov and Commander and Governor, and we could go on. Where the story does *not* conform, however, is in its ending. Bakhtin's adventure romance must have a happy ending, "with the lovers united in marriage" (Ibid.). The Rezanov story lacks this conclusion, and no matter how many writers have retold it in poem, novel and opera, there simply cannot be this, final fulfilment of expectations. Nikolai dies every time; Conchita withdraws into the monastery.

Perhaps it is precisely this kind of deferment that energizes Fort Ross' site-specific performance, and maybe the "sentimentality" that ambassador Kislyak talks about goes directly to a sense of romance unfulfilled, a history cut short. Here Atherton is actually rather astute when she in her novel equates Rezanov's death with the end of Russian America; in many ways it was. It was his efforts that begot Fort Ross as strategic boundary point, but Rezanov also dreamt bigger, as we saw, as had others before him. Again, it is not that Russia ever entertained ideas of reclamation once they withdrew from the California coast; the mere thought would be fantastical. And yet, and yet, there the little fort lies, left behind when Mother Russia called her children home. The site as a site is consequently a monument with a more than average power to *cite* – that is to say, what Fort Ross draws onto its stage are not only historical vectors of momentous reach; in bringing those together, for instance in its yearly festival, it also rehearses the incomplete romance. A version of Casey's "eventmentality" of place is very much at work here, for Fort Ross clearly has the "capacity for co-locating space and time" (Casey 1996, 38). Its gathering potential furthermore also attains to considerable heights, for, as Casey also notes, the way or mode in which place holds, or contains events, is also key to its signification. The arrangement of things in place, he says, "allows for certain things – people, ideas, and so forth – to overlap with, and sometimes to occlude, others as they recede or come forward together. [...] but equally a place holds out, beckoning to its inhabitants and, assembling them, making them manifest" (ibid., 23).

I am intrigued that Casey uses the word "arrangement." The implication of putting things in a certain order, of the placing of things or persons in a series, is precisely what sites in their citations do. They arrange for us, and they do so

according to orchestrating principles that are the co-creations and co-designs of audience, the site itself, and the "work" that emerges in the triangularity of the event. As in music, painting, and other aesthetic expressions, we can furthermore detect a governing theme or motif according to which things and persons and their performances on site find their place, are arranged. In the case of Fort Ross, one can speculate that the nature of this principle has a lot to do with the romance that helped bring it into existence in the first place. But more than that, the suspended conclusion to the adventure time (if read along Bakhtin's lines of the genre) which the site comes shrouded in, has also clearly helped produce it as symbol for several "things." One is the cultural memory of the larger history of empires' designs in the "new world," and the extraordinary history of the Russian count and his Spanish bride to be; another, but similar sentimental orientation toward the past may have to do with the chapel that forms a locus of the fort. As journalist Charles Hillinger remarked several years ago, "for Russian-Americans throughout the United States, Fort Ross today represents the major cultural contribution of prerevolutionary Russian to the United Stated. The tiny chapel here was the eastern and southeastern extension of the Russian Orthodox faith in the 19th century. Because of that, the state park is a mecca for Russian-Americans" (Hillinger 1979). The chapel was the first orthodox church in America, and thus the specific citation that *it* performs also holds in it another kind of long cultural memory that predates the ban on religion that Soviet Union would later enforce.

The fort had and has a cemetery where approximately 130 people were buried in the few decades between the establishment of the fort and its conclusion. These included "Russians, the Kashia Pomo, Miwok, Spaniards and Mexicans" (Minichiello 2018). Located in stunning surroundings overlooking the Pacific, the once weather-beaten crosses and the grounds they protect and commemorate were renovated in 2018, with both Governor Jerry Brown and Russian Ambassador Anatoly Antonov present to celebrate. This, too, was made possible by funding the Fort Ross Conservancy received from the Renova group. Leslie Hartzwell of the cultural resource division in the state park system observed that, "[t]here are so many people who share a history to this place and their cultural traditions are still anchored to Fort Ross, and it's very important to be a place where people can continue to come and celebrate their cultural history and carry on their cultural traditions" (ibid.). The comment reminds us of the power of remembering and excavation that inheres in site-specificity, and we can perhaps in a slightly different vein see the citations that the site administers as a mode of arrangement reminiscent of participatory art.

In her work on participatory monuments Røstad comments that the "only thing clear about working with participation is that you cannot control

everything" (Røstad 2018, 49). She continues to note, however, that in relation to both participation and performance certain things are still shared and constant: "Both practices include public engagement, and both practices challenge the hierarchy of authorship through different approaches to the positioning of roles" (ibid., 51). I find Røstad's observation quite relevant to the site of Fort Ross, because its figure before us today responds to all of the above: it unpredictably has returned itself to a presencing in Russian cultural memory; its presentation brings to the stage an authority, or a kind of co-author, that derives from a region other than the one it belongs to; and finally, as a site it relies fully on public engagement for the story it performs. The kind of imagining into and co-creation of complexity that Fort Ross cites for us consequently corresponds to another characteristic of participatory monuments that Røstad makes more specific note of: Such a monument "brings the public into the artwork, engaging them as participants through interaction with remembrance and forgetting," and "activates memory and contributes to forming collective memory through participation" (Røstad 2019). While Fort Ross, or any site for site-seeing like it, cannot seamlessly be collapsed into the category of participatory art or monuments, borrowing some of this artform's understandings help us see more fully the kind of homecoming festival of meanings that has taken place here.

The yearly event which gathers onto its stage various Russian traditions, be it dance or food or custom, reach out to the visiting audience and, if not exactly "form" as in Røstad's participatory monuments, then it certainly reminds them of and activates a collective memory that originates on the site of the festival. The totality of Fort Ross as a work of commemoration thus complexly invites the audience into a performance of both remembering *and* forgetting, all along responding to the tenor of deferred romance. This produces a sentimental reaction, there is no doubt about that, and the staging is also very much a matter of nostalgia. We recall Boym's approach to nostalgia, where she defines it "as a longing for a home that no longer exists or has never existed. Nostalgia is a sentiment of loss and displacement, but it is also a romance with one's own fantasy" (Boym 2007, 7). Fort Ross fits the description well, for, as a participatory monument and site-specific performance it commemorates precisely what never really existed. That is to say, its once strategic position as the southernmost outpost of the Russian empire in the early decades of the 19th century was in hindsight always an imaginary, an unrealizable dream. The Russian fort's brief existence as such was in many ways the outcome of a romantic view of borders and nations in and of itself, of adventures across great maritime expanses and impossible distances between

center and periphery. The exchanges between Rezanov and St Petersburg clearly refract the obliviousness to the realities of the space the "adventures" occurred in.

So, what kind of nostalgia orchestrates the performance? It is not restorative, as in returning to what has been lost, but it may well be a version of Boym's reflective nostalgia, that strand which she describes as not following "a single plot but explores ways of inhabiting many places at once and imagining different time zones. It loves details, not symbols" (Boym 2007, 14). The lines vibrate with Fort Ross on several levels: its monumentality emerges precisely from the gathering into place worlds and worldviews literally spanning enormous distances; the details of its parts – chapel, cemetery, stockades, festivals – these are concrete objects that do not stand for anything beyond themselves. Fort Ross as a participatory monument veiled in reflective nostalgia furthermore responds with much accuracy to Boym's suggestions that "the rhetoric of reflective nostalgia is about taking time out of time and about grasping the fleeing present" and that its focus is "on the meditation on history and the passage of time" (ibid.). The site of Fort Ross does not restore the past, but invites its visitors to review, again and again, the fantasy of its short-lived existence and inconsummate denouement.

It is perhaps appropriate to conclude these ruminations with an event that took place in San Francisco in 2012, and which oddly echoed some of the elements that played into the fort's genesis. When Renova's Vekselberg organized a fundraising event in San Francisco City Hall to raise money for Fort Ross and to celebrate its bicentennial, we can read from *Forbes'* report that it "featured speeches by Vekselberg, Senator Dianne Feinstein – who sat next to Vekselberg at dinner and told the crowd that she was half Russian: her mother was born in St. Petersburg " (Dolan 19 Oct, 2012). The dinner guests also included the Russian minister of culture, and messages from both Putin and then Secretary of State Hillary Clinton were read. There was a video transmission of the "Mariinsky Theater Orchestra playing a Tchaikovsky symphony – overlaid with stunning images of the Fort Ross park [...] and performances by members of the Bolshoi Opera." *Forbes* concludes that, all in all, the gala dinner "had a distinctive Russian feel" (ibid.). While relations between the US and Russia were not as strained as they would become only a few years later (and had been in years prior), the scene evokes certain images from the 1806 meetings between the imperial plenipotentiaries in the Presidio. In both cases conversations would have turned on questions related to a place far away from larger political schisms, and yet in both cases that locale, the same site, comes to hold in it what Casey refers to as "things," where "people, ideas, and so forth" overlap

with and sometimes occlude "others as they recede or come forward together" (Casey 1996, 23). From the point of view of site-specificity and aesthetics, Fort Ross consequently exemplifies the composite of what Pearson calls the "contemporary past" (Pearson 2006, 41), a standing invitation to romance, to the irresistible, What if?

Conclusion: Tangled Figurations

> ... as place is sensed, senses are placed; as places make sense, senses make place.
>
> STEVEN FELD 1996, 91

∵

Stegner is not the only one to describe the region that holds the five points in this book's visitations so far as being marked by restlessness and transience; similar sentiments are voiced in for instance Neil Campbell's description of the West as "ungrounded, restless, and mobile – rhizomatic – constantly reframed and reinvented in a manner akin to the experience of cinematic montage, association, and suggestion [...]" (Campbell 2008, 301). In *The Rhizomatic West*, he explores the region as a space where routes constantly cross in a space of permanent impermanence. In our five site-seeings, too, we see the ebb and flow of claims to place from differently originated routes surface in traces and memories, and we see them congregate onto the site-stage in unique chorographic postures. They dot California as marks of lasting albeit frequently hasty encounters, and with variously enduring legacies refracted in aesthetic figurations on the sites they belong to. It bears reminding again that they are not site-specific performances in the sense of the artistically intended and orchestrated. They are also not technically speaking site-specific installations or public art works. My intention in this book has rather been to read sites similarly to how texts can be read, bringing the interpretative tools of the aesthetically figurative into dialogue with the vocabulary of site-specificity of performance and installation into chorographic practice. "Events create spaces," Pearson notes (Pearson and Shanks 2001, 21), and the traces of those events/spaces saturate place into site, possible to read and read *for* much like we approach text and the figures it produces. If only momentarily, they congeal into formation long enough that we can aesthetically approach them and the complicated stagings of temporal and spatial intersections that result. Site-seeing aesthetics thus invites a contemplation of place as a sensable site of and for performances, with layers of pastness to be approached and appreciated accordingly.

As we have also seen, the sites as aesthetic formations tend to arrange themselves around figures that bear, as Genette writes in a different context,

"presence and absence simultaneously" (Genette 1982, 50). He refers to texts, but there is no reason we cannot also see site and its citations as a similar kind of texture, intricately woven and patterned. The spatial conundrum of Genette's figure is moreover also the precarious balance of the presencing and absencing of place: For all the efforts at freezing it in time, to give it the coating of a story that can fence it off from subsequent decrypting forays, place sooner or later tears loose. In arrested postures as saturated site, we thus momentarily acknowledge the elements of temporariness and fluctuating performances as a cultural curation emerging between it and us as audience, the co-creation resting on a practice of reading *cum* arrangement. This is to say, in our sensing of sense through the excavatory and the palimpsestuous, we bring into dialogue strands of layered webs of half-forgotten and all but forgotten meanings onto the site-stage. Like fragments, the strands evoke the contours of lived worlds, of imaginaries that convene onto the same podium to speak, albeit sometimes eerily and impossibly tangled. What Ranjan Ghosh says about aesthetic imaginaries can consequently also be said about these kinds of webbed strands and the worlds they summon. They, too, are

> built inside the borders of a nation, a culture, a society, a tradition or an inheritance, but it disaggregates and reconstructs itself when exposed to the callings and constraints of cross-border epistemic and cultural circulations. Aesthetic imaginaries then are entangled figurations bearing out the promise of "shared realities" and what Toni Morrison calls "shareable imaginative worlds"
>
> GHOSH 2015, 134

In all five literary chorographies so far, sited significance is the result, often quite literally, of "callings and constraints of cross-border epistemic and cultural circulations" that mobilize postures of intertwined otherness. Under the pressure of different routes and their roots (Clifford 1997), they disentangle and form again, temporarily resting in place, only to disaggregate again. Fort Ross' romance bears with it into its present s/cited-ness the mark of imperial encounters and the histories of displacements of rightful inhabitants; the story of Dodger Stadium mobilizes vectors of migration, settlement, and replacement onto *its* present s/cited-ness. All five points emerge out of different degrees and kinds of otherness, constellations of aggregations and disaggregations and complex entanglements, and always as the result of the imaginaries that carry them.

With the possible exception of Sara Winchester's house, there is moreover a sense of the ruinous to the sites, elements of disintegration and wreckage

TANGLED FIGURATIONS

of once wholes that more or less clearly inflect on their performances. In the buried strata conjured up from under Dodger Stadium, in the references to long gone camps on the frail paper of Wilson's letters, in Chinese Camp's overgrown, half-hidden, semi-ghostly presentation, and in the fragment of a momentous history that Fort Ross stands for, we are confronted with how "[r]uins makes us think of the past that could have been and the future that never took place" (Boym 2017, 45). As audience to the sites' feel of the ruinous, we are consequently caught in a somewhat restless tension of possibility and closure, and we both enlist and are enlisted by various kinds of nostalgia to procure a script that may make our site-seeing more apprehensible. It can be the restorative kind of nostalgia, where the weight is on the return home and where what is lost is desired rebuilt, or it can be the reflective kind, the weight now on algia, the longing itself as what we seek. The two are not mutually exclusive. Whichever it is, it works as a kind of moderator for the arrangement we attempt as we see the site.

Like site-oriented art the five sites moreover illustrate what Miwon Kwon describes as the "way in which the art work's relationship to the actuality of a location (as site) and the social conditions of the institutional frame (as site) are both subordinate to a *discursively* determined site that is delineated as a field of knowledge, intellectual exchange, or cultural debate" (Kwon 2002, 26). In the California sojourns, the discursively determined in Kwon's definition covers at times messy and muddled fields where multiple traditions of being and seeing intersect, both subjected to and commanding their exchanges in the region's rhizomatic in-becoming. The five sites are consequently also vibrating with a structure of the (inter)textual as much as the spatial, "and its model is not a map but an itinerary" (ibid., 29). We might add that the intertextual and the spatial in relation to the rhizomatic do not move far from each other and still resonate with Ghosh's view of the aesthetic imaginary as "tangled figurations." The performativity that a literary chorography excavates from the sites thus amplifies the itinerant and shifting, echoing the very region it moves through. Recall also how region denotes "an area concatenated by peregrinations between the places it connects" (Casey 1997, 24), a connectivity of the unpredictable that California perhaps more than most regions exemplifies.

What, then, when region and the places it connects presents itself as marked by permanence and boundedness, and which does not as easily let cross-border epistemic and cultural circulations significantly interrupt their sense of sited-ness, and citation? What about sites where the discursively determined is precisely that, determined by one, single story. And are literary chorographies possible in the presentness of the contemporary; is the so-far of the site's performance readable when it projects into the flux of now? The

contemporary itself is of course never what we in everyday use think it is, a time of the absolute now contained in our own present. The contemporary instead complicates itself, as Peter Osborne notes, in that it "projects a single historical time of the present, as a living present: a common, albeit internally disjunctive, present historical time of human lives. 'The contemporary,' then, is another way of referring to the historical present" (Osborne 2013, 22). In this book's final site-seeing I would like to trek across the country to a region not particularly known for change and shifting cultural premises, where entangled figurations take on disturbing vibes, and where the contemporary is very much the historical present. The South comes trailing Stegner's "cumulative associations," and there is one particular node they conglomerate around which also solidifies into stone and marble. This final sojourn goes to a small town in South Carolina whose site-specificity and performance resonate with discourses acutely circling the problem of belonging, tradition, and the claim to place and (hi)story. They are, not surprisingly, generated by the role a monument plays on that stage, and before we begin this particular site-seeing, a few comments on the larger context of what has become known as the monument debates in the US are in order.

Erica Doss problematizes what she calls memorial mania in American public life and asks a series of critical questions that apply also in relation to contemporary debates surrounding confederate monuments in the US. "How," she asks,

> are feelings of grief, fear, gratitude, shame, and anger mediated in America's memorial cultures? How are sociopolitical concerns such as racism, violence, and terrorism negotiated? How do the metaphors of agency, subjectivity, rights, and citizenship work in visual and material cultures? How do memorials represent and also repress national consciousness? What does memorial mania tell us about how Americans feel about themselves as Americans today?
>
> DOSS 2010, 15

The string of questions have become no less pressing in the decade since Doss posed them. The debates that erupted into global attention after the demonstrations and killing of a woman in Charlottesville in 2017 turn on momentous questions related to ownership of and respect for history and stories, as well as the series of Doss' questions. It bears reminding that the more than 1500 monuments and memorials around the South commemorating the Civil War and its dead for the most part came up long after the war itself. Many of them were erected as late as in the 1960s in response to the Civil Rights movement,

even more during the Jim Crow era to assert white supremacy and deter black communities post-Reconstruction from forming political bodies. These monuments and memorials are consequently not always mere commemorations, "designed to recognize and preserve memories," (Doss 2010, 7), but in many cases also came up as warnings stemming from convictions celebrating and protecting a specific story. The monument debates have come to epitomize deep and worrying rifts of polarization that in the beginning of the 2020s are showing no signs of contracting. As they tackle the problem of citations and the string of fundamental questions of cultural existence and co-existence that the monuments bring, many cities and towns are engaging various strategies of negotiation.

One strategy is to remove the monuments, as happened in New Orleans in the summer of 2017 with the three landmark statues of Robert E. Lee, Jefferson Davis, and P.G.T. Beauregard. In the morning following the first removals, when cranes had lifted the statue of Lee off of its pedestal at night and placing it in storage, the then mayor of New Orleans, Mitch Landrieu, gave a seventeen-minute long speech that has since become a reference point in the debates' discourse. He said among other that, "while some have driven by these statu[es] every day and either revered their beauty or failed to see them at all, many of our neighbors and our fellow Americans see them very, very clearly. Many are painfully aware of their long shadows their presence cast not only literally but figuratively" (Landrieu 2017). Landrieu's speech reminded people that stones and markers are not innocent, that their presence and insistence on holding certain memories and stories in place imply the negation of other memories and stories. For, the "long shadows" are indeed long, and the eruption of violence in Charlottesville, Va. later the same summer over the question of confederate statues made clear just how long they are.

Removal of confederate monuments and memorials has taken place in many towns and cities, but not without its critics. The common response from those who disagree with this approach is that removal is an act of historical erasure which does not accomplish re-evaluation and trans-valuation, but instead leaves behind an absence that can also potentially be dangerous. This is partly the motivation behind Atlanta's strategy, where they have been forced to choose a different tactic. As the first city to do so, Atlanta has put up what they call contextual markers next to or at the base of some of the city's many confederate monuments. Georgia, like several other states, prohibits the removal of any monument honoring service in the military, and has since 2019 made vandalizing public monuments punishable by law. In this situation, adding context seems the only option available, and as Sheffield Hale, president and CEO of the Atlanta History Center tells CNN,

> the panels will serve as an example to other communities grappling with
> their own Confederate monuments and will help foster discussions and
> learn how to best address them. 'If you remove the statue, you remove the
> conversation,' Hale said. 'For me and many historians, they provided that
> ability to spark a conversation and put it in our face that we did not have
> a perfect past -- far from it, in the South.'
>
> ANDONE 2019

By engaging the monuments and the spectator in open dialogue about the
causes of the war and its legacies, the contextual markers interrupt the mo-
nopoly on citation that the monuments have had. It is an interesting approach
to historicizing that counters the critique of erasure by addition rather than
removal. There is, however, an element of the musealized shadowing the mark-
ers and what they comment on, a sense that the explanations and the added
contexts as reminders of the fuller story situate their objects in the past, not
unlike the effect of looking at objects curated in a museum and reading the ex-
planatory texts that accompany them. Add to this the visual impression, where
the added markers are often physically dwarfed by the size of some of the mon-
uments and echoing a relationality between the discursive spaces that histori-
cal legacies take up. What Kirk Savage calls "commemorative landscapes" (Kirk
2018, x) thus for many remain challenging, and while acknowledging in public
the fuller histories of American pasts is a definite step in the right direction,
the landscapes remain painfully scarred, and a long way from healing.

Between removal and addition there is, however, a third approach. Abbev-
ille is a small town of about 5000 people in southern South Carolina, and like
numerous other towns across the South a confederate monument sits on its
court square, an obelisk commemorating the fallen soldiers to the Civil War. Its
position as center piece in the small park in the square is the result not only of
the general tradition of memorialization in the region; this is added to by the
relatively little-known fact that the town was both birthplace and deathbed of
the Confederacy itself. Around the park where the monument stands are var-
ious older structures, such as the Opera House, the Court House, the Belmont
Inn, to mention some. In front of the Court House and Opera House, diagonal-
ly across from the confederate monument on the other side of the square, is,
however, a very different kind of marker. This is a plaque erected in 2016 which
memorializes Anthony Crawford, who one hundred years earlier was killed by
a lynching mob. Crawford was a planter who owned more than 400 acres of
land in and around Abbeville and who made several, important contributions
to the community, a school and a church among them. For a black man during
Jim Crow, all of this was in itself dangerous. On 2 October 1916 a white man

TANGLED FIGURATIONS

approached him, wanting to buy cottonseed below price. Crawford refused to sell, which led to an argument, assault, and subsequent arrest. As the plaque explains, "a few hours later, 300 white men seized [Crawford] from jail and dragged him through town behind a buggy. Finally stopping at the fairgrounds, the mob stabbed, beat, handed, and shot Mr. Crawford over 200 times – then forbade the Crawford family to remove his hanging body from the tree" (Equal Justice Initiative, n.d.). Most of the family left Abbeville to go North; all of Crawford's land was lost.

The Abbeville court square is of particular interest for testing the depths of site-specificity and literary chorography, as well as to the complicated register of the monument debates themselves. For one thing, the visual sense of relationality between the confederate monument and the Crawford plaque produces a different kind of effect and affect than do the emptied pedestals in New Orleans. Nor is it like the relationality produced between the contextual markers and the monuments they comment on in Atlanta. In the latter case the conversation, or negotiation between citations, is orchestrated by deliberate placing and wording; on the Abbeville square, however, it emerges in the unscripted but deeply tangled figuration of imaginaries that are indeed "built inside the borders of a nation, a culture, a society, a tradition" (Ghosh 2015, 134). Site-specificity in this case and in the relation it stages is in fact in and of itself an entangled figuration that dramatizes an absolutely singular history, the monument and plaque disturbingly tied in an "installation" where the one does not exist without the other. We come back to this in detail below.

Ladino reminds us that even if monuments and memorials are sometimes conflated, they *are* different: Often, she says, "monuments refer to built structures on a grand scale [...] which tend to (but don't always) celebrate dominant national narratives and reinscribe official histories. Memorials, by contrast, can be as simple as a plaque and tend to mark sites of grief or trauma. Memorials recognize a messier past and give expression to American publics that are 'diverse and often stratified' " (Ladino 2019, xiii). Both types of commemoration are present on Abbeville's square, and they present the visitor with an extraordinary performance absolutely inseparable from this one, particular site. Our considerations in previous chapters and site-seeings of ghosts and hosts, erasures and overwritings, palimpsestic and palimpsestuous relations, restorative and reflective yearnings for the past, the full and awe-some register of Stegner's "sense of place;" all of this comes into powerful play on the Abbeville site. Its site-specificity moreover bears not only on conceptions of past and present, but significantly and possibly also on those of the future.

1 Entangled Figurations As Site-Specific History

The organization behind the Crawford plaque is the Montgomery based Equal Justice Initiative. EJI was founded in 1989, and are dedicated to, as their website says, "ending mass incarceration and excessive punishment in the United States, to challenging racial and economic injustice, and to protecting basic human rights for the most vulnerable people in American society" (Equal Justice Initiative, n.d). EJI is also the architect behind the Legacy Museum established on the site of an old warehouse in the former slave market in Montgomery, Alabama, as well as the famous National Memorial for Peace and Justice nearby, sometimes referred to simply as the Lynching Memorial. Their website provides instructional material for use in education programs, as well as productions such as the award nominated HBO documentary *True Justice: Bryan Stevenson's Fight for Equality* (*2019*). Apart from offering legal council, documenting racial injustice in films, websites, and outreach programs, EJI a few years ago also began a mission to memorialize individual victims of lynching in a historical marker project. The project involves putting up markers or plaques like the Crawford one in Abbeville to identify and memorialize the acts of terror that have more often than not gone silenced in the places where they took place. On one side of these plaques a text tells in detail what happened to the specific individual; the other side gives the broader context for the given state's role in the national scheme of terror. So far, the organization has documented more than 4000 lynchings between 1877 and 1950, and markers have been put up in many of the places, the majority of them around the South. In EJI's own words, the program is "part of our effort to help communities confront and recover from tragic histories of racial violence and terrorism, EJI is joining with communities across the country to install narrative historical markers at the sites of racial terror lynchings" (Equal Justice Initiative, n.d). Wherever plaques are put up, they change that space and re-create it by pulling into its situatedness the historical vectors that occasion its existence.

The idea of context here consequently takes on a different value and function than what we see with the contextual markers in Atlanta. Context, the connection that emerges from the fabric of meanings woven together, is on the Abbeville square and in the relationality that emerges from the figuration of the monument and the plaque placed at a distance across from it, an invitation to the spectator herself to make and understand connections and associations rather than follow the scripted direction of interpretation and gaze. For there is no explicitly intentional relation between the obelisk and the plaque; here is no deliberation by an artist or curator. We witness instead a "dialogue" that emerges into unique form as the result of historical trajectories; the figure that

results is not coincidental, and when we consider context again as the web of meanings, the nature of that relationality is in fact the only possible outcome. What the obelisk commemorates and reminds us of is inextricably linked to what the plaque commemorates and reminds us of; the lynching is the direct result of an ideology that would manifest in the desire to commemorate the confederacy on the other side of the square. The placement itself is similarly the result of the actual sequence of events that would take Crawford's life: the incarceration and mob justice that led to his killing took place at the courthouse that sits behind the plaque. The distance and angle between the two "participants" on this stage of remembering is also disturbingly appropriate. It marks a spatial dissonance echoing the cultural and historical one, and it falls on the spectator to invest that relation with meaning and comprehension. To bring its disturbing register out more fully, site-specificity and the nature of participatory monuments provide helpful lenses for a reading and chorography that deepen the sinister installation that so powerfully forms on the Abbeville square.

I make a brief stop here to emphasize that in the case of Abbeville, as with the other sites, there is no actual composer, curator, artist, or chorographer present. It falls on the viewer/reader to take that role in the attempt to read the square and its production, for in reality, the chorography of the Abbeville square manifests in the "script" that the relationality between obelisk and plaque, between monument and memorial creates itself, and which transpires from the internal workings of overwritten layers. A quick review of how some of the elements that define chorography can work in relation to the site helps us see how the excavatory involved in this particular site-seeing can lead to "new kinds of texts" (Pearson 2006, 9). Aside from the basic point about how chorographies represent space/place, we recall from Rohl's list of more concrete characteristics in Chapter 1 that they see time as a feature of place; they emphasize the interconnection of the human and its environment; they reorient received perceptions of center and periphery ("the particular place or region [...] to which all roads lead"); they are concerned with "real emplaced experiences;" and with the sedimentation of meanings into stories about place (Rohl 2011, 6). Seeing time as a feature of place is the fundamentals of any monument and memorial – the remembering itself what we are asked to do – already temporal and tied indelibly to location as their power to mean derive from concrete emplacement. The concreteness of that emplacement on the Abbeville square, the angular distance between monument and plaque, creates an ambiguous relation of proximity from afar. From this follows "the interconnectedness of the human with its surroundings" (ibid.): The signifying power of the Confederate monument and Crawford's memorial is embedded

in the very fabric of the site of Abbeville itself. The history of the town's role in the Civil War and its aftermath presses ominously on the stage, intensifying as meta-commentary on the web of meanings its existence is part of. From this we now arrive at "the reorientation of periphery and center" (ibid.): The Confederate monument was established as the center until now, with the Crawford memorial from hitherto margins interrupting and literally re-directing our gaze into a differently framed reception of the fabric of relations. Finally, from this follows also the unearthing of sedimentation of meanings not only related to Abbeville, SC, but by extension to an entire region. If these elements of the chorographic approach bring to our attention the detailed life of place in its multiple shades, then the practice of site-specificity helps see more clearly the kind of figure that emerges from this tangled web of referentiality.

Site-specific installation art is commonly distinguished from "sculpture or other traditional art" in that it "is a complete unified experience, rather than a display of separate, individual artworks" (*Tate Art Terms*, 2020). Citing artist Ilya Kabakov, the entry goes on to note that "[t]he main actor in the total installation, the main centre toward which everything is addressed, for which everything is intended, is the viewer" (ibid.). As with all site-specificity, and as we have seen again and again in the preceding chapters, the audience/spectator is an essential component of the "artwork" itself. Its potential can only be realized through a reading of what Pearson calls the saturated space, composed as a scene of crime from layers upon layers of history and story (Kaye 2000, 53). Saturation in this case is inseparable from the concrete specificity of the place the work inhabits, and this will sometimes include geographic, historical, and cultural coordinates and nodes of significance. Reading and seeing the Abbeville town square in this framework has unexpected and uncomfortable consequences, for let us now consider this: What are the two memorials and their angular, distanced juxtaposition but precisely the invitation to a dialogue of layered narratives and rememberings? The square is quite *literally* the scene of a crime, the plaque a synecdochic trope which holds in it only a small part of an impossibly large whole. The spatial relationship between it and the rest of the "works" on the square is, whether intentional or not, also addressed to a spectator in an invitation to re-readings of relationality and answerability.

If up until 2016 the performance on the square was that of one script, the addition of the plaque unsettles it by releasing from underneath it that other narrative, awaiting its time. In an uncanny demonstration of palimpsesting and the palimpsestuous, the emergence of the overwritten layer brings to the surface a record of events and stories that profoundly now modifies the most recent layer as it presents itself to us. In a direct response to Dillon's comment that the "palimpsestuous reading is an inventive process of creating relations

where there may, or should, be none" (Dillon 2005, 254), the tangled histories that co-constitute each other on the site of the square are brought into direct relationality. The "relation that should not be" allegorizes the continued refusal of reckoning and reconciliation, nationally and locally, and produces the site as a summoning to the audience. We are returned to the problem of otherness, because relationality in this palimpsestuous presentation relies wholly on conceptions and practices of the other, reflected in the concrete distance between monument and memorial, and a long history of segregated remembering. Attridge writes that, "[o]therness is that which is, at a given moment, outside the horizon provided by the culture for thinking, understanding, imagining, feeling, perceiving" (Attridge 2004, 19). The relationality between the two "actors" on the Abbeville square is defined by variants of outsideness, but crucially, otherness can only be other in the sense of a relation of referral, or a relating, already embedded in a shared cultural-historical form. If it is not, it cannot be recognized, and hence as perceivable entity it can in fact not exist: "the other [...] is premised on a *relation*. To be 'other' is necessarily to be 'other than' or 'other to,'" unless we are referring to an absolute other, "a wholly transcendent other" (ibid., 29).

It is the relation that inheres in otherness that in turn motivates into recognition what Jacques Rancière calls "figures of the thinkable" (Rancière 2010, 17). The connectivity between figures of thinkability and their reception as such on site goes via aesthetics, which can be related to the "re-configuration of sensible experience," the relation between a "power that provides a sensible datum and a power that makes sense of it" (Rancière 2010, 15). In this relation between "sense and sense" the concept of power cannot be separated from the modalities of inscribed memories, and hence, pressing from the edges of history to claim its place in the center of remembering, the Crawford plaque in this way disrupts the hitherto familiar presentation of the court square and its interpretation. The site-specificity in the Abbeville "installation" is consequently the result of an entangled figuration that aesthetically emerges onto the same site and surface in a palimpsestuous posture of historical and cultural "callings and constraints of cross-border epistemic and cultural circulations" (Ghosh 2015, 134). In the singular form that the monument and the memorial create, otherness-*cum*-relation furthermore grimly analogizes a type of relationality within a much larger structure than what merely concerns this small place in South Carolina. Again, this produces a different effect and affect than does removal; it is also not the same as the impact formed by deliberate curations of monument and contextual markers that brings otherness to the front but may fail to summon relationality. Instead, I will suggest that in its unscripted form and subsequent open beckoning to the audiences' contemplation, the

158 CONCLUSION

Abbeville "installation" brings its relationality of otherness onto the site with all the weight the saturated space it inhabits contains. All in all, the experience resonates with what Doss in a paraphrase of Ann Cvetkovich says about memorials more generally, namely that they "are archives of public affect, 'repositories of feelings and emotions' that are embodied in their material form and narrative content" (Doss 2010, 13).

If monument and memorial are the major repositories on this site, they do, however, not exhaust the archive, for their silent "conversation" is intensified by other "participants" on the scene. While less prominently positioned, these markers further amplify the effect of the complicated performance. To the immediate right of the Crawford plaque is a standing clock. A little past the clock is a smaller stone marker, located in the space between the Court house and the Opera house. If you go closer and read the inscription, you realize the stone marker commemorates the law offices that once housed John C. Calhoun's practice. To most his name evokes a staunch defense of slavery and views on states' rights; in the well-known address titled "The Positive Good of Slavery" Calhoun gave to the Senate in 1837, he among other stated that, "I hold then, that there never has yet existed a wealthy and civilized society in which one portion of the community did not, in point of fact, live on the labor of the other. Broad and general as is this assertion, it is fully borne out by history" (Calhoun 1837). To Calhoun, the institution of slavery was inseparable from the survival of the South as a region, as civilization, and it is perhaps not without reason that he is sometimes referred to as the man who started the Civil War. The marker that commemorates his presence on the Abbeville square can consequently be read as a symbol that anticipates the war that would lead to the monument across from it and in turn the memorial next to it.

It is furthermore fitting that between the Calhoun marker and the Crawford plaque is the standing clock. It is taller than the other markers in that space, and if we contemplate it as part of the "installation," its function as measure of time ambiguously signifies as both reminder and warning. If the marker, plaque and monument intone the trajectories of history and remembering wrapped into the space of a small-town square, then the clock is all temporality. Loosened from the confines of emplaced happening, the clock's relentless measuring brings to the "installation" a compelling signal of the urgency of remembering and reckoning. In this sense the constellation on site carries elements of syncopation, what Boym describes as a mode that "precludes synthesis or symbolism and incorporates loss into a fragmented musical composition" (Boym 2017, 31). This bears on the Abbeville square since the effect of its (unintentionally) syncopated curation is precisely that of liberating "an event or process from being trapped in only one kind of way of articulating time, essentially, the modern

TANGLED FIGURATIONS

world's understanding of 'clock time' " (ibid., 31). The reminder that the clock inserts into the staging of remembering and reckoning thus bypasses chronology and instead forces an account of Faulknerian continuity, of bringing the past into the present as the only thinkable way into a future. The "installation" thus comes to stand before us as a chorography in its own right, a writing of place that is impossible to turn away from, and which emphasizes the element of warning that resides in the Latin root of monument, *monere* – to remind *and* to warn. This ambiguity of temporal orientation adds to the complexity of the Abbeville "installation:" the relationship between the monument and the memorial is spatially and dialogically bound in a simultaneous leaning toward the past as well as future, the expression of an impulse to re-member as well as *de*-member, to protect as well as to destroy.

I would like to return to Rancière, for having now assessed as best as we can what actually goes into the site we are looking at, what is it, aesthetically speaking, that transpires? Ranciere says about the ethical order in relation to aesthetics that it is "a whole organization of the visible, the thinkable, and the possible, determining what can be felt, seen, thought, and done by this or that class of beings, depending on its place and occupation" (Rancière 2010, 17). The description fits the nature of the town square before the Crawford memorial came up all too well, and synecdochically so, that of an entire region which as direction (Casey) extends beyond its spatial confines. The impact of the Abbeville work, so to speak, illustrates accurately what Ranciere goes on to call an aesthetic heterotopia, a rupture with the ethical order that opens up a space for sensing differently. It is, however, not entirely heterotopic, if by that we mean other in an absolute sense, because the Abbeville square and its installation is conditioned by the specificities of tangled relations in all their complex layeredness and which pertain indelibly to its site and that which precedes its current form. Recall again what Rohl says about chorography's emphasis on "real emplaced experiences," and the sedimentation of meanings that transpire into stories about place. Long silent and invisible, the stories and sedimentations that enshroud the town square have not been absent; instead their veiled presences mark the very conditioning of the figure the square has made. Seeing the site aesthetically in this manner can finally be related to Rancière's conception of aesthetics as referring "first and foremost to a form of experience, a mode of visibility and a regime of interpretation" (Rancière 2010, 24). And yet the implications of seeing thusly extends further, because in presenting itself in a definite form, the site also reflects on the *how* of its emergence as form. If I understand Rancière correctly, this form furthermore presents itself as an issue "of the configuration of a common world" (ibid.), already reaching deep into the layered frameworks that occasion its emergence.

The effect furthermore has some affinities with what Ranciere in his commenting on Hegel's discussion of two paintings by Murillo describes as "the configuration of the sensible landscape in which a community is framed, a configuration of what it is possible to see and feel, of the ways in which it is possible to speak and think. It is a distribution of the possible which also is a distribution of the capacity that these or those have to take part in this distribution of the possible" (ibid.). The wording here resonates on several levels, from the problem of framing and configuration to that of distribution and possibility. The seeing of the site itself must account for all, and re-frame and re-configure the emerging form in its entanglement as an ultimately ethically charged event that lays claims to answerability on part of the audience. This perhaps corresponds to the "common world" that aesthetics is capable of generating and mediating, that the landscape may in fact be sensed, in all senses of sense. In its own quiet way, and in an address to an audience willing to see and listen, Abbeville's site-specificity consequently comes close to answering the call Kirk Savage makes for the future of monumentalization. In the new preface to his *Standing Soldiers, Kneeling Slaves,* he says that "public monuments must [...] speak to the changing demographics and challenges that are affecting every community across the globe. That task is not about erasing the past but reconstructing it, to use the political term that still resonates from the late 1860s" (Savage 2018, xiii). If we take the meaning of the word reconstruct seriously, namely as that of building something in the sense of fitting parts together as well as accomplishing that task by working together, the reconfigured Abbeville square with its Crawford memorial is a forceful beckoning to the audience. Similar to participatory monuments, it, too, "activates memory and contributes to forming collective memory through participation" (Røstad 2019). The keyword here is in other words participation, occasioned by reckoning and the hope of reconciliation in the monumental bid for re-construction that the square as site potentially mobilizes.

By way of conclusion I want to return to the observation of place which this book began with, namely the passing through a Five Points and thinking about the energies that produce it as the star-shaped center it presents itself as. We all do this at some point or other, distractedly we contemplate the place we are in or pass by and wonder what it is like there, how people live, who they are. In this sense we are perhaps all amateur geographers, noticing our surroundings and reflecting on their histories and meanings. In his introduction to *Geographic Thought: A Critical Introduction,* human geographer Tim Cresswell opens with the very simple statement that, "Geography is a profound discipline" (Cresswell 2013, 1). What he means is that in our everyday lives as sentient beings, maneuvering in and engaging with the physical world, we are at

all times engaged in geographical questions, including those concerning how we ideologically live our lives in this world that we are part of. Creswell quotes an anecdote by Denis Cosgrove, who recounts something so banal as a trip to the shopping precinct, going through all the calculations and thought processes involved in the noticing of everything that is going on around him. Cosgrove concludes the account of his outing saying that, "[t]he [shopping] precinct is a symbolic place where a number of cultures meet and perhaps clash. Even on a Saturday morning I am still a geographer. Geography is everywhere" (Cosgrove quoted in Cresswell 2013, 2). One does not have to be trained as a geographer to instinctively recognize that what Cosgrove says is true; that geography, understood very simply as the study of "diverse environments, places, and spaces of Earth's surface and their interactions" (*Britannica*) is intrinsic to our sense of existing. It certainly resonates with the narrative excursions in this book; after all, what are they but a series of visits to localities absolutely symbolic, "highly textured [...] with multiple layers of meaning" (Cresswell 2013, 2).

Cresswell continues to suggest that, "[u]nlike theoretical physics or literary theory, it is hard to escape geography. [...] It is this confluence of the profound and the banal that gives geographical theory its special power" (ibid., 3). While I cannot speak for theoretical physics, I can speak for literary theory, and I am not so sure that we do escape literary theory. On the most basic level it is a blanket term for the different ways we make sense of what we read. However, the little word read, as we saw in the Introduction, carries connotations of as various and complex activities as advising, planning, arranging, predicting, guessing, and deliberating. Our readings in all those senses are operations that must be reflected upon, consciously or subconsciously, very similarly to how Cosgrove describes the mundane activity of going shopping as a practicing of geography. It would be difficult to escape literary theory, if by that we mean the making sense of and arranging what we perceive around us into some form of comprehension. This is a view that comes very close to how Cresswell describes theory in general, as what goes on in our minds as "more or less organized ways of ordering the world which exist in our minds and which we share with others" (ibid., 5). But here is the thing: that ordering, whether profound or trivial, is precisely what makes our reading and the thinking about our reading so intrinsic to how we are in the world. As Steven Feld says in the epigraph to this chapter, "as place is sensed, senses are placed; as places make sense, senses make place" (Feld 1996, 91). The entanglement of sense and place brings out how absolutely embodied our sense of place is, and the stories we tell are every bit as much the places we tell.

Works Cited

Adichie, Chimamanda Ngozi. 2009. "The Danger of a Single Story." *TEDGlobal*. Accessed 11.11.2018 https://www.ted.com/talks/chimamanda_adichie_the_danger_of_a_single_story/transcript.

Andone, Dakin. 2019 ."Georgia Law prohibits removing these Confederate monuments. So Atlanta is adding context," *CNN*, August 2,2019. https://edition.cnn.com/2019/08/02/us/atlanta-confederate-monuments-context/index.html.

Appudurai, Arjun. 2010. "How Histories Make Geographies: Circulation and Context in a Global Perspective." *Transcultural Studies* 1: 4–12.

Assman, Jan. 2008. "Communicative and Cultural Memory." In *Cultural Memory Studies. An International and Interdisciplinary Handbook*, edited by Astrid Erll and Ansgar Nünning, 109–118. Berlin, New York: de Gruyter.

Associated Press. 2019 "Forgotten Winchester' gets own exhibit," 28 May, 2019. Accessed 10 June 2019 https://mailtribune.com/news/happening-now/forgotten-winchester-gets-own-exhibit-gun-nevada-old-west-museum.

Atherton, Gertrude. 1906. *Rezánov*. New York and London: The Authors and Newspapers Association.

Attridge, Derek. 2004. *The Singularity of Literature*. Abingdon: Routledge.

Bakhtin, Mikhail. 1991. *The Dialogic Imagination: Four Essays*. Edited by Michael Holquist. Translated by Caryl Emerson and Michael Holquist. Austin and London: University of Texas Press.

Bakhtin, Mikhail. 1986. *Speech Genres and Other Late Essays*. Edited by Michael Holquist and Caryl Emerson. Translated by Vern W. McGee. Austin: University of Texas Press.

Bakhtin, Mikhail. 1984. *Problems of Dostoevsky's Poetics*. Edited and translated by Caryl Emerson. Minneapolis: University of Minnesota Press.

Bal, Mieke. 2011. "Heterochrony in the Act: The Migratory Politics of Time." In *Art and Visibility in Migratory Culture: Conflict, Resistance, and Agency*, edited by Mieke Bal and Miguel Á. Hernández-Navarro, 209–237.

Battles, Matthew. 2015. *Palimpsest: A History of the Written Word*. New York: W.W. Norton & Company.

Brambilla, Chiara and Holger Pötzsch. 2012. "InVisibility/InVisuality; (Medial) Borderscapes; Bordering." unpublished draft, 2012. Bodie State Park, n.d. Accessed April 4, 2019. http://www.parks.ca.gov/?page_id=509.

Bossing, William P. 2000. *Chorography: Writing an American Literature of Place*. PhD dissertation, University of Kansas.

Boym, Svetlana, 2017. *The Off-Modern*. New York: Bloomsbury.

Boym, Svetlana. 2008. *The Future of Nostalgia*. New York: Basic Books.

Boym, Svetlana. 2007. "Nostalgia and its Discontents," *Hedgehog Review* 9 (2), 7–18.

Boym, Svetlana. 2011."Nostalgia." *Atlas of Transformation.* http://monumenttotransformation.org/atlas-of-transformation/html/n/nostalgia/nostalgia-svetlana-boym.html.

Calhoun, John C. 1837. "Speech on the Reception of Abolition Petitions, February 1837." *Speeches of John C. Calhoun: Delivered in the Congress of the United States from 1811 to the Present Time.* New York: Harper and Brothers, 184 California Department of Parks and Recreation. Accessed 01.05.2019. https://www.parks.ca.gov/?page_id=91.

Calisphere. 2011. "California Cultures: Native Americans." Curated by University of California. Accessed 25.05.2019. https://calisphere.org/exhibitions/t1/native-americans/.

Campbell, Neil. 2008. *The Rhizomatic West: Representing the American West in Transnational, Global, Media Age.* Lincoln: University of Nebraska Press.

Casey, Edward S. 2001. "Between Geography and Philosophy: What Does It Mean to Be in the Place-World?," *Annals of the Association of American Geographers,* 91 (4): 683–693.

Casey, Edward S. 1996. "How to get from space to place in a fairly short stretch of time: phenomenological prolegomena." In *Senses of Place,* edited by Stephen Feld, and Keith H. Basso, 13–52. Santa Fe: School of American Research Press.

Casey, Edward. 1987. "The World of Nostalgia," *Man and World* 20: 361–384.

Casey, Edward. 1988. "Levinas on Memory and the Trace." In *The Collegium Phaenomenologicum, The First Ten Years,* edited by J. Sallis Giuseppina Moneta and J. Taminiaux, 241–255. Berlin/Heidelberg: Springer Netherlands.

Cowden, C. and M.C. Clarke, editors. 2007. *Cassell's illustrated Shakespeare: The plays of Shakespeare.* 2007. Illustrations by H.C. Selous. Oxford: Oxford UP.

Castoriadis, Cornelius. 2007. *Figures of the Thinkable.* Translated by Helen Arnold. Stanford: Stanford University Press.

Castoriadis, Cornelius. 2005. *The Imaginary Institution of Society.* Cambridge: Polity Press.

Clifford, James. 1997. *Routes: Travel and Translation in the Late Twentieth Century.* Cambridge: Harvard University Press.

Cooder, Ry. N.d. "Album Liner Notes," Chavez Ravine, online "Liner Notes," accessed December 20, 2018. http://albumlinernotes.com/Chavez_Ravine.html.

Cooder, Ry. 2005. *Chávez Ravine: A Record by Ry Cooder.* Los Angeles: Village Recorders, Sound City Studios.

Cosgrove, Denis. 2004. "Landscape and Landschaft" *GHI Bulletin* 35 (fall): 57–71.

Cresswell, Tim. 2013. *Geographic Thought: A Critical Introduction.* Hoboken, NJ: Wiley-Blackwell.

Damschroder, James. 2009. "Historic town's future is uncertain." *Union Democrat,* April 9, 2009. https://www.uniondemocrat.com/csp/mediapool/sites/UnionDemocrat/LocalNews/story.csp?cid=3755695&sid=753&fid=151.

De Certeau, Michel. 1984. *The Practice of Everyday Life.* Translated by Steven Rendall. Berkeley: University of California Press.

WORKS CITED

Dell'Agnese, Elena. 2015. " 'Welcome to Tijuana': Popular Music on the US–Mexico Border." *Geopolitics* 20: 171–192.

Denselow, Robin, 2005. "Ry Cooder, Chavez Ravine." *The Guardian*, June 10. https://www.theguardian.com/music/2005/jun/10/popandrock.shopping6.

De Poletica, Pierre. 1822. "The chevalier de Poletica to the secretary of state [John Quincy Adams]." *Niles' Weekly Register* 22 (1822): 145–160, 150–51. https://heinonline.org/HOL/Page?collection=journals&handle=hein.journals/nilesreg23&id=158&men_tab=srchresults.

Dickinson, Emily. 1924 "One need not be a chamber to be haunted." *The Complete Poems of Emily Dickinson*, edited by Thomas Herbert Johnson. Boston: Little, Brown, and Company.

Dillon, Sarah. 2005. "Reinscribing De Quincey's palimpsest: The Significance of the Palimpsest in Contemporary Literary and Cultural Studies." *Textual Practice* 19 (3): 243–263.

Dillon, Sarah. 2007. *The Palimpsest: Literature, Criticism, Theory.* London: Continuum.

Dolan, Kerry A. 2012. "Russian Billionaire Vekselberg's Non-Oil Endeavor: Raising Funds for a California State Park." *Forbes*, October 19, 2012. Accessed 10.06.2019 https://www.forbes.com/sites/kerryadolan/2012/10/19/russian-billionaire-vekselbergs-non-oil-endeavor-raising-funds-for-a-california-state-park/#173929c271dc.

Doss, Erika. 2010. *Memorial Mania: Public Feeling in America.* Chicago: University of Chicago Press.

Duncan, James. 2004. *The City as Text: The Politics of Landscape Interpretation in the Kandyan Kingdom.* Cambridge: Cambridge University Press.

Dunn, Roger and Ting Morris. 1995. *The Composite Novel: The Short Story Cycle in Transition.* New York: Macmillan Publishing Company.

Elicker, Martina. 1999. "Concept Albums. Song Cycles in Popular Music." In *Essays on the Song Cycle and on Defining the Field,* edited by Walter Bernhart and Werner Wolf. 227–248. Amsterdam: Rodopi.

Equal Justice Initiative. N.d. https://eji.org.

Feld, Steven, and Keith Basso. 1996. *Senses of Place.* Santa Fe, NM: School for Advanced Research Press.

Ferdman, Bertie. 2018. *Off Sites: Contemporary Performance Beyond Site-Specific.* Carbondale: Southern Illinois University Press.

Field, Andy. 2008. " 'Site-specific theatre'? Please be more specific." *The Guardian*, February 6, 2008. https://www.theguardian.com/stage/theatreblog/2008/feb/06/sitespecifictheatrepleasebe.

Fluck, Winfried. 2005. "Imaginary Space; Or, Space as Aesthetic Object." In *Space in America: Theory, History, Culture*, edited by Klaus Benesch and Kerstin Schmidt, 25–40. Amsterdam: Rodopi.

Frank, Waldo David. 1919. *Our America.* New York: Boni and Liveright.

Friedman, Susan Stanford. 1998. *Mappings: Feminism and the Cultural Geographies of Encounter*. Princeton: Princeton University Press.

Garcia, Mario T. 1989. *Mexican Americans: Leadership, Ideology, and Identity, 1930-1960*. New Haven: Yale University Press.

Genette, Gerard. 1982. *Figures of Literary Discourse.* Translagted by Alan Sheridan. Introduction by Marie-Rose Logan. New York: Columbia University Press.

Ghosh, Ranjan. 2015. "The Figure that Robert Frost's Poetics Make." In *Singularity and Transnational Poetics*, edited by Birgit Kaiser, 134–154. London: Routledge.

Gibson, James, 2013. *California Through Russian Eyes 1806–1848*. Translated and edited by James Gibson. Norman, OK.: The Arthur H. Clarke Company.

Goodavage, Maria. 2012. "Russian Rock Opera? Epic Love Story hits Bay Area." *San Francisco Classical Voice*, June 26, 2012. https://www.sfcv.org/article/russian-rock-opera-epic-love-story-hits-bay-area.

Grese, Robert E., and Knott, John R. 2001. "Introduction." *Michigan Quarterly Review*, XL (1): n.d.

Grinev, Andrei V. 2010. "The Plans for Russian Expansion in the New World and the North Pacific in the Eighteenth and Nineteenth Centuries." *European Journal of American Studies* 5 (2): 2010, 1–27 https://journals.openedition.org/ejas/7805.

Gudde, Erwin G. 2009. *California Gold Camps: A Geographical and Historical Dictionary of Camps, Towns, and Localities Where Gold Was Found and Mined; Wayside Stations and Trading Centers*. Oakland: California University Press.

Guerrero, Mark. 2003."Lalo Guerrero Recording Sessions with Ry Cooder." January 29–30. https://markguerrero.net/misc_43.php. Accessed January 3, 2019

Harte, Bret. 1926. "Concepcion de Arguello." *The Literature Network*. http://www.online-literature.com/bret-harte/complete-poetical-works/27/ Accessed May 12, 2019.

Hicks, Jack, and James D. Houston, Maxine Hong Kingston, Al Young, eds. 2000. *The Literature of California: Writings from the Golden State*. Berkeley: University of California Press.

Hillinger, Charles. 1979."The Russians Were Here, the Russians Were Here." *The Washington Post*, April 1, 1979. https://www.washingtonpost.com/archive/lifestyle/1979/04/01/the-russians-were-here-the-russians-were-here/18aea486-0505-445b-a881-b6d5c921280e/?utm_term=.fddeec290126.

Hitchcock, Peter. 2003. *Imaginary States: Studies in Cultural Transnationalism*. Urbana and Chicago: University of Illinois Press.

Hoelscher, Steven and Alderman, Derek H. 2004. "Memory and Place: Geographies of a Critical Relationship." *Social & Cultural Geography* 5 (3): 347–355.

Horsman, Reginald. 1981. *Race and Manifest Destiny: The Origins of American Racial Anglo-Saxonism*. Cambridge, Mass.: Harvard University Press.

Huyssen, Andreas. 2003. *Present Pasts: Urban Palimpsests and the Politics of Memory*. Palo Alto: Stanford University Press.

WORKS CITED

Huyssen, Andreas. 2006. "Nostalgia for Ruins." *Grey Room* 23 (Spring): 6–21.

Ignoffo, Mary Jo. 2012. *Captive of the Labyrinth: Sarah L. Winchester, Heiress to the Rifle Fortune.* Columbia, OH., University of Missouri Press.

Jardine, Jeff. 2014. "Falling lake levels expose rising relics at Don Pedro." *The Modesto Bee,* Feb 1, 2014. https://www.modbee.com/news/local/news-columns-blogs/jeff-jardine/article3160104.html.

Jefferson, Thomas. 2008 [1801]. "Thomas Jefferson to James Monroe, 24 November 1801." In *The Papers of Thomas Jefferson*, vol. 35, *1 August–30 November 1801*, edited by Barbara B. Oberg, 718–722. Princeton: Princeton University Press. Founders Online https://founders.archives.gov/documents/Jefferson/01-35-02-0550.

Jones, Carolyn. 2009. "Russians urge governor to save Fort Ross." *SF Gate*, August 28. https://www.sfgate.com/news/article/Russians-urge-governor-to-save-Fort-Ross-3288673.php.

Junker, Christine R. 2015. "Unruly Women and Their Crazy Houses." *Home Cultures* 12 (3): 329–346. https://www.tandfonline.com/doi/full/10.1080/17406315.2015.1084763 Accessed 10.05.19.

Kaye, Nick. 2000. *Site-Specific Art: Performance, Place, and Documentation*, Abingdon: Routledge.

Klahn, Norma. 2002–2003. "Chicana and Mexicana Feminist Practises: De/Linking Cultural Imaginaries." *Genealogies of Displacement: Diaspora/Exile/Migration and Chicana/o/Latina/o/Latin American/Peninsular Literary and Cultural Studies*, edited by Jordi Aladro, Norma Klahn, Lourdes Martínez-Echazábal and Juan Poblete. *Nuevo Texto Crítico* 29/32: 163–174.

Kwon, Miwon. 2002. *One Place after Another: Site-Specific Art and Locational Identity*. Boston: MIT Press.

Lacan, Jacques. 2003. *Écrits: A Selection*, Abingdon: Routledge.

Ladino, Jennifer. 2019. *Memorials Matters: Emotion, Environment, and Public Memory at American Historical Sites.* Reno: University of Nevada Press.

Ladino, Jennifer. 2012. *Reclaiming Nostalgia: Longing for Nature in American Literature*. Charlottesville, VA: University of Virginia Press.

Landrieu, Mitch. 2017. "On the Removal of Four Confederate Monuments in New Orleans," 19 May 2017, Gallier Hall, New Orleans. *American Rhetoric* n.d. https://www.americanrhetoric.com/speeches/mitchlandrieuconfederatemonuments.htm.

Least Heat-Moon, William. 1991. *PrairyErth: A Deep Map*. Boston: Houghton-Mifflin.

Lee, Erika. 2002. "Enforcing the Borders: Chinese Exclusion along the U.S. Borders with Canada and Mexico, 1882–1924." *Journal of American History* 89 (1): 54–86.

Limón, José E. 1992. *Mexican Ballads, Chicano Poems: History and Influence in Mexican-American Social Poetry*. Berkeley: University of California Press.

Lipsitz, George. 2007. *Footsteps in the Dark: The Hidden Histories of Popular Music*. Minneapolis: University of Minnesota Press.

López, Ronald. 1989. "Community resistance and conditional patriotism in cold war Los Angeles: The battle for Chavez Ravine." *Latino Studies* 7 (4): 457–479.

Lowenthal, David. 1990. *The Past Is a Foreign Country*. Cambridge: Cambridge University Press.

MacCannell, Dean. 2011. *The Ethics of Sightseeing*. Berkeley: University of California Press.

Maher, Susan Naramore. 2009. "Deep Map Country: Proposing a Dinnseanchas Cycle of the Northern Plains." *Studies in Canadian Literature*, 34 (1): 160–181. https://journals.lib.unb.ca/index.php/SCL/article/view/12385/13258.

Marchitello, Howard. 1997. N*arrative and Meaning in Early Modern England: Browne's Skull and Other Histories*. Cambridge: Cambridge University Press.

Marx, Karl and Engels, Frederick. 1850. "Review: May–October 1850." *Neue Rheinische Zeitung Revue*, n.d. https://www.marxists.org/archive/marx/works/1850/11/01.htm#45.

Marx, Leo. 1967. *The Machine in the Garden: Technology and the Pastoral Ideal in America*. Oxford: Oxford University Press.

Massey, Doreen. 1994. *Space, Place, and Gender*, Cambridge: Polity Press.

Massey, Doreen. 2005. *For Space*. Thousand Oaks: SAGE Publishers.

McCue, Andy. 2012. "Barrio, Bulldozers, and Baseball: The Destruction of Chavez Ravine." *Nine: A Journal of Baseball History and Culture*, 21 (1): 47–52.

McDougall, Walter. 1997. *Promised Land, Crusader State*: *the American Encounter with the World since 1776*. Boston: Houghton Mifflin Co.

Mechner, Jordan, n.d. "About Chavez Ravine: A Los Angeles Story," Jordan Mechner. Accessed May 20 2019. http://www.jordanmechner.com/projects/chavez-ravine/.

Métraux, Daniel A. 2010. "Ghosts of the Gold Rush: Visiting Chinese Camp, California." *Southeast Review of Asian Studies* 32: 158–62.

Miller, Arthur, 1983 [1949]. *Death of a Salesman*. London: Penguin Plays.

Miller, Gwenn. 2010. *Kodiak Kreol: Communities of Empire in Early Russian America*. Ithaca and London: Cornell University Press.

Mininchiello, Susan. "Restored cemetery at Fort Ross draws praise from Gov. Brown, Russian Ambassador Anatoly Antonov." *The Press Democrat*, Oct. 13, 2018. https://www.pressdemocrat.com/article/news/restored-cemetery-at-fort-ross-draws-praise-from-gov-brown-russian-ambass/.

Monk, Philip. 2006. *Spirit Hunter: The Haunting of American Culture by Myths of Violence: Speculations on Jeremy Blake's Winchester Trilogy*. Toronto: Art Gallery of York University.

"Monuments." 2019. Nordic Association for American Studies conference. April 25–28, 2019. Bergen, Norway.

Morgan, Aaron Augustus. 1876. *The Mind of Shakespeare as Exhibited in his Works*, London, G. Routledge and Sons. Accessed January 12, 2019. http://catalog.hathitrust.org/Record/006057100.

WORKS CITED

Moretti, Franco. 1999. *Atlas of the European Novel 1800–1900,* Brooklyn, N.Y., Verso.

Newitz, Annalee. 2012. "The Creepiest Haunted House in Silicon Valley." *Gizmodo,* May 23, 2012. Accessed 10 March 2019. https://io9.gizmodo.com/the-creepiest-haunted-house-in-silicon-valley-5912689.

Nicolini, Dolores. 1977. "Chinese Camp." *Chispa: The Quarterly of the Tuolumne County Historical Society.* April-June. Sonora, Ca.

Nora, Pierre. 1989. Between Memory and History: Les Lieux de Mémoire. *Representations* 26: 7–24.

Normark, Don. 1999. *Chavez Ravine, 1949. A Los Angeles Story.* Los Angeles: Chronicle Books.

The Oxford Shakespeare: Richard II. 2011. Edited by Anthony B. Dawson and Paul Yachnin. Oxford: Oxford University Press.

Oxford English Dictionary. 2020. Oxford University Press. https://www.oed.com.

Olwig, Kenneth C. 1996. "Recovering the Substantive Nature of Landscape." In *Annals of the Association of American Geographers* 86 (4): 630–653.

Osborne, Peter. 2013. *Anywhere or Not at All: The Philosophy of Contemporary Art.* New York: Verso Books.

Paden, Irene D. and Margaret E. Schlichtmann. 1955. *The Big Oak Flat Road; an Account of Freighting from Stockton to Yosemite Valley.* San Francisco: Lawton Kennedy.

Parkman, Breck. 1996/1997. "Fort and Settlement: Interpreting the Past at Fort Ross State Historic Park." *California History* 75 (4): 354–369.

Pearson, Mike and Shanks, Michael. 2001. *Theatre/Archeology.* London and New York: Routledge.

Pearson, Mike. 2010. *Site-Specific Performance,* London: Palgrave Macmillan.

Pearson, Mike. 2006. *In Comes I: Performance, Memory and Landscape.* Exeter: University of Exeter Press.

Pfaelzer, Jean. 2008. *Driven Out: The Forgotten War Against Chinese Americans.* Oakland: University of California Press.

Paredes, Américo. 1993. *Folklore and Culture on the Texas-American Border.* Austin: University of Texas Press.

Pierce, Richard A., ed. 1972. *Rezanov Reconnoiters California, 1806.* San Francisco: the Book Club of California. Courtesy of Fort Ross Conservancy. www.fortross.org.

Pötzsch, Holger. 2017."Visuality." Email to author, May 25, 2017.

Powell, Benjamin D. and Tracy Stephenson Shaffer. 2009. "On the Haunting of Performance Studies." *Liminalities*: *A Journal of Performance Studies* 5 (1). Accessed December 12, 2018. http://liminalities.net/5-1/hauntology.pdf.

Reps, John William. 1984. *Views and Viewmakers of Urban America: Lithographs of Towns and Cities in the United States and Canada, Notes on the Artists and Publishers, and a Union Catalog of Their Work, 1825–1925.* Columbia: University of Missouri Press.

Rancière, Jacques. 2010. "The Aesthetic Heterotopia." *Philosophy Today* 54: 15–25.

Rezanov, Nikolai Peterovitch. 1926. *The Rezanov Voyage to Nueva California in 1806. The Report of Count Nikolai Petrovich Rezanov of His Voyage to That Provincia of Nueva Espana from New Archangel.* Translated by Thomas C. Russell. San Francisco: The Private press of Thomas C. Russell. www.americanjourneys.org/aj-128/.

Richter, Gerhard, with Elger, Dietmar, Obrist, Hans Ulrich. 2009. *Text. Writings, Interviews and Letters. 1961–2007.* London: Thames and Hudson.

Rodriguez, Richard. 2002. *Brown: The Last Discovery of America.* New York: Viking Press.

Rodriguez, Richard. 2008. Interview. "Amerikas Historier på Langs" [America's Stories: Perpendicular]. *Replikk* 26: 16–23.

Rohl, Darrell J. 2011. "The Chorographic Tradition and Seventeenth- and Eighteenth-Century Scottish Antiquaries." *Journal of Art Historiography* 3: 1–18.

Rohl, Darrell J. 2012. "Chorography: History, Theory and Potential for Archeological Research." In *TRAC 2011: Proceedings of the Twenty First Annual Theoretical Roman Archeology Conference, Newcastle 2011.* Edited by Maria Duggan, Frances Mcintosh and Darrell J. Rohl, 19–32. Oxford: Oxbow Books.

Roorda, Randall. 2001. "Deep Maps in Eco-Literature." *Michigan Quarterly Review* XL (1). http://hdl.handle.net/2027/spo.act2080.0040.138.

Routledge Performance Archive. Accessed 03.01.2019 https://www.routledgeperformancearchive.com.

Russell, Philip. 2013. *100 Military Inventions that Changed the World.* London: Hachette UK.

Ryden, Kent C. 1993. *Mapping the Invisible Landscape: Folklore, Writing, and the Sense of Place.* Iowa City: University of Iowa Press.

Røstad, Merete. 2018. *The Participatory Monument: Remembrance and Forgetting as Art Practice in the Public Sphere.* Oslo: Oslo National Academy of Arts.

Røstad, Merete. "The Participatory Monument Remembrance and Forgetting as Art Practice in Public Sphere." Paper presented at the 26th Biennial Conference of the Nordic Association for American Studies, Bergen April 25–27, 2019.

Sandage, Scott. 2006. *Born Losers: A History of Failure in America*, Harvard University Press.

Saldívar, Ramon. 1990. *Chicano Narrative: The Dialectics of Difference*, Madison: University of Wisconsin Press.

Savage, Kirk. 2018. *Standing Soldiers, Kneeling Slaves: Race, War, and Monument in Nineteenth-Century America*, 2nd ed. Princeton: Princeton University Press.

Seitel, Peter. 2003. "Theorizing Genres – Interpreting Works." *New Literary History* 34 (2): 275–297.

Shanks, Michael and Witmore, Christopher. 2010. "Echoes Across the Past: Chorography and Topography in Antiquarian Engagements with Place." *Performance Research: A Journal of the Performing Arts* 15 (4): 97–106.

Shakespeare, William. *Richard II, The Complete Works of William Shakespeare.* N.d. TheTech. MIT. Accessed 10 January 2019 http://shakespeare.mit.edu/richardiii/index.html.

WORKS CITED

Shaughnessy, Nicola. 2012. *Applying Performance: Live Art, Socially Engaged Theatre an Affective Practice.* London: Palgrave Macmillan.

Sierra Nevada Geoturism, "Chinese Camp." Accessed 01.06.2019. https://sierranevadageotourism.org/entries/chinese-camp-no-423-california-historical-landmark/bb258d77-a52f-4a27-ae47-17e6fb91e40e.

Sillars, Stuart. 2016. Email to author, February 20, 2016.

Sobchack, Vivian. 1992. *The Address of the Eye: A Phenomenology of Film Experience.* Princeton: Princeton University Press.

Sofer, Andrew. 2013. *Dark Matter. Invisibility in Drama, Theater, and Performance*, University of Michigan Press.

Solomon, Thomas. 2014. "Music and Race in American Cartoons: Multimedia, Subject Positions, and the Racial Imagination." In *Music and Minorities from Around the World: Research, Documentation and Interdisciplinary Study*, edited by Ursula Hemetek, Essica Marks and Adelaida Reyes. 142–166. Cambridge: Cambridge Scholars.

Sprague, Marguerite. 2011. *Bodie's Gold: Tall Tales and True History from a California Mining Town.* Reno: University of Nevada Press.

"St. Joseph of Copertino." N.d. *Catholic Online.* https://www.catholic.org/saints/saint.php?saint_id=72.

Stanford, Leland. 1865. "Central Pacific Railroad Statement Made to the President of the United States, and Secretary of the Interior, on the Progress of the Work, October 10th 1865." *Sacramento History Online.* Accessed 10 January 2020. http://www.sacramentohistory.org .

Stegner, Wallace. 1986. "The Sense of Place." The University of Wisconsin-Madison: Silver Buckle Press. http://www.pugetsound.edu/files/resources/7040_Stegner,%20Wallace%20%20Sense%200f%20Place.pdf.

Starr, Kevin. 2005. *California. A History.* New York: The Modern Library.

Starrs, Paul. 2007. "When the Dozers Came, Only Music Was Left: Ry Cooder on Chaávez Ravine." *Geographical Review* 97 (3): 404–417.

"Supervisor Julian Chavez." N.d. County of Los Angeles Board of Supervisors Accessed 09.11.2018 http://file.lacounty.gov/SDSInter/lac/112080_jchavez.pdf.

Takaki, Ronald. 2008. *A Different Mirror: A History of Multicultural America.*New York: Back Bay Books.

Tate Glossary of Art Terms, http://www.tate.org.uk/learn/online-resources/glossary.

Taylor, Charles. 2004. *Modern Social Imaginaries.* Durham: Duke Press.

Tuan, Yi-Fu. 1991."Language and the Making of Place: A Narrative-Descriptive Approach," *Annals of the Association of American Geographers* 81 (4): 684–696.

Turner, Cathy. 2004. "Palimpsest or Potential Space? Finding a Vocabulary for Site-Specific Performance." *New Theatre Quarterly* 20 (4): 373–390.

Van Alphen, Ernst. 2017. "The Gesture of Drawing." In *Gestures of Seeing in Film, Video and Drawing*, edited by Asbjørn Grønstad, Henrik Gustafsson, and Øyvind Vågnes. Abingdon: Routledge.

Van Eyck Akademie. 2017. "Nearch Project Art & Archaeology. The Materiality of the Invisible." August 30–November 26, 2017. Maastricht.http://www.janvaneyck.nl/en/home/the-materiality-of-the-invisible_1/.

Vinkovetsky, Ilya. 2001. "Circumnavigation, Empire, Modernity, Race: The Impact of Round-the-world voyages on Russia's Imperial Consciousness." In *Ab Imperio: Studies of New Imperial History and Nationalism in the Post-Soviet Space* 1 (2): 191–209.

Voloshinov, Valentin Nikolaevich. 1996. *Marxism and the Philosophy of Language*. Translated by Ladislav Matejka and I.R. Titunik. Cambridge: Harvard University Press.

Von Langsdorff, Georg H. 1814. *Voyages and Travels in Various Parts of the World. The years 1803, 1804, 1805, 1806, and 1807. Part Two*. London: Henry Colburn. (San Francisco History Center).

Warner, Kara. 2018. "America's Most Haunted House? Creepy Secrets of the Winchester Mansion." *People*. February 2, 2018. Accessed 14.05.19 https://people.com/movies/americas-most-h aunted-house-creepy-secrets-of-the-winchester-mansion/.

Watrous, Stephen. 1998. "Russian Expansion to America." In *Fort Ross* © Fort Ross Interpretive Association (Fort Ross Conservancy). Accessed 29.05.19 https://www.fortross.org/russian-american-company.htm#Fort%20Ross%20-%20The%20Russian%20Colony%20in%20California.

Welty, Eudora. 1978. "Place in Fiction." *The Eye of the Story: Selected Essays and Reviews*. New York: Random House.

Whitman, Walt. 1900. "Song of the Redwood-Tree." In *Leaves of Grass*, edited by David Kaye. Philadelphia: Sherman & Co.

Whitman, Walt. 1900. " 'Facing West from California's Shores.' " In *Leaves of Grass*, edited by David Kaye. Philadelphia: Sherman & Co.

White, Hayden. 2003. "Commentary: Good of Their Kind." *New Literary History* 34 (2): 367–376.

White, Hayden, 1978. *Tropics of Discourse: Essays in Cultural Criticism*. Baltimore: Johns Hopkins University Press.

Wilson, David. *Letters* 1849–1855. BANC MSS 2001/134 cz Box 1. Berkeley: Bancroft Special Collections, University of California Berkeley.

Wilson, Janelle. 1999." 'REMEMBER WHEN...': A Consideration of the Concept of Nostalgia." *ETC: A Review of General Semantics* 56 (3): 296–304.

Winchester Mystery House. Accessed 01.04. 2018 http://www.winchestermystery-house.com/thehouse.cfm.

Winchester Mystery House. Accessed 06.05.19 https://winchestermysteryhouse.com/sarahs-story/.

"Winchester Model 1873 Rifle Recovered in Great Basin National Park." National Park Service. January 14, 2015. Accessed 20 January 2019. https://www.nps.gov/grba/learn/news/upload/Jan-15-Rifle-Discovery-PR.pdf.

Index

Abbeville, SC. 150–153
Abbeville court square 152
 Chorography 155
 Otherness 156–157
 Participatory monument 160
 Site-specificity 152–158, 160
 Spatial dissonance 154
Aesthetic function 23–24, 75, 76
Aesthetic imaginary 147–148
Appudurai, Arjun 4
Archeology 26–27
Atlanta, GA. 151
Autotopography 30, 33, 48
 Chavez Ravine 49

Bakhtin, Mikhail 1, 21, 38, 97, 125, 141
Bodie 52–53
 As text 53
 Performance 55
 Nostalgia 56
Boym, Svetlana 9, 31, 49, 56, 62–63, 72–73, 125, 144–145, 149, 159

Calhoun, John C. 159
California 4–5, 7
 Marx and Engels 4
 Chinese in California 61
Cartography 68–69
Casey, Edward 2, 11, 24, 56, 71, 87, 98, 109, 113, 117, 125, 142, 149
Castoriadis, Cornelius 136
Center and periphery 17, 155
Chavez Ravine 8, 17, 27–30
 Battle of 27–28
 Palimpsest 27
 The Dodgers 28
Chavez Ravine (album) 30–34
 Autotopography 33, 48
 "Chinito, Chinito," 42
 Chinese in Mexico 43
 Palimpsestuous 45
 Passing 45
 Pest farm 44
 Chorography 30
 Composite novel 33
 Concept album 33

"Corrido de Boxeo," 38–41
 Bakhtin 38
 Corrido 39–40
 Cultural imaginary 41
 Genre 38
 Host/ghost 41
 Palimpsest 41
 Site-specific performance 41
Confederate monument 150–153
Contemporary 149
Counter-nostalgia 50
Ghostly visitation 36
"In My Town," 45–47
 Edward Grieg 46
 Site-specificity 47
memorial 50
Nostalgia 31, 49–50
Place-making 47
Performance 30, 33, 36
Site-seeing 31
Site-specific performance 31, 34, 36, 48–49
"3rd Base, Dodger Stadium," 35
 Palimpsestuous 37
 Soundscape 35–36
Chinese Camp, CA. 57–59
 Affective dissonance 63
 Bodie 63
 Chorography 63
 Curation 66–67
 Exclusion Act 61
 Haunting 67, 69, 71
 Nicolini, Dolores 63
 Performance 65–66, 69–70
 Reflective nostalgia 73
 Site-specific performance 67–68
 Staging 64, 68, 73
 Suspension (figure) 71
Chorography
 history 13–14, 16, 18
 performance 18
 perspective 24
chorographic thinking 17
cite/site 1, 100
Clifford, James 3–4
Confederate monuments 150–153

Cooder, Ry 8, 30, 32–33
 Chavez Ravine (album) 26–50
Corrido genre 39–40
Cosgrove, Denis 14, 16, 63, 160
Crawford, Anthony 152–153
Crawford plaque 154
Cultural imaginary 3, 41
Cultural landscape (Landschaft) 9
Cultural memory 71
 and Fort Ross 124, 142
"Cumulative association," 51–52
 Metonymy 52, 55, 73, 115–116
Cupertino, CA. 120

De Certeau, Michel 2, 19, 41
Deep maps 12, 106
Dillon, Sarah 22, 26, 30, 37
Dodger Stadium 26–28, 30

"Elsewhen," 9
Equal Justice Initiative 154
Excess (visibility) 83
 Monument 100, 108
 Trace 116, 120

Five Points 1–2
Fluck, Winfried 23–24, 75–76
Fort Ross 123–124
 Argüello, Maria Concepción 138–139
 Arrilaga, José Joaquin 130, 136
 Atherton, Gertrude 140
 "Bostonians," 131
 Contemporary past 145
 "eventmental" (Casey) 125–126, 142
 "globality," 130
 Gold Rush 131
 Harte, Bret 140
 "homecoming festival"
 (Bakhtin) 125–126, 143
 Imaginary 132, 135–136
 Juno and Avos 141
 Metonymy 134
 Monument 137, 143
 Moscow 124
 Nostalgia 124, 134, 137, 144–145
 Relation to past 132–134
 Romance 138, 141
 Adventure romance (Bakhtin) 141
 Russian American Company 126, 130

Schwarzenegger, Arnold 138
 Suspension (motif) 142
Fragment 8, 11, 13, 26, 30, 45, 52, 147
 Abbeville 158
 Chinese Camp 63, 73
 performativity 53
Frank, Waldo David 109

Geography 160–161
 Reading 161
Ghosh, Ranjan 147–148, 153, 157
Ghost town 52–53, 56
Gold Country 13
Guerrero, Mark 38
Guerrero, Lalo 38
 "Corrido de Boxeo," 38

Huyssen, Andreas 14, 52, 56

Kaye, Nick 19, 24, 34, 122

Lacan, Jacques 115
Ladino, Jennifer 50, 63, 153
Landrieu, Mitch
Langsdorff, Georg Von 128
Literary chorography 14, 23

Mansions 99–101
Marx, Carl and Engels, Friedrich 4, 9, 92, 99,
 108, 132
Massey, Doreen 2, 98
Materiality 18
 of site 67
 "of the invisible" (Van Eyck) 84
 David Wilson's letters 85, 91
McLucas, Cliff 36, 71, 108
Mechner, Jordan 30
Monument 100–101, 142
Memorial 150, 155, 157
 Crawford memorial 25, 153

New Orleans 151
Nicolini, Dolores 63, 66
 "Chinese Camp," 63
Normark, Don 29–30
Nostalgia 49–50, 55–56, 72, 145, 148

Palimpsest 22–23, 26–27, 30, 57, 85, 125, 156
Palimpsestuous 37, 45, 49, 156

INDEX

Paredes, Américo 39
Participatory monument 100, 143–145, 154
Pearson, Mike and Shanks, Michael 26–27,
 36, 45, 47, 49, 51–52, 84, 88, 147
Pearson, Mike 7, 16, 19, 21–23, 31, 47–48,
 67, 71, 88–89, 95–96, 98, 116, 137, 145,
 155–156
Place 1–2
 Figuration 24
 "sense of place" (Stegner) 13, 51–52
 Letters 74
 Site 7, 116

Rancière, Jacques 157, 159
 The thinkable 159
Region 98
 place (Casey) 2, 11, 15
 chorography (Pearson) 16
Rezanov, Nikolai Petrovitch 127
 Argüello, Luis Antonio 128
Rohl, Darrel 14, 16–17, 155
Ruinophilia 62
Ruins 49, 62
Russian River, CA: 138

Sedimentation 17, 49, 53, 125, 155, 159
Shanks, Michael 5, 16
Shanks, Michael and Wittmore,
 Christopher 18, 20–21
Sight 1, 6
"single story" (Adichie) 15
Site 1, 6–7, 18
 aesthetics 24
 genre 39
 reading 6, 11–12, 20–21, 36
 spectacle 19
 text 6, 20
 tropes 24
 sight-seeing 100
Site-oriented art 149
Site-seeing aesthetics 71, 75, 147
Site-specific performance 19–22, 31, 36, 41,
 45, 47–48, 70–71, 107, 122
 cultural memory 37, 47
 Displacement (figure) 105–107
 Excavation 91
 Figure 25
 Haunting 21–22, 25
 Host/ghost 21–22, 36

music 47
nostalgia 50
palimpsestuous 49
sites 147–149
trace (Casey) 71
Site-specific work 111–112
Site-specific installation art 156
Sonic excavation 36
Soundscape 8, 35, 48
Space 2, 14
 Performance 19
 Place 19, 98
 Saturated space (Pearson) 36, 147, 156
Spatial practices 24, 122
Spatial turn 13
Speculative history 53
Stegner, Wallace 13, 51, 92
Synecdoche 54–55, 115–116

Taylor, Charles 135
Topography 16–17
Trace (Casey) 71
Tuan, Yi-Fu 12
Tuolumne County 57, 84
Turner, Cathy 21, 41–42

Whitman, Walt 3–4, 118
 "Song of the Redwood Tree," 3
Wilson, David 77–82
Wilson, David, *Letters* 1850–1855 77–97
 Chorography 89
 Crosshatching 91–93
 As image 92
 Figure of absence 83
 Figure of deferral 95–97
 Figure of invisible 84, 87, 91
 Dialogization 94
 Horse Shoe Bend 85
 Invisuality 87
 Map 43
 Otherness 88
 Performativity 82, 96
 Site-specific performance 91
 Spectral reading 88
 Trace 42–43
 Tropology 97
Winchester House (San Jose) 101–102, 104
 Desire 115–119
 Dickinson, Emily 112

Winchester House (San Jose) (*cont.*)
 Displacement 115–116, 118
 Figure of displacement 107
 "little event" (Hawthorne in
 Marx) 106–107, 113
 Installation 111–113
 Marx, Leo 106
 Metonymy 116
 "Mystic word" (Frank) 117

 "off-time" 119–120
 Performative 105, 109, 116
 Roosevelt, Theodore 107
 Shakespeare 110–112
 Site-specific performance 108, 113
 Trace 109, 113, 117
 Winchester rifle 105
Winchester rifle 106
Winchester, Sarah 103–104, 114

Printed in the United States
By Bookmasters